Susie Cooper

A PIONEER OF MODERN DESIGN

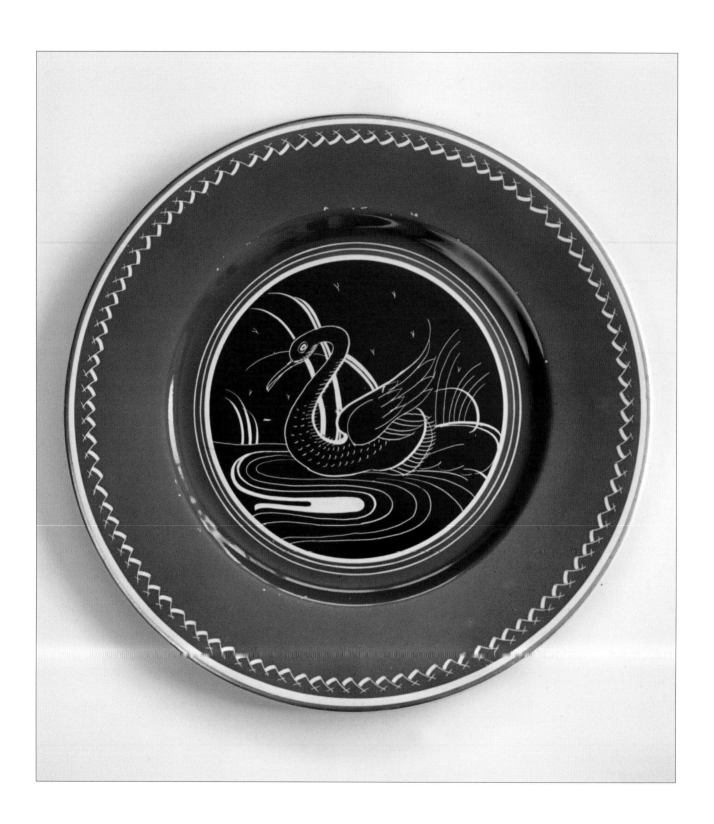

Susie Cooper

A PIONEER OF MODERN DESIGN

edited by

Ann Eatwell and Andrew Casey

ANTIQUE COLLECTORS' CLUB

ISBN 1 85149 411 1

The right of Tim Barker, Susan Bennett, Cheryl Buckley, Andrew Casey, Nick Dolan, Ann Eatwell, Sharon Gater, Alun Graves, Kathy Niblett, Lord Queensberry, John Ryan, Greg Stevenson, Julie Taylor and Bryn Youds to be identified as authors of their contributions to this work has been asserted by them in accordance with the Copyright, Designs and Patents Act 1988

British Library Cataloguing-in-Publication Data
A catalogue record for this book is available from the British Library

DEDICATION

To Susie Cooper (1902-1995) and all her workers

EDITORS' NOTE: Pattern names in inverted commas indicate names more recently adopted by collectors for identification, not names given to the designs by Susie Cooper herself.

FRONTISPIECE: An earthenware service plate, diameter 11in (28cm), aerographed with sgraffito decoration of a stylised swan with gilding to edge. Despite some references to swan designs in the pattern book, this pattern has not been seen before. About 1938.

TITLE PAGE: See page 166.

ENDPAPERS: See page 70.

Printed in Italy
Published by the Antique Collectors' Club Ltd., Woodbridge, Suffolk

CONTENTS

ACKNOWLEDGEMENTS

The editors and contributors would like to thank the many individuals, museums and organisations that have helped put this book together. In particular we appreciate the generous support of Susie Cooper's family and friends who assisted and provided archive material. We especially thank Tim Barker for his unfailing help and enthusiasm and for kindly writing the Introduction, and Jill Ikeringill for looking after us after long days of research and photography. Several members of Susie Cooper's family have given freely of their knowledge and memories for this book. We would like to thank Marian Chainey, Kenneth and Rita Cooper, Barbara and Derek Morris. Many close friends and colleagues of Susie Cooper, including Joy Couper, Ronald and the late Joan Bailey, Mr and Mrs Platt and Miss Daphne Gray, were also keen to assist us.

Thanks also to the many people who worked for Susie Cooper over the years, and many of her associates. They are Margaret Brindley, Mrs Elaine Colclough, E. Cook, Freda Davies, Doris and Kenneth Gleaves, the late Nora Dobbs, A. Haynes, Phyllis Howe, Ron Hughes, Percy Jones, Vera Knapper, the late May Lindsay, Evelyn Pearce, Mrs Rosamund Purvis, Gladys Tomkinson and Mrs Walker. We would like to thank Bert Critchlow for providing from memory information on the organisation of the factory. Several people from the pottery industry have shared information with us, including E.G. Copeland, Dora Shaw, Ted Hughes and Eddie Sambrook.

We would like to thank Josiah Wedgwood and Sons Ltd. We acknowledge the kind help that we received from the Wedgwood Museum during the preparation of this book. especially Gaye Blake-Roberts (Curator of the Wedgwood Museum), Lynn Miller (Information Officer), Sharon Gater and Martin Chaplin.

We are grateful to the Potteries Museum for their support and also for allowing us to use several images in the book, with some produced especially for us. Thanks to Miranda Goodby, Julia Knight, Steve Crompton and Sue Taylor.

We would also like to acknowlege the staff of the Horace Barks Reference Library, Hanley, Stoke-on-Trent; The British Library; The British Newspaper Library (Colindale); The Victoria and Albert Museum, particularly Martin Durrant and Terry Bloxham; BBC Radio Stoke; The National Trust; Staffordshire University (formerly North Staffordshire Polytechnic); the John Lewis Partnership; Tableware International Ltd., Jo Thackray, Administration RDI Archive; Michael Jeffrey from Christie's South Kensington; Sally Dummer of Ipswich Borough Museums and Galleries; Adam Unger from the Cinema Theatre Association, Cath Townsend from *The Evening Sentinel*. Also Mark Clemas, Stephen Dale, Nathalie Dalman, Richard Dennis, Irene Dolan, James Dolan, Gordon Elliott, Alan Flux, Colin Gent, Anthony Griffiths, Clare McCarthy, Hilary McGowan, Fiona Neilson, Judy Rudoe, Krystyna Sargent, Jessie Tait, Jenny Thompson and Alex Werner.

PHOTOGRAPHERS
We acknowledge the photographers, including Edward Allen, Martin Black, Derek Brindley, John Broadbent, Lance Cooper, Brian Mitchell, Andrew Parr and Chris Rushton, John Sharp, Steve Crompton, Akiko Higuchi, Northern Counties Photographers. Victor Bristol and Jane Walsh of the British Library's Newspaper Library organised the special reproduction of an archive item.

FOREWORD

British Pottery manufacturers were not noted for their enthusiasm for Modern design in the twentieth century. The Modern Movement and the teaching of the Bauhaus hardly penetrated the 'potbanks' of Stoke-on-Trent. Not only was Modern design not to the taste of the potters themselves, but they also believed that it would have little appeal to their customers. They considered traditional design a much safer bet. Susie Cooper stands out as one of a small group of ceramic designers and manufacturers in this country who believed in Modern design. She is in my opinion amongst the most influential British pottery designers and indisputably the most important designer to have been born and bred in the Potteries in the twentieth century.

I have always admired designers who take full responsibility for manufacturing and marketing their own designs. They know that there are risks but it is the only way in which they can be sure that their design concepts will not be compromised. Susie Cooper was not only a talented ceramic designer but also an influential and commercially successful manufacturer. She proved to the pottery industry that there was indeed a market for more adventurous design.

She opened her own pottery in 1929 and her reputation was established in the thirties, and it was during this period that, in my view, she did her most creative work. The post-war period was to see her once again active as a designer and manufacturer and then in 1966 she became a member of the Wedgwood Group, England's most prestigious pottery manufacturer. The chairman of Wedgwood, Sir Arthur Bryan, greatly admired Susie Cooper's work and her designs were to give Wedgwood a new look. Some, like 'Corn Poppy', were to prove remarkably successful commercially. She was, however, like many creative people, never completely comfortable in a corporate environment.

She joined the design establishment in 1940 when she was elected to the Faculty of Royal Designers for Industry. This was followed by a doctorate from the Royal College of Art, an O.B.E. and perhaps most importantly of all, a major retrospective of her work at the Victoria and Albert Museum in 1987.

Susie Cooper started her career in Stoke-on-Trent and her life was spent working for the British pottery industry. She can rightly be called the first and the greatest 'Pottery Lady'.

David, Lord Queensberry
January 2002

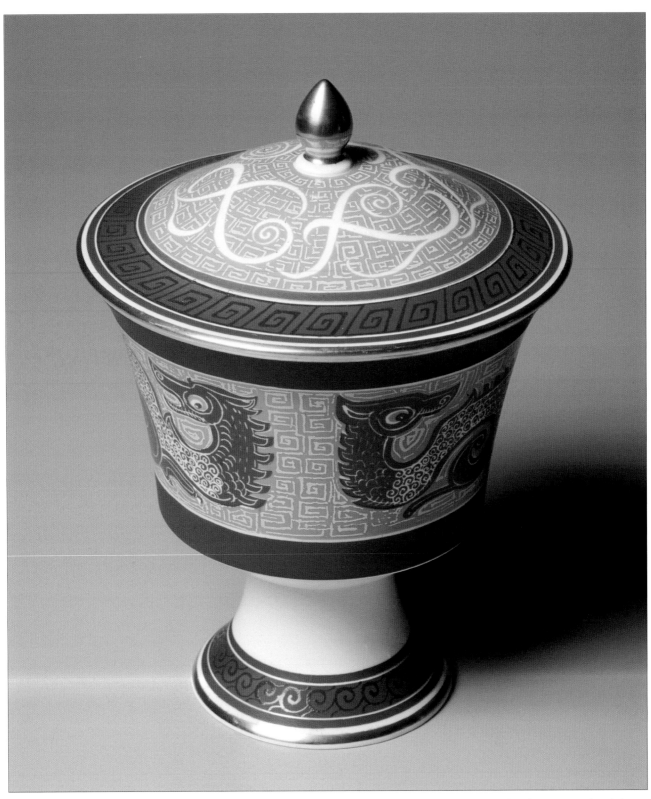

1. A bone china footed bowl and cover, 8½in (21.5cm) high, decorated with covercoat, banded, aerographed and gilded decoration. Inside the cover is a label that reads: 'Based on the period of the Chinese Warring States 4th or early 3rd century B.C.' Designed by Susie Cooper for Josiah Wedgwood and Sons Ltd., from 1976. This item was not put into production.

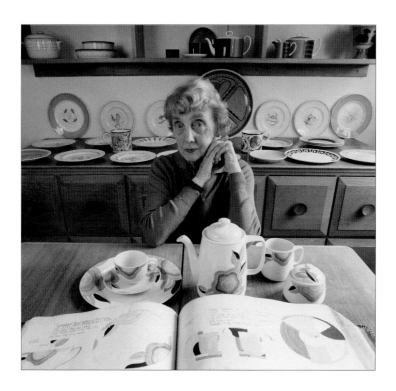

INTRODUCTION

Tim Barker

1. Susie Cooper with examples of her work and the Susie Cooper factory pattern book at the Adams studio, 1985.

My mother, Susie Cooper, was born one hundred years ago, on 29th October 1902. This book marks the centenary of her birth and celebrates her long working life, which spanned almost the entire length of the twentieth century. Her vitality, creativity and innovative vision are celebrated here in the images of the pottery which was her life's work. The book brings together authors who knew my mother, as well as those who never met her, but were inspired by her example and admired her work. I am contributing a short memoir as her son.

One of my earliest memories is that of feeling singled out. My father was a partner in a well respected North Staffordshire architectural practice yet I found that I was rarely introduced to strangers as Cecil Barker's son, or even Mrs Barker's son, but most often as Susie Cooper's son. As a youngster attending kindergarten this made me both puzzled and embarrassed because I saw this didn't happen to other children, who were generally being introduced by reference to their father; so at an early age I began to realise that my mother was unusual by being well known and highly thought of in the local community.

I remember my early birthday parties as being very well organised, always with a Punch and Judy show or a conjurer. I recall trestle tables and gilt chairs being hired (from Swinnertons) for the dining room, and that after playing games in the lounge the group of about forty children would sit down to tea. Afterwards every child went home with a Susie Cooper beaker decorated with their own name, and one year the design was aerographed with the names reversed out of the

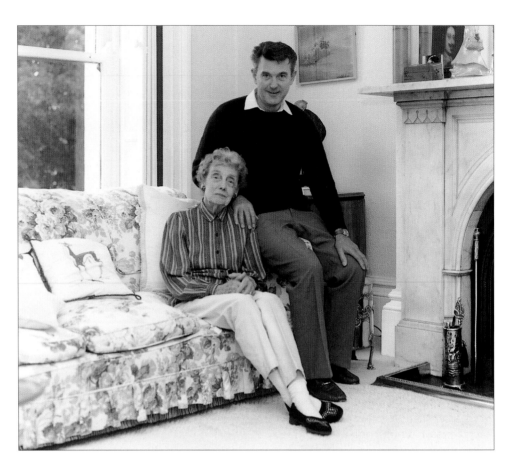

colour. I wonder where all those beakers are now?

I also have early memories of the Susie Cooper factories both at Longton and particularly at Burslem where as a young boy I enjoyed the company of Jack Shufflebotham, a long-serving kiln fireman, who as a special treat used to take me off the works for ice creams at Lenas. Sometimes I rode with Uncle Jack (Beeson) when he drove the van taking the white china from the Longton works to Burslem for decorating. Later, I would accompany the firm's driver, Len Griffiths. During this period I always found the decorating shop a great embarrassment because I felt I was the centre of the paintresses' attention and whenever I couldn't avoid walking that route a buzz of interested excitement seemed to pass through the building.

I joined the Susie Cooper business aged nineteen, in about 1962. I didn't go there straight from school. My father had been keen for me to join one of the professions and I first trained as a chartered accountant with Bourner, Bullock and Company, the Susie Cooper firm's auditors. They had a variety of clients including local pottery people, and whilst I didn't enjoy their job I did enjoy the Potteries, and began to talk to my mother about joining the Industry.

It was decided that I would learn her business. At the same time my cousin, Kenneth Cooper, succeeded my mother as Managing Director, extending his responsibilities from Sales Director, and relieving her from the day to day running of the factory. Kenneth agreed to train me, and to get a good grounding in the way the business ran I was put to work for Mr Moran, the general manager, in the order department of the finished warehouse. In those days I was addressed as Mr Timothy, such was the fashion in the industry, and my cousin

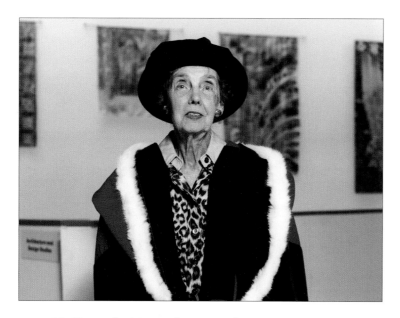

4. Susie Cooper at the Royal College of Art to receive her Honorary Doctorate in 1987.

was known as Mr Kenneth. My mother was always Miss Cooper.

Experience in the finished warehouse inevitably took me to all parts of the factory in the hunt to follow up on shortages or search for missing items to make up a consignment for shipment. To gather an order, the first port of call would be the stock pens situated all the way up the right hand side of the warehouse, where the completed ware would normally be stored in racks divided by pattern. Sometimes I would need to go down to the decorating department to find out why saucers had come through but no cups, or to the selectors to find ware still on its way through to the stock pens.

Inevitably there would be some loss, and occasionally items needed to be completely re-ordered. My job was to act as the last quality control point. The selectors might judge a tea pot lid and body individually but I had to make sure they fitted together. This was all part of getting the order out. Once it was assembled it was put on a trolley and wheeled through the steel doors to Alec the packer. The flammable straw wool used for packing was kept out of the warehouse by the steel doors. Barrels were used to pack the orders for export and cartons for the home market.

I also spent some time working with Mr Hagan, the decorating manager, who managed the decorators' and paintresses' work. The paintresses would put their completed work, banded patterns for example, on boards on racks behind their benches. The girls would call me to put their work in the settling books; these accounts determined their pay, as they were paid on a piecework basis. Mother often sat quietly at a bench with Alice and Nora to design her patterns or work out how a pattern could be broken down for the paintresses. There was often a bit of banter between some of the younger paintresses, but at twenty I was better able to cope with this than when I was a lad.

After a year or so, I went off to Tuscan to learn the clay end part of the business and studied for a Pottery Manager's Diploma at the College of Ceramics but I never came back to the Susie Cooper Pottery at Burslem. The Wedgwood takeover came just as I was finishing at college, and despite gaining a First Class Certificate in Ceramic Technology and the Award of a Travelling Scholarship by the B.P.M.F. I had decided within two years to leave the industry and strike out on my own.

3. A photograph showing May Lindsay, who worked for Susie Cooper from 1938 to 1980, banding on biscuit ware, 1950s. Note the stillages of finished ware behind the decorator.

11

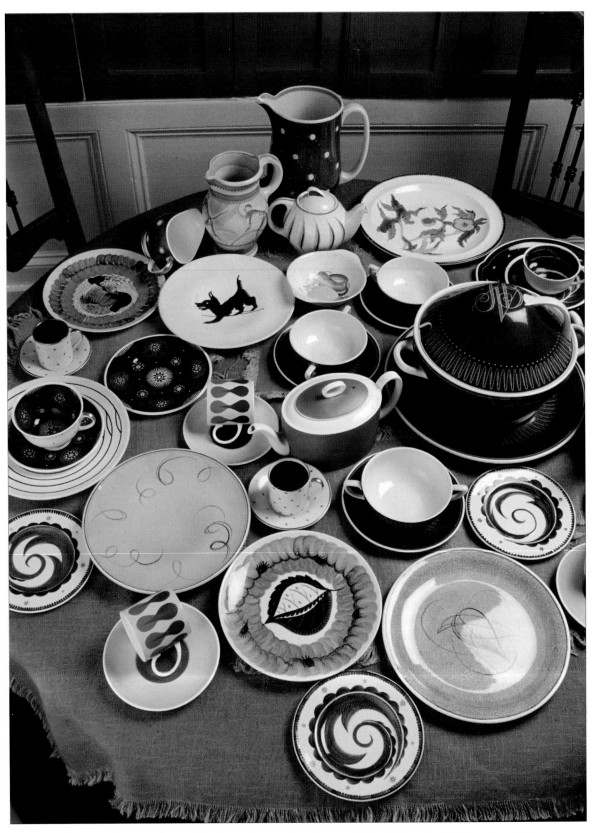

1. A wide selection of patterns decorated on bone china and earthenware. Note the hand-painted monkey jug from the early 1930s, the Scottie dog tube-lined on to a matt-glazed dessert plate and a selection of bone china designs.

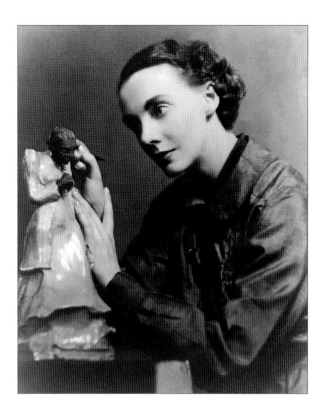

CHAPTER 1

A PORTRAIT OF SUSIE COOPER

Bryn Youds

Susie Cooper created her own remarkable career. Her life was driven by the desire to work, to perfect designs and to express herself. In addition, she was an ambitious and successful businesswoman who wanted to sell her designs widely. As well as doggedly pursuing her career interests and goals, she also managed a happy and stable private life, which was remarkable in itself. Despite her international reputation and recognition, few people knew the real Susie Cooper.

Locally, and within her workforce, she was revered. Joy Couper, first employee then friend, recalled her earliest memories of Susie: 'she was the highest of the high, nobody knew her, she didn't appear often and she didn't like publicity, …she gave her life to her art.'

Dedicated to economy and functionalism, Susie Cooper was, at the same time, supremely elegant and expressive. These characteristics, together with modernism, materialised in her ceramic designs. Her pragmatism and hard work, allied to her art, design and business skills, were attributes that attracted talented people. When she could, she surrounded herself always with the most skilled and trustworthy.

Quietly spoken, with just a trace of a Potteries accent, she is described by workers as 'a real lady', with poise and a cultured manner. Her appearance did much to

2. A portrait of Susie Cooper with her Lummox figure, inspired by Fannie Hurst's novel dated 1924. This photograph was one of several taken in 1938 in Cleo Cottrell's studio, at 16 Grafton Street, London.

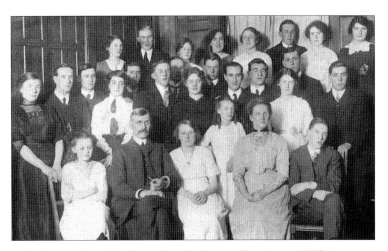

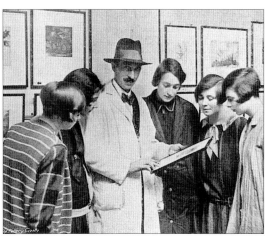

3. A photograph of the Cooper family taken on Susie's sister Hilda's twenty-first birthday. Susie Cooper can be seen at the front, right of centre.

4. Gordon Forsyth and his students at the Burslem School of Art, 1920s.

promote her enigmatic aura. Although petite, she commanded a powerful presence. Her slight, almost bird-like frailty was dispelled by the prodigious energy and intellect she focused on her 'project or experiment'. Her hands were often commented upon as elegant and expressive, as well as large and capable, clear evidence of her hard-working life. One of the secrets in good freehand painting, she said, was brush control and there was much dexterity and strength in her hands. When decorating ceramics, or painting, she had a fluid eloquence, accuracy and command of her materials.

Susie Cooper always dressed smartly and fashionably in simple, co-ordinated fabrics, with a slightly bohemian quality. Joy Couper recalled what Susie wore whilst designing in the late 1930s: 'She always looked stylish and well, to me, just beautiful. She used to wear these delightful painting smocks, they were shantung, pure Chinese silk, dyed cornflower blue and primrose yellow, like the one in the picture of her with Lummox' (plate 2). Susie kept her tiny figure throughout her life and because she rarely discarded things, had an astonishing collection of fashion items. Susie and Joy spent many happy days together, chatting about family and friends whilst they sewed. A favourite activity was a 'fashion show', where Susie would try out her wardrobe of the twentieth century. This sense of style and hospitality continued with breakfast for Joy. 'She was so kind and thoughtful, every morning she would bring breakfast on a tray with a flower in a vase and a different cup and saucer each day.'

The public perception of Susie Cooper and her work was of elegant reserved order, so to those who encountered her personal studio space the 'organised chaos' was always a tremendous shock. Sharon Gater, assistant curator at the Wedgwood Museum, helped to clear her office at the Adams factory and told of bulging cabinets and the drawers of her desk crammed with drawings, designs, sheets of covercoat, scraperboard designs, all of the things she needed around her as she re-worked and refined designs. Her studio '…had a really lived-in look, lots of work all over, the pattern books were open and obviously used, well thumbed… you couldn't throw anything away… there was this crinkled-up bit of paper with green parrots on it, I asked her "is this anything in particular?" She said, "oh it's just an idea I had for some wallpaper".' Tim Barker, her son, reprimanded his mother when he caught her squirrelling away small pieces of string; the protest reply 'might come in useful someday' is a cliché for hoarders. She did, however, make creative use of the things

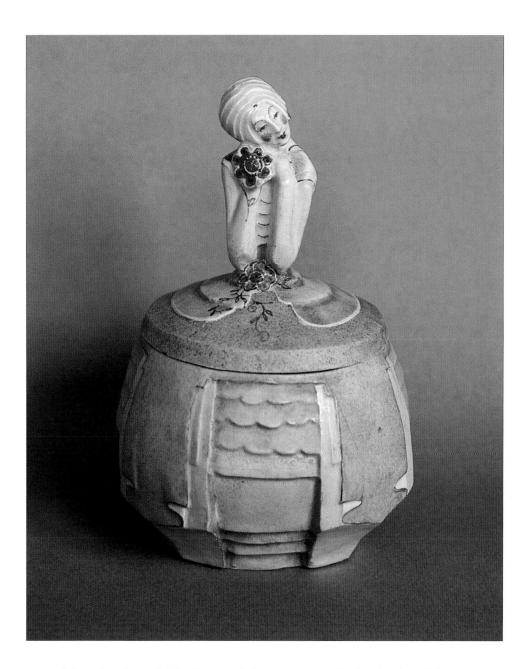

around her. In about 1932 she saw kiln men using thick chunks of dry ceramic colour, marking letter codes on to firing trials. She thought that these could be used for decoration and had pencils and crayons made up for her, spawning the very successful underglaze crayon patterns. She constantly sought refinement in her techniques, both in their functionality and in the aesthetic qualities of a design, solid banding becomes wash banding, hand painting into lithography and so on.

Perhaps the greatest quest for Susie Cooper was her desire to have her designs duplicated as purely as possible and applied as if by her own hand. Expanding sales meant that her company increasingly needed lithographic transfer prints for mass production. Her designs caused a storm in the industry because of their detailed quality, as if hand painted. Union rules meant that her designs had to be reproduced by a design artist at the lithography suppliers and they were therefore at the mercy of whoever worked on the job. Initially Susie combatted this problem by having a

5. An earthenware powder bowl and cover modelled by Susie Cooper during her education at the Burslem School of Art in 1919-22, painted in various colours. Height 6⅞in (17.5cm).

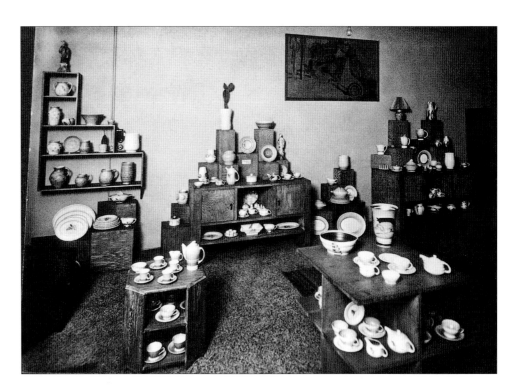

6. An interior view of the Susie Cooper Pottery showroom at Woburn Place, London showing the very latest products including various Curlew shapes, studio wares and other assorted items, about 1933.

close relationship with the printers and later she had a secret agreement that her original separation designs would be used, and not those of the lithography designer, whose work was discarded. A close look at Susie Cooper's lithographic designs such as Nosegay and Patricia Rose for example, show the tell-tale flourishes of her hand. Tim Barker recalls how Susie tried to join the Union for lithography artists so that she could legitimately use her own work, 'She wasn't allowed to join the Union, the reply she got from them was "the only women we have in the Union are cleaners", basically it wasn't the best person doing the job.' Needless to say it was events such as this that coined the often quoted remark: 'If someone told Susie Cooper that she couldn't do something and particularly if it was a man, then she would make sure that she did do it.'

Many of her closest business associates firmly describe Susie as an artist working in industry. Her illustrious working career was at times turbulent, with fires devastating her factory in 1942 and in 1957, personal and professional loss blighting her in waves. Susie too ebbed and flowed between the desire to express herself as an artist and the need to design for industry, by and large it seems that she succeeded in fusing the two demands.

Born in 1902, she was the youngest of seven children in a strict Victorian middle class family. As a small child Susie Cooper naturally took on the role as helper in the family bakery and butcher's shop. Hard work was the day to day experience, with the fidgety Susie helping with duties and kept quiet with drawing materials. She was often to be found sketching away in the bustle of the large family life. Later she recounted that she had a 'happy childhood'. There were two key defining moments in her early family life. An eighth child, Peter, was born to the Coopers but died in infancy, and the next major trauma was the death of her father in 1913. John Cooper's death, followed by the First World War brought uncertain and hard times for the family as they fought to re-adjust. When Susie left school and was deciding on a career, the family had re-established itself and she said 'nobody really cared what the youngest did'. She dropped out of a typing class and took art instead. The Burslem

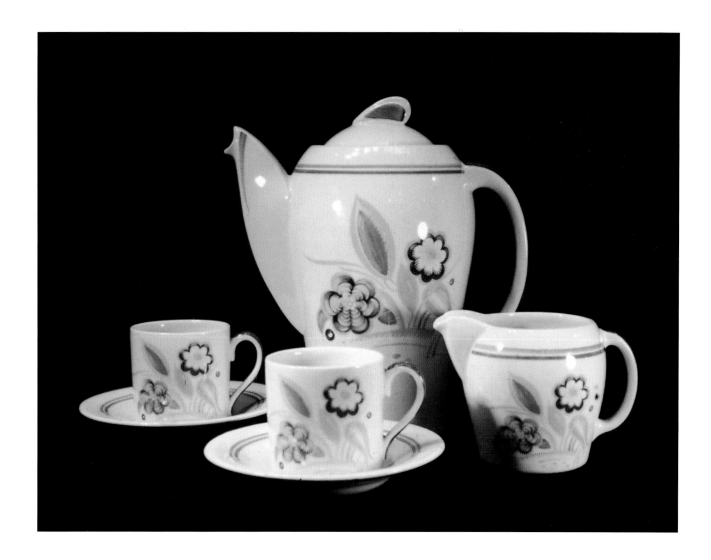

7. Part of a Kestrel shape coffee set decorated with the transfer-printed pattern Nosegay with hand-painted bands (E/1146), about 1936.

School of Art registers from 1919 have Susan Vera Cooper aged sixteen years and seven months enrolled to take art courses. For many years the School of Art provided Susie with a focal point for socialising and for working, as she later taught some classes there. Gordon Forsyth, Superintendent of Art Education in the Potteries (plate 4), noticed her talent and encouraged her to work directly – 'just do it', he told Susie. He also advised her to work at A.E. Gray and Co. Ltd., 'artistic' pottery decorators. Susie Cooper started work at Gray's as a piecework paintress but was soon to approach Edward Gray directly, protesting that she had joined the firm to design. She very quickly established herself in the industry with her bold, stylised designs.

Susie Cooper's niece, Marian Chainey, recalls staying with Susie at that time. 'Auntie Susie was more like a fun-loving older sister to me, she was a young modern miss, smartly dressed with flair, she made such a fuss of me. I remember once I got back from Auntie Susie's and my mother tutted "who would think of putting a child in a red and white gingham dress with a big black artist's bow at the neck?"' The bungalow built for the rising star of ceramic design and her sister, Agnes, was a glamorous experience for the young Marian: 'it had a bathroom, very different from the farm house, and Coty powder in the bathroom, it had a garden – heaven.'

Hilda and Jack Beeson, her sister and brother-in-law, were eager to work with Susie and financially support the establishment of a new pottery in October 1929.

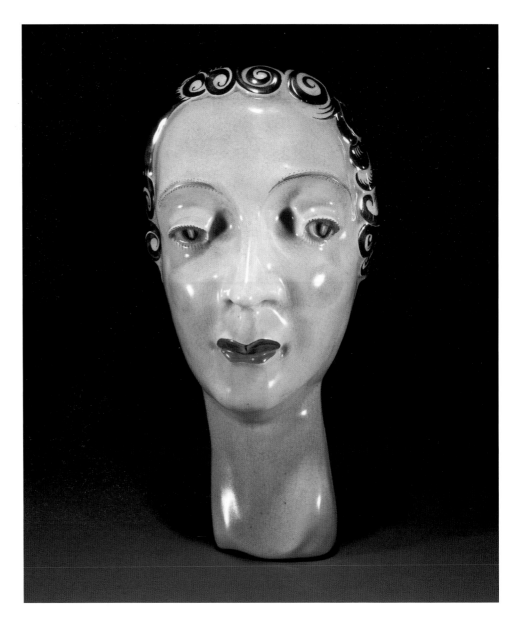

8. The Susie Cooper 'self portrait' face-mask. This earthenware mask is hand painted and dated 1933. Enigmatically, she never confirmed whether or not this mask really was a self portrait.

Six paintresses were employed for the paint shop in Tunstall to start up Susie Cooper Productions. Bold abstract, banded floral decorations were early designs. She began straight away to experiment with economic freehand painting. With Zen-like resonance she later described the philosophy of her designs: 'the space you leave behind is as important as the space you fill.' She was certainly determined to succeed. 'I knew that there was an opening, there was nothing between the very cheap, very ordinary earthenware and the fine china, I knew there must be an opening and things took off very quickly.'

Gordon Forsyth continued to support Susie Cooper by encouraging good students to join her factory. One such student was Joy Couper, whose father, John Butler, was an art director at A.J. Wilkinson Ltd. From her days at Gray's Susie had been aware of the wide range of paintress' skills, and swiftly recognised a skilled hand and like mind. Very quickly the two became, and remained, lifelong friends. 'She influenced me in everything I did and thought, from when I first heard of her when I was at the Burslem School of Art, she was held up as an example of perfect design. I just

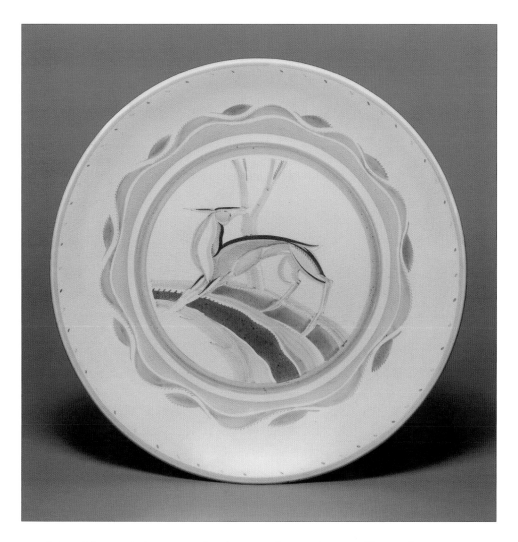

worshipped her and she was so kind to me. I consider myself very fortunate in my life having known her.'

The Susie Cooper Pottery thrived throughout the 1930s with Susie experimenting furiously with decorating techniques and shape design. Critical acclaim followed and export markets expanded. Susie's energy became legendary as she introduced many innovative techniques and shapes. She was typically described by her workers as strict, but fair. Workers generally recognised their own high status within the industry, centred on Susie Cooper's hard work and design skills. High standards, commitment and hard work were expected and demanded by Susie, bringing her respect across generations of workers. Paintresses were given a painting trial when they applied to work for her. She had a 'paternalistic' approach to her workforce and to protect jobs she refined factory output constantly to best employ the skills of her workers. By design and determination Susie Cooper wares required a highly skilled workforce, who were encouraged to stay as a strategy to cope with labour market shortages. It made sound business sense and accorded with her own ethics. She was backed by many talented people who enabled her company to function well and gave her sufficient space to experiment and refine her art and design. Many recalled that it was the work of the designer that drew their attention.

In 1938 her marriage to architect Cecil Barker led to personal fulfilment, giving her new security and a new position in the family hierarchy. By the early 1940s she

9. A hand-painted pattern of a deer within a stylised landscape decorated on an earthenware plaque, diameter 14⅔in (37.3cm), dated on the back 1933.

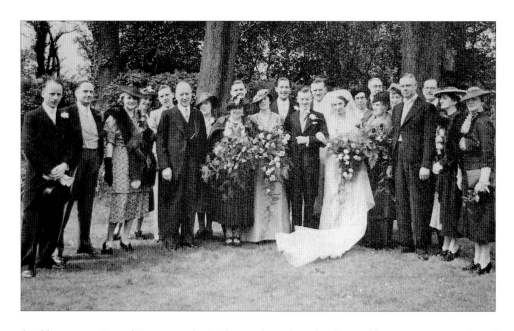

10. The wedding of Susie Cooper and Cecil Barker in 1938.

had become a Royal Designer for Industry (RDI) and achieved huge commercial and critical success.

Upon the outbreak of the Second World War, many employees, including Jack and Hilda Beeson's son, Ted, were drafted into the forces. Government restrictions on manufacturing and raw materials and a fire in May 1942 led the company to conclude that the factory should close rather than rebuild. Another nephew, Kenneth Cooper, recalled 'The war changed everything. Ted's death almost destroyed Jack and Hilda Beeson.' The Coopers were traumatised and the Susie Cooper Pottery business partnership in shreds. At the centre of the shockwave was

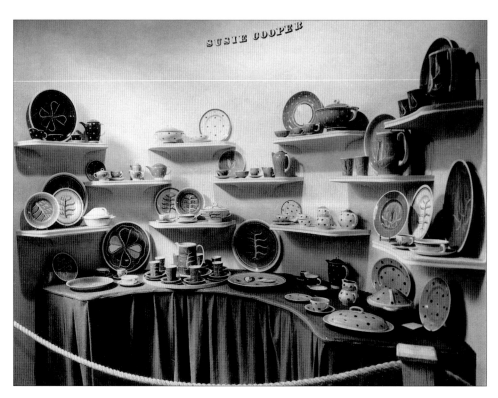

11. The Susie Cooper Pottery trade stand at the British Industries Fair in 1947. Note the range of hand-painted patterns, including Tree of Life and Chinese Fern.

20

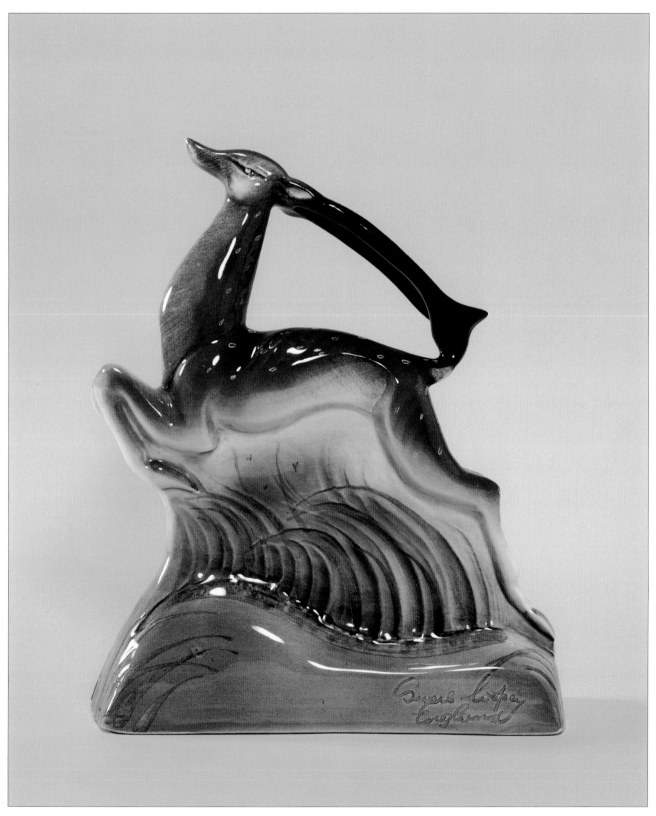

12. An earthenware deer table centre, height 7⅞in (20cm), painted in colours. This item was complemented by a fox, a hound and flower troughs that could be purchased separately. It was introduced in 1936.

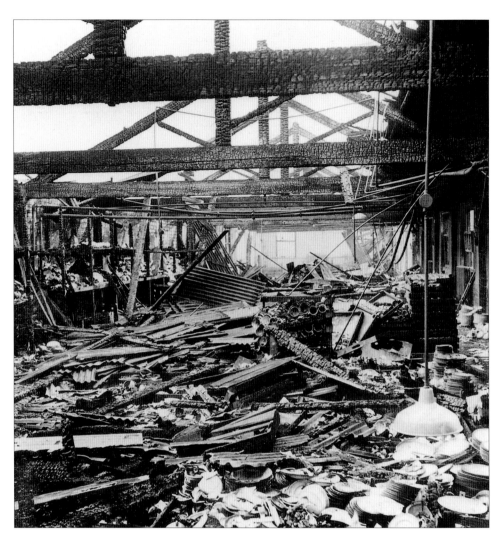

13. The Crown Works after
the devastating fire in 1957.

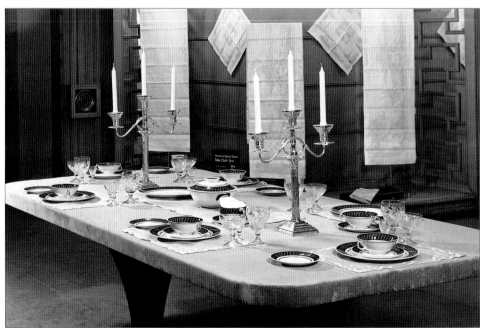

14. A table arrangement of
the Romanesque pattern
(C.814), on the bone china
Quail shape, at Harrods in
1956.

the death of Ted Beeson in 1942. His gunshot wounds at Sidi Rezegh led to his eventual death in South Africa. Ted had become a key figure in Susie's life and the factory and was very well liked. The hard work, support and promotion of the firm by the Beesons and their son had brought so much success. The four had formed a stable and harmonious core for the strong workforce. Susie later recalled how she felt Ted was like a son to her and at a time of such loss, the birth of their only child, Timothy, in March 1943, must have seemed particularly miraculous for Susie and her husband.

Encouraged by her old overseas clients and family Susie decided after the war to rebuild and open up the factory. Once again she turned to her family for support. 'I perhaps wouldn't have restarted after the war but for my other nephew Kenneth.' This choice must in some way have been made because of the happy and successful pre-war family collaboration. Kenneth was young, talented and charismatic; he had been commissioned into the Royal Horse Guards from an English degree. Feeling the inevitability of family duty strongly, Kenneth left the Army on a Saturday in August 1947 and started work at the Susie Cooper Pottery on the following Monday. Filling the void left by Ted was very difficult for Kenneth: 'stepping into Ted's shoes was fraught with difficulty, Ted was so loved and the team, Ted, Susie, Hilda and Jack Beeson, was a perfect combination.' The Beesons had just one child and J.L. Cooper had five who all survived the war, 'it just seemed so unfair I suppose'.

15. One of Susie Cooper's first patterns in the new medium of bone china. This plate was aerographed in green with sgraffito and painted in-glaze decoration, about 1950. One of a set made for her own use.

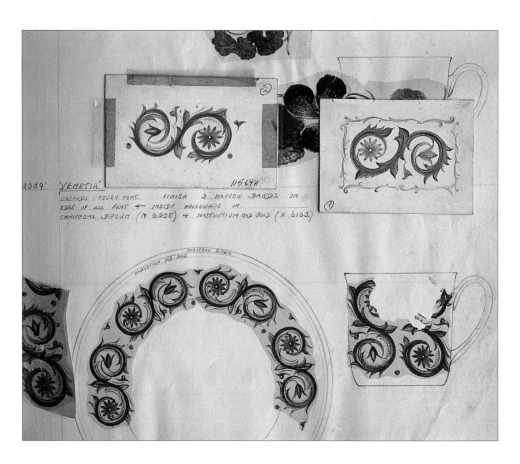

A rapport developed between Susie and Kenneth and despite the shortages they rebuilt the Crown Works and Susie embarked on one of her most cherished personal goals, in-glaze decoration. In-glaze 'is where durable colour is put on to the first glaze, then glazed over again, we felt that these designs were stylish enough to warrant the cost of the three firings', Susie explained. The in-glaze technique was one thing that she always regretted not being able to put into general production, instead she extended her use of underglaze techniques and border designs to meet increasing demands for durability.

Buoyed by the resurgence in her personal and professional life, and the optimism of the age, Susie Cooper began a short period of high personal and financial investment in an ultimately unsuitable factory, Jason China Co. Ltd., which was renamed Susie Cooper China Ltd. 'I wanted to do in the china field what I had done in the earthenware field – make dinner ware. When the Federation did their research the number of people with a matching dinner service was very small. I wanted to change that, I wanted to make china more accessible, nice china, china with style and quality, and that the people could buy and use.' Labour shortages hit ceramic production hard and supplies across the board were difficult, those from Wood's were hit badly. Setting up her own factory was fraught with difficulty. The Jason factory did not have the space or production capacity to supply Susie's aim of 'accessible' tablewares. She became distracted from her core business at the Crown Works and eventually searching questions had to be asked by Kenneth Cooper of Susie and Cecil, who by now had retired from his architecture to focus on the china factory. New designs were being produced slowly, indeed productivity was at an all time low.

By the late 1950s the company made some key changes, committing to a

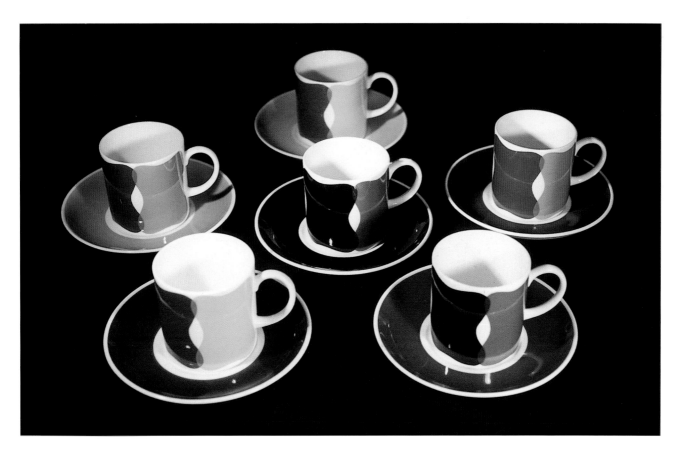

simplification of stock and a move towards giftware and boxed sets. In March 1957 a fire devastated the packing house of the factory, setting back the new plans, so Susie took stock (plate 13). Collaborating with another manufacturer to make china tableware production feasible economically, seemed the answer. The Plant family, with a huge production capacity, outstripping their own needs, were long-time friends and associates. The merger of the Susie Cooper companies into R.H and S.L. Plant took place in 1958. She later recounted how she realised with Jason's sale and the merger that 'we were not in the business of acquiring premises but in the business of making pots'.

Without the major distraction of the Jason Works, Susie Cooper was free to concentrate on design, embarking on what she, Kenneth and many considered to be one of her most successful periods in industrial design. Her radically simple and modern Can shape was produced, as well as a string of acclaimed and commercially successful designs such as Assyrian Motif and Venetia. Kenneth brought very many qualities to the business and a highly productive creative tension grew between the designer and her nephew.

Susie Cooper Ltd., now part of the Tuscan Group, was taken over by Wedgwood in 1966. She hoped for a chance to develop her designs and those of Wedgwood but ultimately, through an at times turbulent relationship, she felt frustrated: 'I could have done a tremendous lot more for Wedgwood' she said in summary. Many have remarked that Susie Cooper may have felt an icy draught of ageism, when at the age of sixty-four she entered the male-dominated bastion of this huge company. Her illustrious career and enormous reputation for hard work and exacting standards set up all sorts of dynamics within the management. Despite the slow deterioration of morale in the old business team, Susie Cooper produced some of

17. A set of six bone china Can shape coffee cups and saucers decorated with the printed Harlequinade pattern (C.2115), about 1968-69. Diameter of saucer 5½in (14cm).

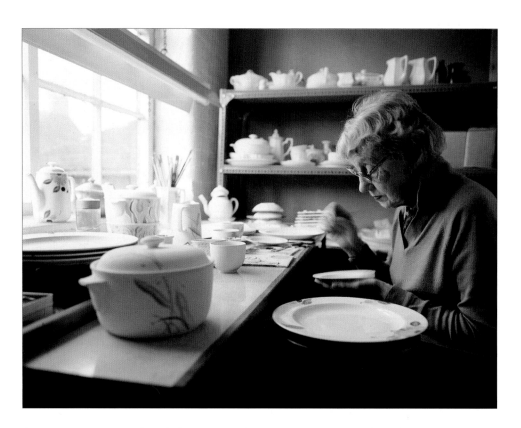

18. Susie Cooper working on tableware in her studio at William Adams Ltd., 1985. Note some of the trial designs such as the re-working of the 1933 pattern (E/544) hand painted on a Micratex tureen and cover.

her most commercial and also some of her most experimental work. Ultimately the tension of not being at the centre of production confounded her, she felt under-used and disempowered.

The death of Cecil in 1972, after a long period of illness, fractured the Susie Cooper team and both Susie and Kenneth resigned their Directorships at Wedgwood. Kenneth and Susie split sadly and, in keeping with the Cooper tradition, it was quietly done and deeply felt. The eventual closure of the Crown Works in 1980 forced Susie a step further away from the heart of her professional life. In a typical mood of optimism she set about a period of fierce experimentation with all aspects of decoration, even experimenting with her favourite in-glaze techniques, with the extra dimension of reactive colours. Working four days a week in her Adams studio, she threw herself into a huge range of projects. Susie was also continuing to hold her quiet influence over the family. Barbara Morris, Susie's great-niece, recalled at her memorial: 'It was often difficult to reconcile her commercial and artistic stature and reputation with the small, modest, quietly-spoken great-aunt who took such an interest in the activities of all the family. Her interest in others was genuine and fully focused, her memory prodigious. Listening to her talk about her work, past, present and future, was something I always found totally fascinating and inspirational. The graceful and eloquent movements of her hands when talking about her beloved hand-painting is something I shall never forget.'

Susie Cooper had one last major working passion – her seed paintings. The technique of wood panel painting, which adorned the BIF trade stands and her home, was the starting point for these works, on to which Susie painstakingly applied swirling lines of seed and grain; some stained in vibrant colour (plate 23). The pictures are experimental, expressive renditions of her favourite subject matter of natural forms, taken to their logical and final conclusion, the forms themselves are made from the natural objects. The wonderfully naive technique of collage is

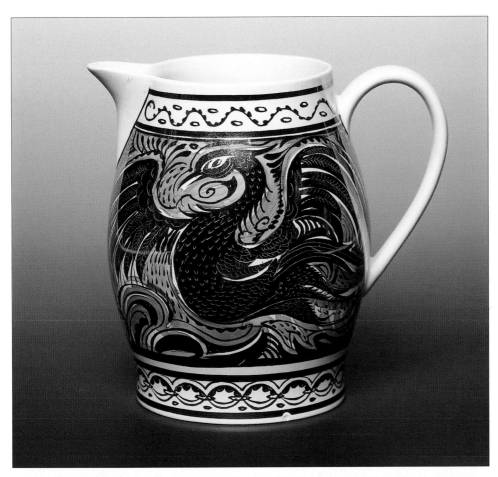

19. A trial design of a Phoenix decorated on a Queen's ware jug (Wedgwood shape), about 1978-79. Height of jug 6½in (15.9cm).

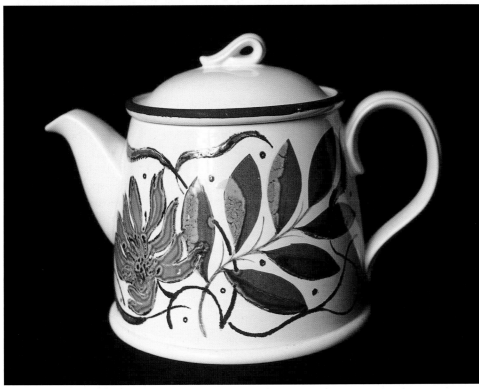

20. An in-glaze trial piece decorated on an earthenware tea pot, 1980s.

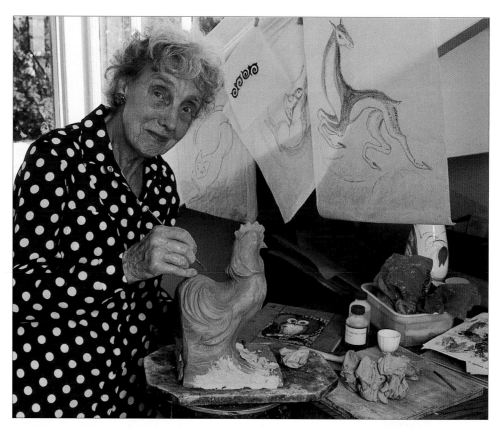

21. Susie Cooper in her studio on the Isle of Man, working on her Roosters book ends, about 1992.

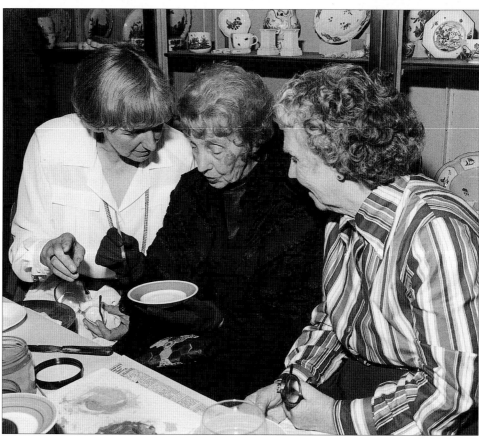

22. Susie Cooper with Doris Gleaves and Nora Dobbs decorating wares at the opening night of the Susie Cooper Productions exhibition at the Victoria and Albert Museum, London, 1987.

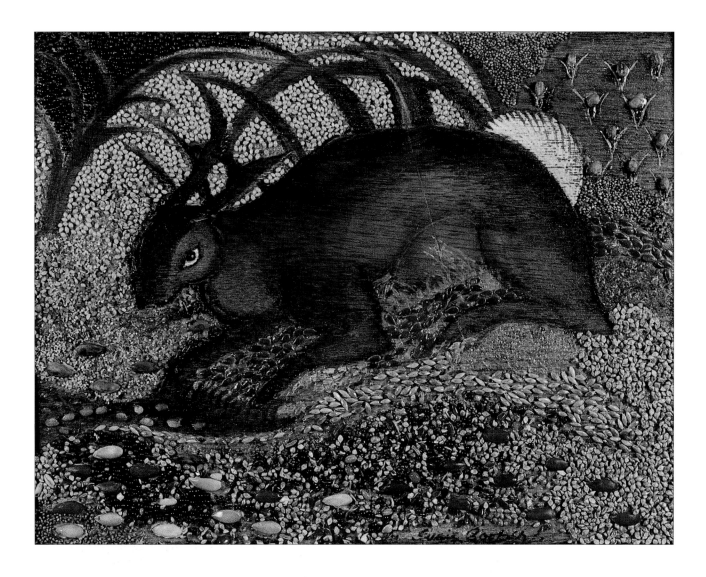

taken to supreme heights of subtlety and decorative sophistication. Almost ludicrously, individual seeds, sometimes chosen for their colouring or pattern, were often applied individually. Space was scrutinised by Susie's exceptional eye and treated with merciless economy and myriad complexity.

Her son recalled: '…when she was doing the seed paintings she did not particularly care if the recycled pieces of plywood, offcuts at the end of my boatbuilding, were out of shape, and we used to laugh about it. Well, once we went to the Salvador Dali museum at Figueras, she admired some of his early work, then triumphantly pointed out a Dali work that was on badly cut board "there you see" she said "the thing is, if you are an artist you have got to get it out. Just do it, and when it's done and it's out, move on".'

23. An example of one of Susie Cooper's seed paintings, about 1990.

1. A freehand-painted vase, 7½in (19.1cm) high, in multi-coloured lustre and gold outlines, pattern (5399), about 1925. Gloria Lustre backstamp, gold foot ring.

CHAPTER 2

SUSIE COOPER AT GRAY'S POTTERY 1922-1929

What did she design?

Kathy Niblett

Albert Edward Gray (plate 3) founded his pottery with a burning ambition to improve the quality of design in mid-range tableware and giftware. A.E. Gray & Co. (Gray's Pottery) was registered in 1907 and continued as an independent business until Susan Williams-Ellis purchased it in January 1960. Throughout the 1920s, the company operated from premises in Mayer Street, Hanley, Stoke-on-Trent.

Gray's Pottery was primarily a business devoted to the hand decoration of pots bought 'in the white', mainly in earthenware clay, but small quantities of bone china and stoneware were also used. Good quality design was foremost in Edward Gray's beliefs[1] and to ensure success he always employed competent designers and artists. He was a well-known figure in societies like the Design and Industries Association and the Ceramic Society, an influential association of manufacturers.

2. An early photograph of Susie Cooper, 1920s.

3. Albert Edward Gray FRSA, 1871-1959.

He kept close contact with artists, teachers and the world of education in Stoke-on-Trent.[2]

Edward Gray gave the young student Susie Cooper the opportunity to work at his design-led company to gain the required industrial experience before taking up a place at the Royal College of Art, London, to study dress design. Prompted by Gordon Forsyth, Superintendent of Art Education in Stoke-on-Trent from 1920, she joined Gray's Pottery to get a good understanding of what design meant in a commercial environment. Ultimately, rather than leaving to pursue a career in fashion, she remained in Stoke-on-Trent and worked in the pottery industry for sixty-five years, 1922-86. On 1 March 1933, Susie Cooper was quoted in *The Manchester Evening News*, saying: 'So many people get their training in their native place only to desert it as soon as they begin to make their way. It never seems fair to me. I shall just stay in the Potteries and do what I can for them.'[3]

It is thought that Susie Cooper joined Gray's in 1922, but she could not remember exactly when and no written evidence exists. There is very little documentation to confirm any of the details of her period at the company and we have a dilemma in trying to establish a body of work which can be attributed to her with absolute confidence.

Today, we think of Susie Cooper's typical patterns as being restrained, often using motifs derived from nature. Classical forms abound. However, in 1923 she was on the brink of her long career. She probably tried everything, anything that fashion might relish or desire – abstract floral themes, jazzy patterns, bright banded wares, even nursery ware. And we must not forget that life was tough then, with a major world recession approaching. Design had to sell. It therefore becomes difficult to conceive of patterns that she did not try in the 1920s. Many were day-to-day patterns but the lustres were highly decorative and stylish and probably helped to satisfy her desire for innovative designs, either simple or exuberant.

One of the obstacles to a firm attribution of Susie Cooper's designs at Gray's Pottery is the other designers. It seems likely that, in addition to Susie Cooper, four others were designing at Gray's during the 1920s: John Guildford in the early years;[4] Sam Talbot from 1925; Gordon Forsyth, who was a guest designer;[5] and Dorothy

4. The liner backstamp, in use on all types of ware to about 1931.

5. The Gloria Lustre backstamp was used on lustre decorated ware, also printed in black or gold, from about 1923-28. The foot rings on pots with this mark are usually painted, often black but green, blue and gold have been recorded.

6. The second galleon backstamp, printed in black with yellow sails, as used by Gray's on all types of ware, from about 1921 to about 1931.

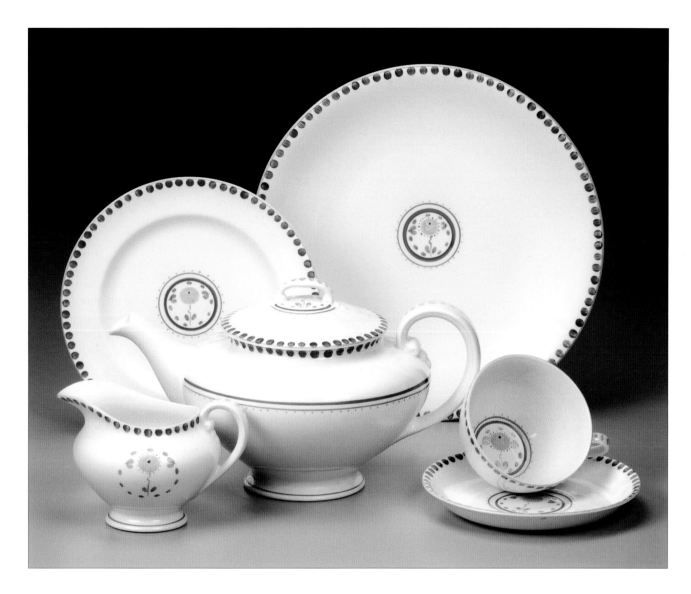

Tomes at the end of the decade, who, it is thought, favoured the use of black in her designs.[6]

In spite of more than twenty years of research, neither pattern books, shape books nor catalogues of Gray's Pottery have been discovered. Therefore no comprehensive proof exists to confirm the authorship of a shape or pattern.

During Susie Cooper's eight years at Gray's, four backstamps were in use. One, of a ship like a liner, printed in black, orange and green, carries the words DESIGNED BY SUSIE COOPER and so we can have some confidence that these patterns were her own (plate 4). However, the liner mark often appears in a shortened form, with the words DESIGNED BY SUSIE COOPER removed. What does this mean? – were these patterns designed by Susie Cooper or not? Does the boat carry the authority or do the words? We simply do not know because there is no evidence for confident attributions.

Many lustre designs were marked with either the Gloria Lustre mark (plate 5) or the second galleon mark with yellow sails (plate 6). But we know that Susie Cooper was at Gray's with a major brief to design in lustres – so, how can we know which were her designs? The fourth mark is the first galleon, all black (see Resource File).

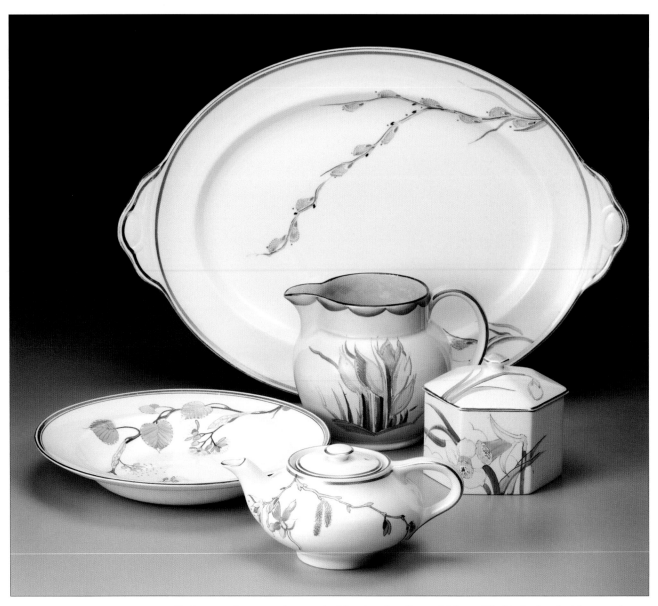

8. A range of patterns decorated with printed outlines which are filled in by hand with enamel colours. A large earthenware oval plate pattern (8084), about 1929; jug with deep cream glaze pattern (8118); hexagonal box and cover pattern (8085), about 1929; tea pot decorated with the Golden Catkin pattern (7671), from about 1928, with the pattern name incorporated within the backstamp; and a soup plate decorated probably with pattern (7938). Length of oval plate 18⅛in (46cm) and height of tea pot 3½in (9cm).

A group of spectacular lustre pots are signed with monograms based on the letters SVC.[7] These can be attributed, with great confidence, to Susie Cooper as designer. It is also possible that she may have personally painted all these pots, but that is not confirmed merely by the presence of the letters SVC. The designs are characterised by cherubs, trees, stylised flowers and mythical and heraldic beasts. These latter two motifs were frequently used by Gordon Forsyth when he was art director at Pilkington's Lancastrian Pottery, Clifton Junction, near Manchester, 1905-20. Several pots with this type of design exist with other initials, indicating

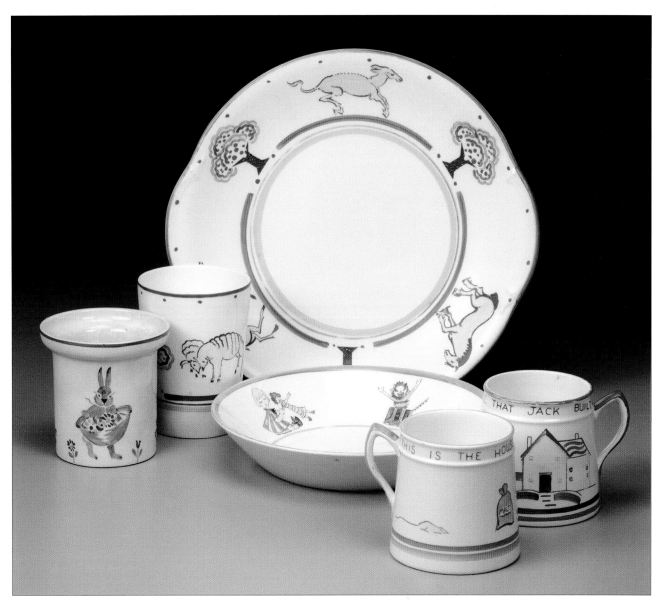

9. Tableware for children: a small earthenware pot decorated with a freehand-painted rabbit, pattern (2675) marked with the second galleon backstamp, a beaker and plate decorated with the Quadrupeds pattern, printed outline in blue and filled in with enamel colours (7742), bowl with printed outline filled in with lustre colours, pattern (4343) with Gloria Lustre backstamp; two earthenware mugs, height 3⅛in (8cm), decorated with the This is the House that Jack Built pattern (7834), from about 1928.

that Susie Cooper herself did not necessarily paint them – RH (Roland Heath) and HML (Hilda May Lockett) for example. These magnificent examples fall within the 5000 series of Gray's pattern numbers, a series which was in use during Miss Cooper's period there, and carry the Gloria Lustre mark.

Without the factory pattern books, evidence with which to date pattern numbers is very scarce. Sometimes a number may be quoted in a magazine article and with that a date can be confirmed – but this does not help with either the start or the end date of the use of a design. The following pattern references help to confirm

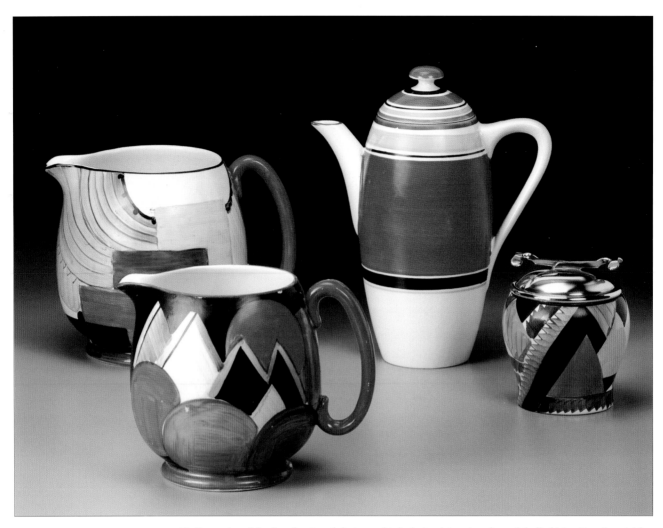

10. Examples of freehand-painted designs which design historians have labelled 'Art Deco' – vivid colours in geometric patterns which became popular at the end of the 1920s, having a very short lifespan as tastes changed in the early 1930s. An earthenware coffee pot, height 7⅞in (20cm), banded in bold colours pattern (7670); a geometric patterned sugar box with silver plated tongs attached to lid, pattern (8127) marked with second galleon; an earthenware Paris jug decorated with pattern (7960), from about 1928; a larger Paris jug decorated with the Cubist pattern (8071), about 1928. Susie Cooper was frustrated that she could design only the pattern on other manufacturers' shapes, rather than conceiving the shape and pattern as a whole idea and this led to her decision to establish her own pottery. She did however design three pot shapes which were made for Gray's. The bold, red banded patterned coffee pot (7670) is one of these.

the logic that numbers increased sequentially with time and provide certain milestones:

2204: March 1921 – *Pottery & Glass Record* Volume 3 No.5 p.191
4345: 1924 – A beaker including the 1924 British Empire Exhibition mark – Private Collection
4417: 1925 – *Pottery & Glass Record* Volume 7 No.11 p.339
5181: September 1923 – A bowl with a date inscribed, also with the 1924 British Empire Exhibition mark – Private Collection
5225: 1925 – A beaker with a date inscription – Private Collection

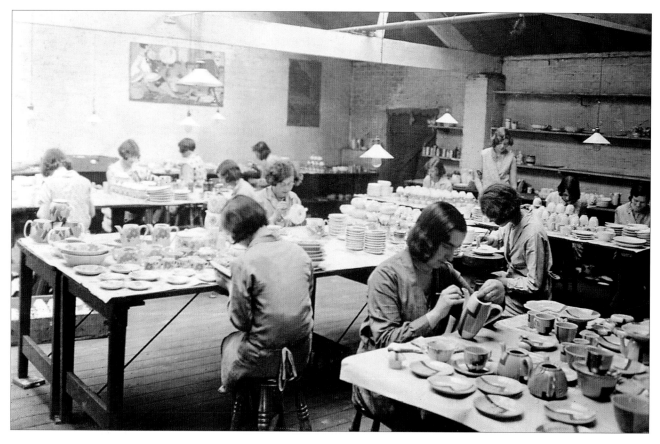

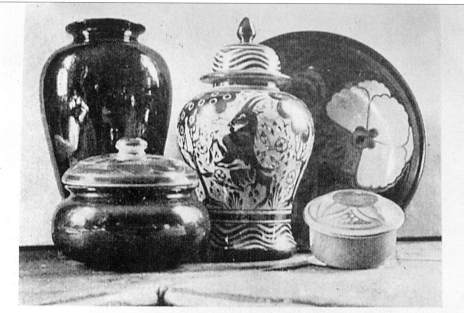

Group of Gloria Lustre Handpainted. Covered jar 5153, painted in lustre rouge ; Bowl 5393 painted in carmine blue, lavender and green lustre ; Powder Bowl 4421 and Trinket Box 4423, painted in multi-coloured lustres and gilt.

11. The painting shop at Mayer Street, Hanley, Stoke-on-Trent, probably late 1920s. The painting on the back wall is said to be the work of Susie Cooper. Note the patterns being painted, especially the Paris jugs to the extreme left – pattern 7960.

12. An illustration from the *Pottery and Glass Record* from September 1925 confirming that this type of ware was called Gloria Lustre and is hand painted. It gives some help with dates, shape names and topical descriptions: 'multi-coloured lustres and gilt'.

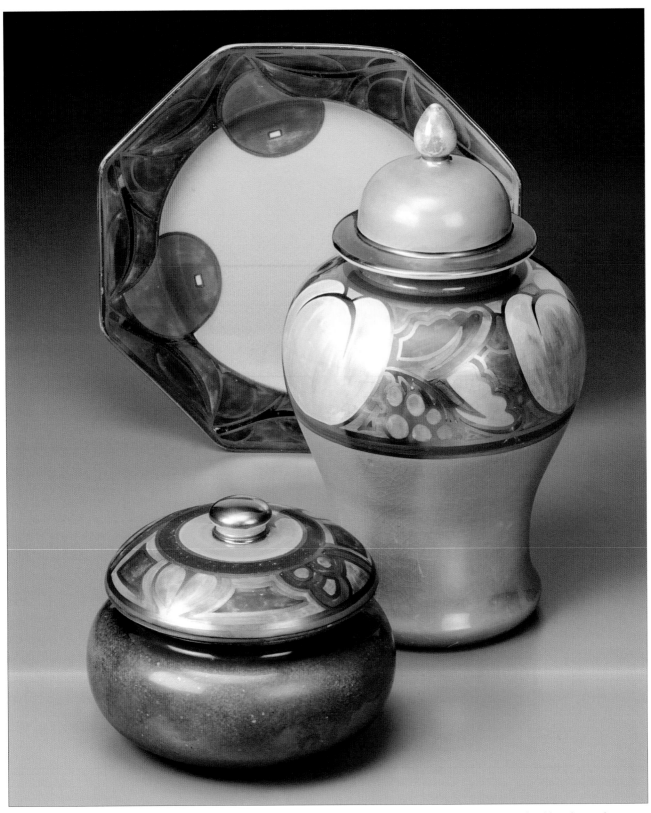

13. A range of freehand-painted ornamental wares in 'multi-coloured lustres' and gold outlines: plate, matt yellow enamel in centre, pattern (7314), marked with second galleon; covered jar, 9¼in (23.5cm) high, pattern (7082), Gloria Lustre in gold; powder bowl, black foot ring, no pattern number, Gloria Lustre.

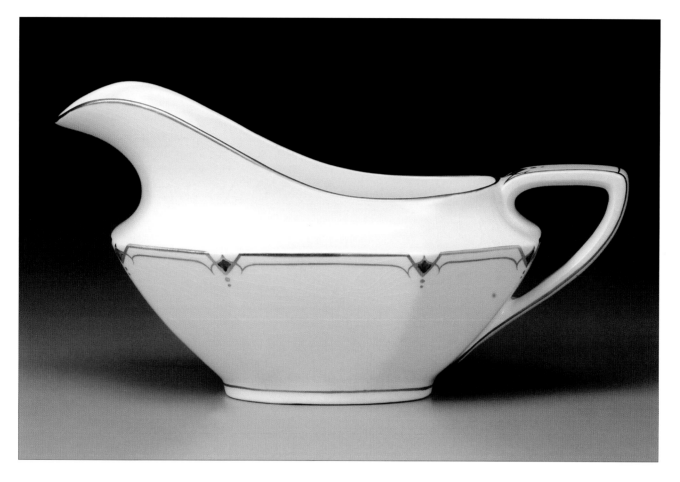

7082: April 1926 – *Pottery Gazette and Glass Trade Review* p.602
7207: March 1928 – *Pottery & Glass Record* Volume 10 p.73
7813: September 1928 – *Pottery & Glass Record* Volume 10 p.266
8286: 1930 – Layebands pattern items presented to Manchester City Museum and Art Gallery[8]
8375: July 1933 – *Pottery Gazette and Glass Trade Review* pp.970-1
8401 March 1930 – items presented to Manchester City Museum and Art Gallery[9]. Pattern numbers after 8401, recorded to date, have the words DESIGNED BY SUSIE COOPER removed.
8643: March 1930 – Items presented to Manchester City Museum and Art Gallery[10]

This is the last pattern number recorded with any version of the liner backstamp.

From this scant evidence, it would seem that Susie Cooper designed patterns within the range 2500 to 8401 or 4001 to 8401 – but it is highly unlikely that she designed every pattern within these possible ranges.

Researchers also have a problem with the quality of the information which can be gleaned from the bases of pots. Piecework payment systems meant that decorators paid little attention to the quality of the pattern numbers or their individual cyphers on the underside of their work. In consequence, pattern numbers can be incorrectly recorded (plate 7) and often are difficult to read.

One aspect of pattern sequencing is open to little doubt. The use of pattern number letter prefixes, for example A, B and D, was not introduced until Gray's moved its factory to a larger works in Whieldon Road, Stoke-on-Trent in 1933.[11] Therefore no pattern with a letter prefix can be attributed to Susie Cooper.

14. An earthenware sauce-boat freehand-painted in a restrained classical style, pattern (2843), marked with a second galleon. This is very early within Susie Cooper's portfolio, if one takes 2500 as her likely first pattern number.

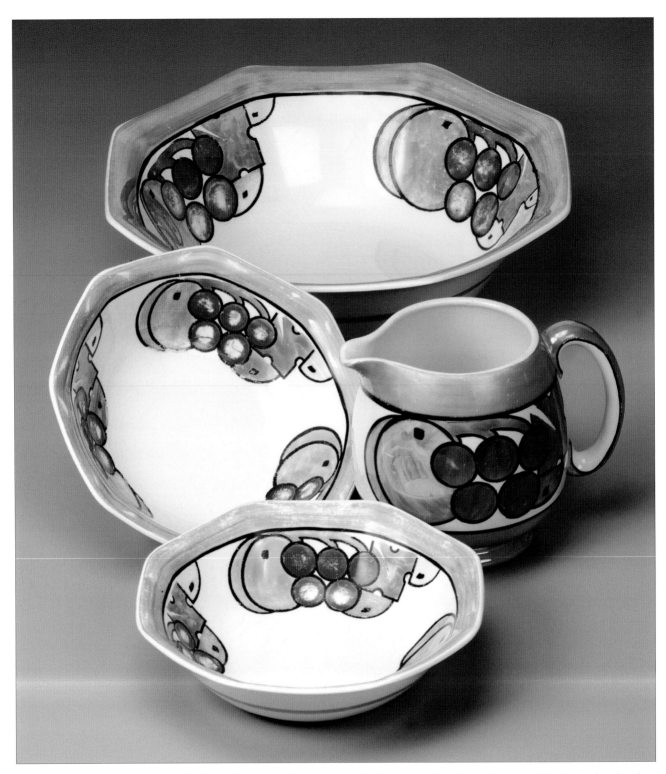

15. An earthenware fruit set decorated with a printed outline in black and filled in by hand with lustre colours, pattern (4474), the bowls are marked with the Gloria Lustre mark whilst the jug has the second galleon mark. These were some of the typical patterns being made at Gray's Pottery when Susie Cooper joined. Note that the lustre on the bowls is very worn, whilst the jug is unaffected. The damage results from wear and attack by fruit acids on the very thin layer of lustrous metal. Diameter of large bowl, 9¼in (23.5cm).

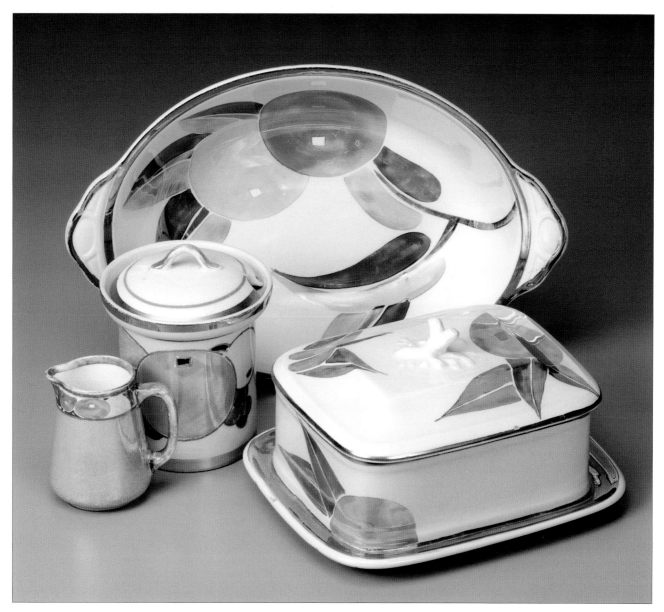

16. Examples of freehand-painted tableware with lustre colours: vegetable dish, length 10in (25.6cm), decorated with pattern (7244), a sardine box decorated with pattern (7173) and creamer decorated with pattern (4588), R&D Ltd. and preserve pot decorated with pattern (4733). The sardine box and preserve pot are marked with the Gloria Lustre backstamp.

Gray's Pottery only named a tiny proportion of its patterns. Thousands of pattern numbers have been recorded but only thirty-nine official names have been recorded to date (February 2002). The names printed on the bases of pots. These appear either as black, rubber-stamped upper case letters, as a lithographic transfer-printed mark or as part of the backstamp. 'Everyday' names were used in the works for some patterns and thirty-eight have been recorded in conversations with Gray's employees. This contrasts with the trend in recent years for new names to be coined by collectors, a practice which does not accord with the actual routine whilst the firm was trading. Within the possible range of Susie Cooper designs, the following pattern names have been recorded:

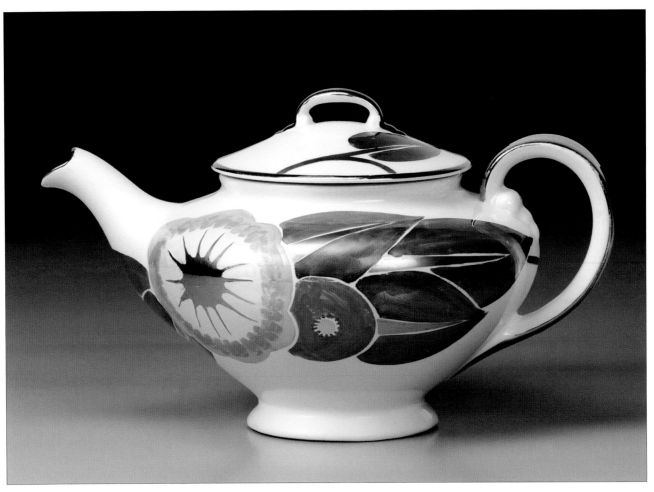

17. An earthenware tea pot, height 5¾in (14.5cm), decorated with a freehand-painted stylised floral pattern (7242) in lustre colours and two shades of silver lustre with solid black foot ring, marked with second galleon, about 1927.

Golden Catkin	7671 (plate 8)
Golden Catkin	7713 – different colourway
Almond Blossom	7714 – numbers 7711 and 7712 are confirmed in use in March 1928[12]
Quadrupeds	7742 – confirmed in use in 1928[13] and 1930[14] (plate 9)
Heliophila	7743 – seen on plate impressed 1930
Cubist	8071 (plate 10)
Harmony	8312 – confirmed in use 1938[15] and 1955[16]
Pastoral	8327 – seen on plate with second galleon mark and possibly impressed 1929
Roumanian	8332
Pastorel	8335 – seen on Liverpool shaped jug with liner mark
Hawaiian	8374 – seen with second galleon, liner and clipper marks

Style alone is not sufficient evidence on which to make an attribution to any designer. Manufacturers have always made what they could and what the customer wanted. 'Flavour of the month' is always a factor. Since more than one designer

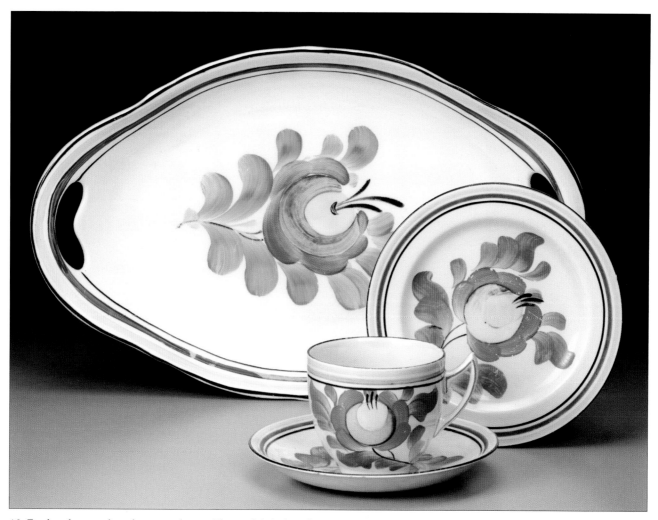

18. Freehand-painted earthenware shapes. The oval dish, length 13½in (34.3cm), made by Ditmar Urbach, Teplitz, Czechoslovakia, is typical of large quantities of pottery being imported during the 1920s. Susie Cooper felt that Gray's could easily equal the quality of the imported wares and suggested a change from making domestic pottery with the fragile lustre painting to wares painted in the more robust enamel colours. The tea cup, saucer and plate are marked GRAY'S POTTERY HANLEY ENGLAND, but without a pattern number.

worked at Gray's whilst Susie Cooper was an employee, any one of them could be the author of a particular pattern.

To establish a body of work which Susie Cooper was responsible for designing whilst at Gray's Pottery we have to weigh the evidence from several sources: primary sources which are materials of the day, such as factory records, trade journals, magazines of art, newspapers and exhibition catalogues,[17] in conjunction with an appropriate backstamp, a pattern number from within the range of possibility and very tentatively, 'the look' of a design. However, no definitive list can be compiled, since without the factory records there is no ultimate authority from which to make absolute attributions. Many, many designs are ascribed to this genius amongst ceramic designers, but even she could not have been so productive in a mere eight years!

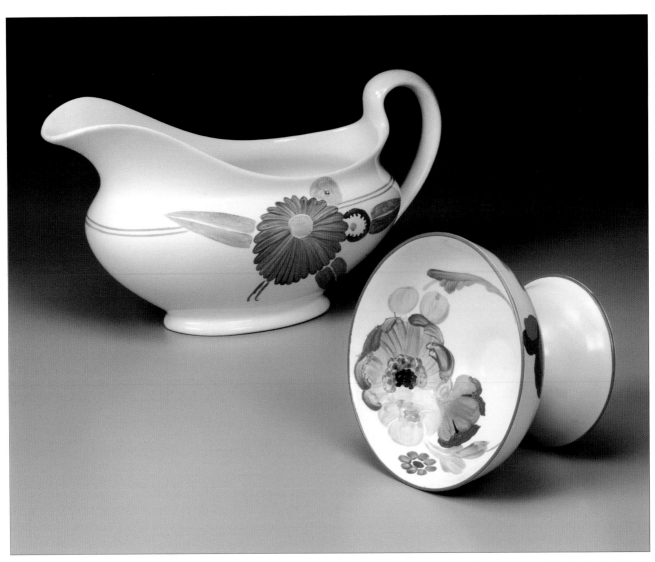

19. Freehand-painted earthenware tablewares perhaps designed in response to the Czechoslovakian imports. The sauceboat, length 8¼in (21cm), is decorated with pattern (7209) in the stylised commercial painting where one brushstroke forms a petal and would be done very quickly and the footed grapefruit dish, pattern (7514) is decorated with a realistic flower design where more work would be needed to create the effect, thereby influencing the piecework rate. Both marked with the second galleon backstamp, about 1927-28.

FOOTNOTES

1. 'The Encouragement of Art in the Potteries'. Paper presented by A.E. Gray to the Ceramic Society, 1917; published in *Transactions of the Ceramic Society*, Vol. XVII Session 1917-1918, pp.159-180. 'As the result of this discussion an Art Section of the Ceramic Society has been formed' p.180.
2. Obituary of A.E. Gray, Service to Ceramic Art. 'A man with a compelling interest in art and design', *Evening Sentinel*, 1 July 1959.
3. Critchlow, D., Susie Cooper – An artist who brings beauty to many homes, *The Manchester Evening News*, 1 March, 1933.
4. *Decorative Art – The Studio Year Book* 1920, p.83.
5. Gordon Forsyth designed Gloria Lustre wares, *Pottery and Glass Record*, February 1923, p.358.
6. Oral evidence from employee 1931-34.
7. Eatwell, A., *Susie Cooper Productions*, Victoria & Albert Museum, 1987, p.95.
8. Accession number 1930.47.
9. Accession number 1930.46.

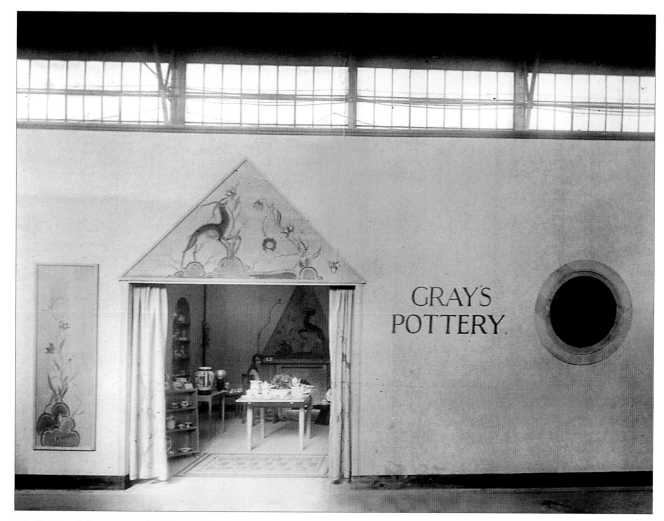

20. The Gray's Pottery stand at the British Industries Fair of 1926 or 1927. The Gray family believes that Susie Cooper designed this stand. This may be substantiated by the press reports: 'Nobody could avoid being struck by the stand of Messrs. A.E. Gray & Co. Ltd., which was certainly designed by an artist' (*Pottery & Glass Record*, March 1926, p.576) and 'A.E. Gray & Co. Ltd. ...had an exhibit... which stood out conspicuously as an example of something different' (*Pottery Gazette and Glass Trade Review*, April 1927, p.632). Note the use of the leaping deer, a design icon of the 1920s and 1930s and a favourite Susie Cooper motif throughout her life. Two versions of a deer may be seen inside and outside the trade stand. The same elegant creatures may be seen on a large ginger jar in the collection of the Victoria and Albert Museum. It is possible that this is the ginger jar on display at the BIF. In about 1936-37 she produced an earthenware deer table centre (see Chapter 1, plate 12).

10. Accession number 1930.45.
11. Niblett, P., *Hand-Painted Gray's Pottery*, The Potteries Museum & Art Gallery, Stoke-on-Trent, 4th revised edition, 1992.
12. *Pottery and Glass Record*, March 1928, Vol.10, p.73.
13. ibid.
14. *Decorative Art – The Studio Year Book*, 1930, p.152.
15. *Pottery and Glass Record*, September 1938, Vol.20, p.64.
16. *Pottery Gazette and Glass Trade Review*, September 1955, p.1302.
17. Examples of published primary sources: *The Pottery Gazette and Glass Trade Review*; *Pottery and Glass Record*; *Decorative Art – The Studio Year Book*; Design and Industries Association – Year Book; Forsyth, G.M., *Art and Craft of the Potter*, 1934; Dowling, H.G., *A Survey of British Industrial Arts*, 1935; Forsyth, G., *20th Century Ceramics*, The Studio Limited, 1936.

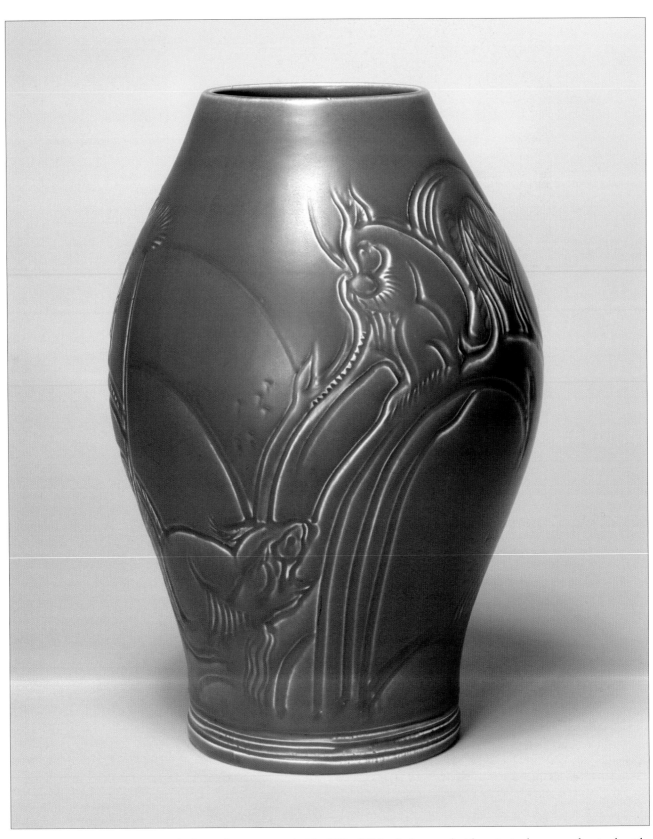

1. An earthenware vase, height 11⅜in (28.8cm), decorated with an incised pattern of squirrels with a matt dark blue glaze, possibly (M154), about 1933.

CHAPTER 3

THE SUSIE COOPER POTTERY 1929-1966

Nick Dolan

Susie Cooper's work for Gray's Pottery was a success, establishing her name as a leading designer,[1] but the limitations there frustrated her. She wanted to produce ware that she thought would sell, rather than be confined to designing what the salesmen asked for. She had come to realise the importance of complete artistic control and wanted to experiment with new shapes, glazes and patterns. She later said that coming from a business background had encouraged her ambition to run her own firm.[2] She left Gray's in October 1929. With £4,000 capital (from her family) and her brother-in-law Jack (A.E. Beeson) as a partner (he also acted as her main London agent), she moved with six paintresses into rented rooms at the George Street Pottery, Tunstall.[3]

Her mentor, Gordon Forsyth, and her ex-employer Edward Gray forecast that she would return to Gray's within eight months. Such gloom appeared to have some foundation when the Wall Street Crash scared the creditors of the George Street Pottery into bankrupting her landlord's firm in November 1929. Wisely, Susie

2. A portrait of Susie Cooper, 1938.

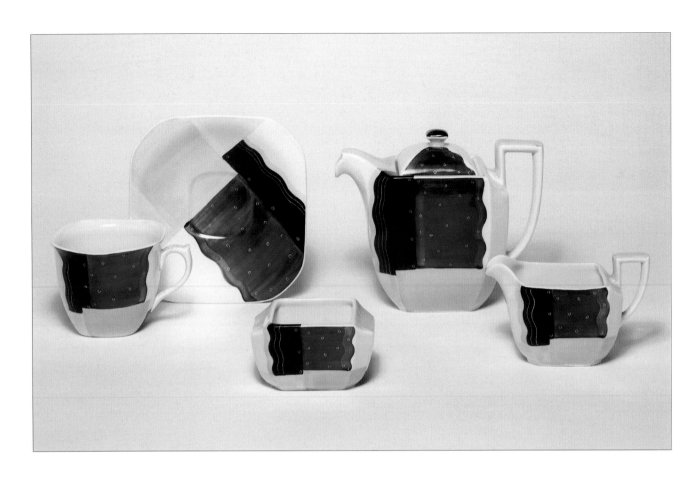

3. An earthenware part tea set, Cube shape, supplied by Wood and Sons Ltd., decorated with the Galaxy pattern (E/282). Hand painted with sgraffito decoration, about 1932. Height of tea pot 5⅞in (18cm).

Cooper realised that pottery manufacturers would, in the strained financial climate of the time, welcome any opportunity to sell their white (undecorated) earthenware. Consequently, in spring 1930 she re-established her decorating business at the Chelsea Works, Moorland Road, Burslem, renting space from Gibson and Sons, and buying in ware from local manufacturers including Doulton and Co. and Wood and Sons. Her products were described as 'Art Ware', though commercial tableware was her main output, continuing the hand-painted geometric, floral and banded patterns of the Gray's Pottery period (plate 3).

In 1931, Wood and Sons offered space to Susie Cooper at the Bursley end of their Pottery site in Newcastle Street, Burslem, with the agreement that they would make shapes in earthenware to her design. She accepted the offer and remained at the Crown Works, as it was called, until 1980, production being broken only by fires in 1942 and 1957. The situation suited her very well. Being a small operation she was able to respond to market trends swiftly and at a competitive price.

Her first commission came from the Nottingham department store 'Griffin & Spalding'. During the Stoke-on-Trent Historical Pageant (18th-24th May 1930) she was visited by one of their representatives. Miss Langford, of the firm's China and Glass department, was quoted as saying: 'There are certain things which we have to seek from foreign sources, but wherever possible we are placing our orders at home.'[4]

Other early orders came from Grant's of Croydon (morning sets and honey pots) and Dunn's of Bromley. From 1933, the John Lewis store was an important client, ordering banded and polka dot patterns for open stock. Later, Harrods commissioned monogrammed wares and her pottery was also sold in Heals. Outside

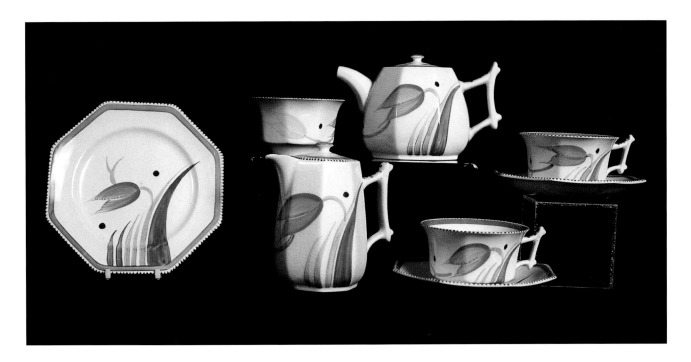

London, from Plymouth to Glasgow and from Bath to Scarborough, fashionable shops stocked Susie Cooper pottery.

She understood the value of advertising to establish a reputation and an identity for her business, though she did not indulge in the excessive blanket advertising that was a feature of some firms. Throughout the 1930s her advertisements were judiciously placed, with just enough information to intrigue the trade buyers targeted. Her first advertisement was in April 1930, when the Pottery was at the Chelsea Works. The layout is striking. There is a designer's eye to the use of white space, and the typography is in contemporary hand-written script. The information

4. A stylised hand-painted floral pattern, Fritillary (E/152), decorated on the less common Orleans shape, bought in from a supplier, about 1930-31.

5. The Crown Works, Burslem, 1970s.

·THE SUSIE COOPER POTTERY·

CHELSEA WORKS
BURSLEM
STAFFORDSHIRE

ELEGANCE COMBINED
WITH UTILITY
ARTISTRY ASSOCIATED
WITH COMMERCE &
PRACTICABILITY· ·
TRULY A STRONG
COMBINATION· ·

6. The first Susie Cooper advertisement placed in *The Pottery Gazette and Glass Trade Review*, April 1930.

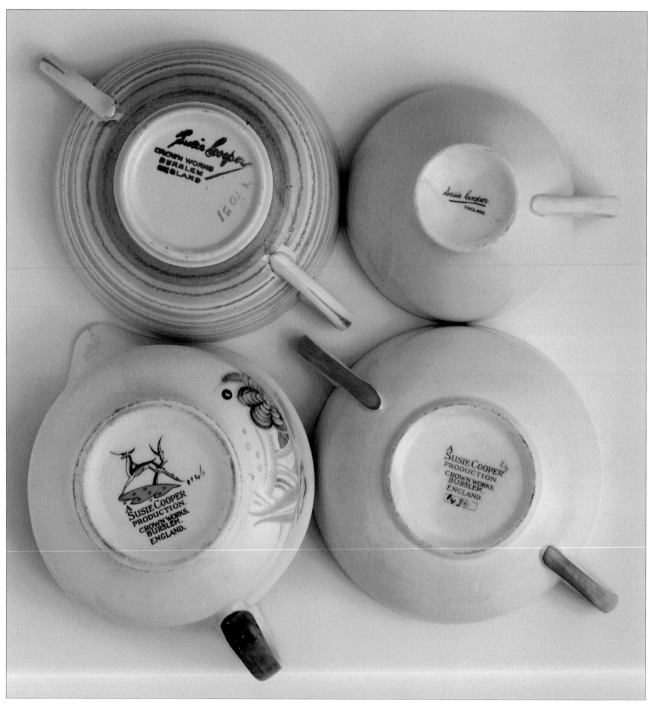

7. A selection of backstamps used by Susie Cooper from the thirties until the immediate post-war period.

8. (Opposite, top) A group of spotted patterns, from left to right: An earthenware Kestrel shape preserve jar and cover decorated with a rubber stamp pattern and banded decoration (probably within the pattern range E/2323-2328), about 1956; dinner plate decorated with the hand-painted Academy pattern designed by Susie Cooper for Wood and Sons Ltd., 1935; a Kestrel coffee can and saucer and hot water jug, height 6¼in (17cm), decorated with the Polka Dot pattern, hand painted in blue (E/898) from 1934.

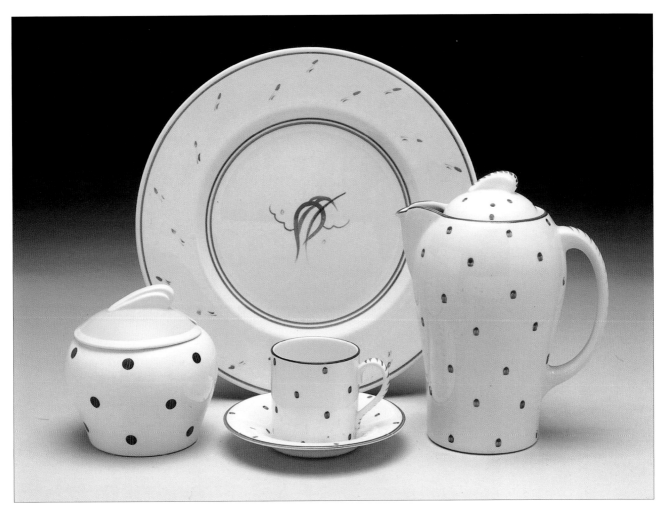

9. The Susie Cooper show-
room at 42 Woburn Place,
London, about 1933. Note
the uncommon shapes and
studio wares.

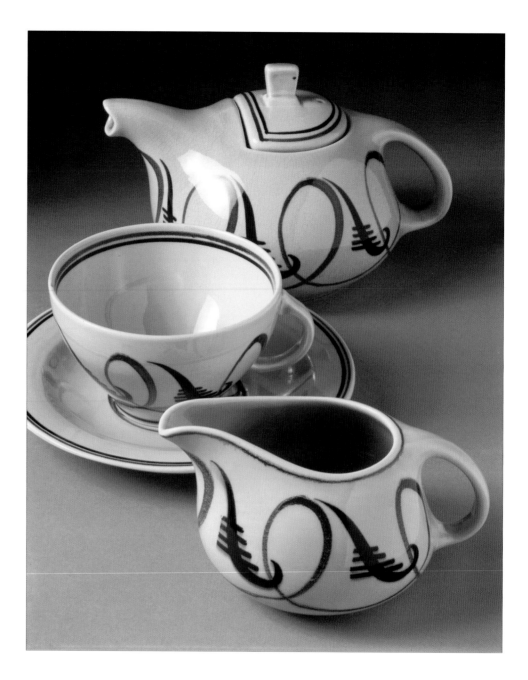

10. An earthenware Curlew
shape tea pot, length 6¼in
(16cm), milk jug and cup and
saucer decorated with a hand-
painted pattern in underglaze
black and brown with a grey
glaze (E/616), 1933.

contained is concise, in contrast to that of other manufacturers (plate 6).

Susie Cooper's products had a high profile in the 1930s, at trade fairs and design exhibitions, as well as in major department stores. She exhibited at the British Industries Fair throughout the 1930s, always getting good reviews in the trade press for her innovative work. She also showed at an exhibition in Dorland Hall in 1933 organised by the Design and Industries Association and had wares displayed at The Royal Academy in the 'British Art in Industry' exhibition of 1935. Such persistent presentation of her designs as the epitome of good modern taste would have influenced the middle class professionals seeking a contemporary look at a competitive price.

For this market she developed smaller service ranges, stacking products and multi-purpose items. Her designs were elegant and practical (such as the tureen lid

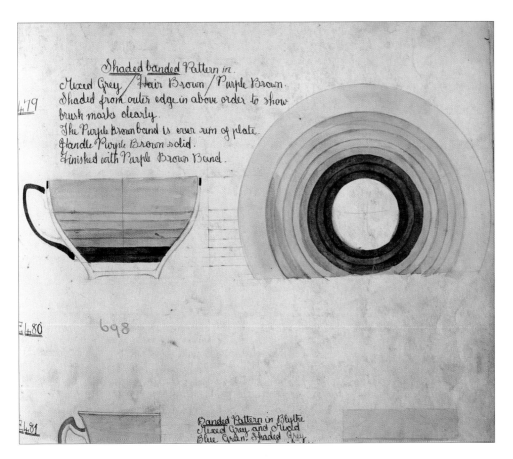

11. A pattern book entry illustrating one of the most popular Wedding Ring colour variations (E/479), about 1932-33.

Within the image (pattern book handwriting):

Shaded banded Pattern in.
Mixed Grey / Hair Brown / Purple Brown.
Shaded from outer edge in above order to show
brush marks clearly.
The Purple Brown band is over rim of plate.
Handle Purple Brown solid.
Finished with Purple Brown Band.

479

E480 698

E481 *Banded Pattern in Blythe*
Mixed Grey and Mixed
Blue Green. Shaded Grey.

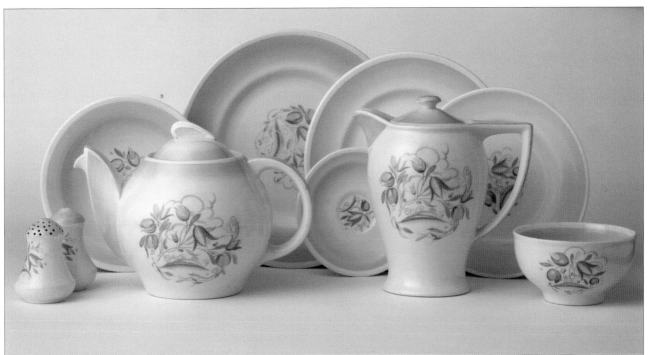

12. A selection of earthenware shapes, including a Kestrel shape tea pot and a Rex shape hot water jug (right) decorated with the Dresden Spray pattern, transfer-printed centre motif with shaded band in pink (E/1005), about 1935.

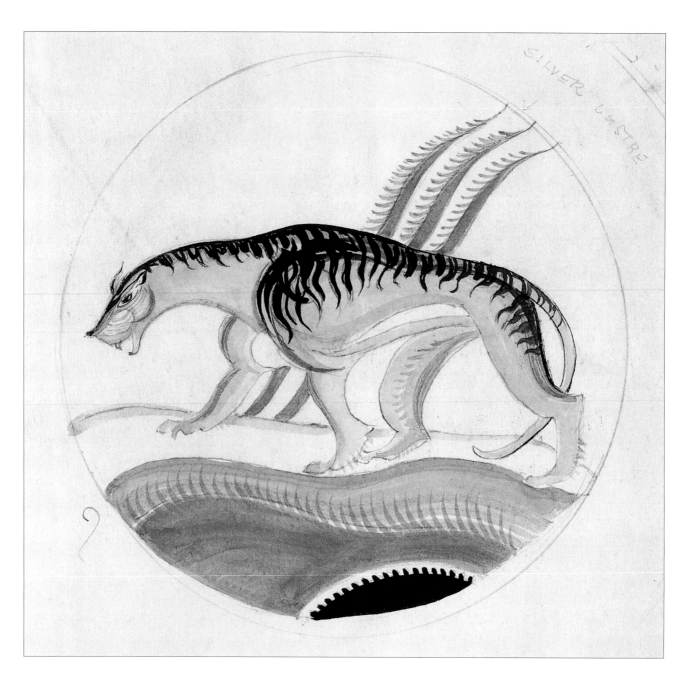

13. A hand-painted pattern of a tiger for a service plate entered into the Susie Cooper pattern book (E/974), about 1935. This outstanding design was part of a group of patterns that included 'Fox' (E/972), 'Leopard' (E/973) and 'Hound' (E/975).

that could become an extra serving dish) but the streamlined shapes, such as Kestrel and Curlew, and the minimalist patterning were never threatening (plate 10). Although the design theory that informed her work was essentially modernist it was not the bleak and stark modernism of the continental model but one that was adapted to encompass the best design traditions of the English industry and the need that she correctly perceived in her market for good quality patterns. The hand-painted polka dots, the crayon loops, and the tube-lined and banded designs that she introduced in the early 1930s were soon in such demand that firms throughout Staffordshire were forced to copy her work. The rapid increase in the number of her employees reflected the popularity of her pottery. By 1933 over forty paintresses were employed.[5]

Susie Cooper's desire for her firm to achieve success was not solely for aesthetic

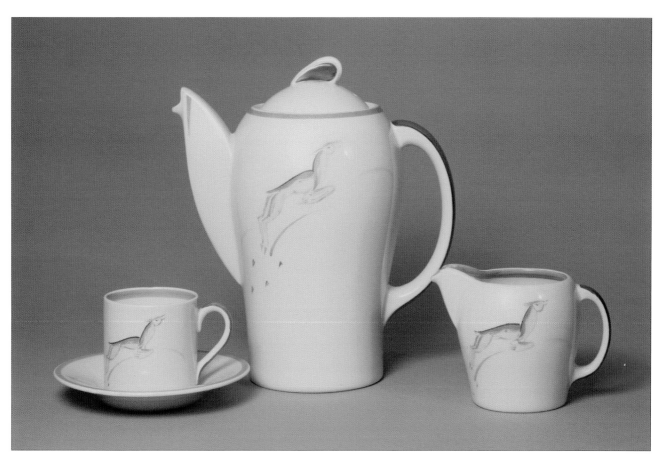

14. An earthenware Kestrel shape coffee pot, height 7⅝in (19.5cm), coffee can and saucer and milk jug decorated with a transfer-printed pattern of leaping deer (E/1011) with hand-painted bands, about 1936.

15. A collection of earthenware dinner plates and a Classic shape tureen and cover, a Woods shape improved by Susie Cooper, decorated with an underglaze crayon pattern (E/1232), about 1936. Length of tureen (including handles) 9½in (24cm).

16. Examples of the Spiral shape dinner and tea ware launched in 1938, decorated with the transfer-printed Endon pattern (E/1417), about 1938.

or personal reasons. She felt a responsibility, as an employer and as a member of a relatively wealthy local family that 'it was in everyone's best interest to keep people employed.'[6]

Between 1933 and the outbreak of war, the pottery industry had an unemployment rate higher than the national average. Susie Cooper criticised the architect Serge Chermayeff who addressed the Society of Industrial Artists in 1932, for suggesting a decrease in the methods of decorating pottery, as this would jeopardise the jobs of 'all those craftsmen in the industry – the bulk of the people who were dependent for a livelihood upon their share of work in the industry.'[7]

Susie Cooper told young designers 'their first job as a designer is to keep all these people employed.'[8] The genuine nature of Susie Cooper's paternal attitude can be

17. An earthenware part coffee set, Falcon shape, decorated with the Regency Feather pattern (possibly E/1469). Aerographed in green with sgraffito decoration, about 1938. Height of coffee pot 7½in (19cm).

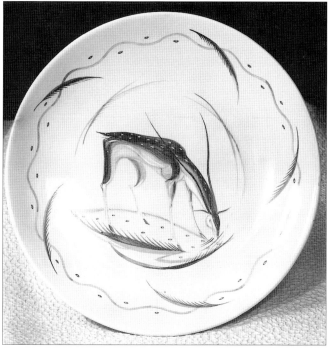

18. An earthenware plaque decorated with a hand-painted pattern of a deer grazing. About 1938-39.

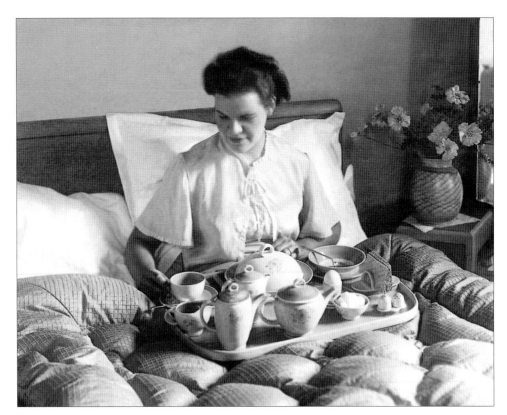

19. This photograph of a woman using a Susie Cooper breakfast in bed set featured in a company advertisement in the trade press in 1939. The Falcon shape range is decorated with a hand-painted pattern from the late thirties, possibly (E/1813).

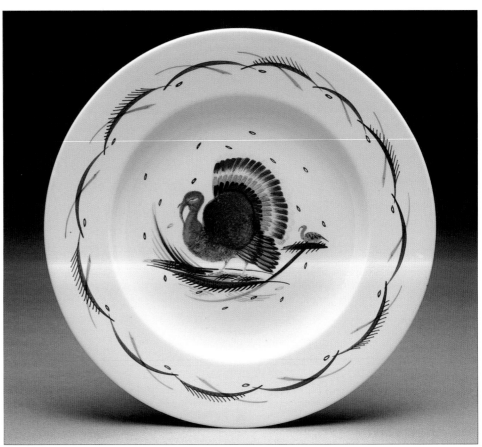

20. An earthenware dinner plate, diameter 10⅝in (27cm), decorated with the Turkey pattern (E/1838) made for the North American market. The pattern is printed and hand painted, about 1939-40.

21. Plan and side elevation for changes to the layout of Susie Cooper Pottery Ltd., at the Crown Works, 1937. The architects were Cecil Barker (later Susie Cooper's husband) and William J. Venables, of Gordon Chambers, Cheapside, Hanley.

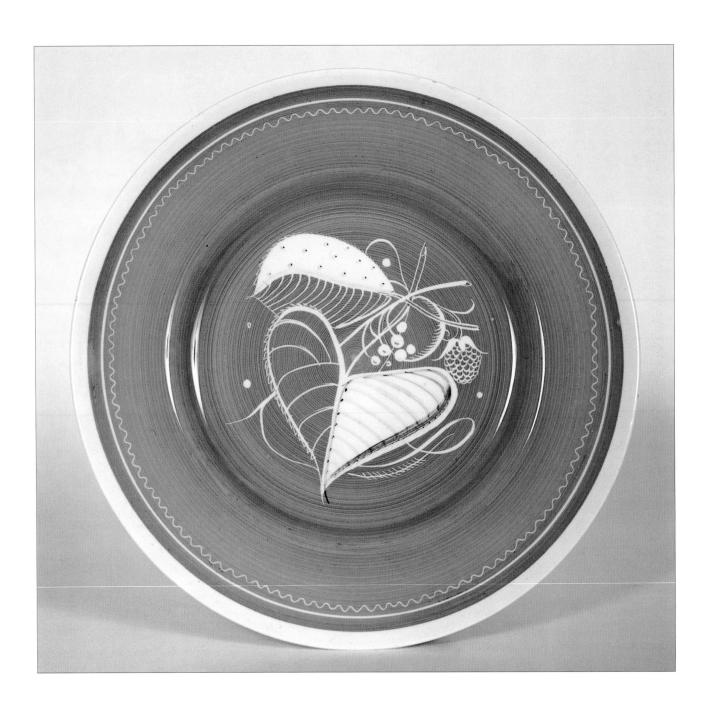

22. An uncommon pattern
decorated on an earthenware
plate. The pattern is banded
in blue with painted and
sgraffito decoration, probably
late 1940s.

judged by the fond memories and high regard with which she was remembered by
her workforce. Her view of a designer's role was not just paternalistic. By designing
patterns to suit the paintresses' particular skills she could achieve maximum
production from the minimum outlay of labour costs and materials.

From the mid-1930s Susie Cooper ware could be bought throughout Britain and
a growing international network of agencies ensured that her designs reached a
global market. She fostered close connections with specific retail outlets, such as
Proud's in Australia, and Henry Morgan and T. Eaton in Canada.

To meet the increasing demand for her products she turned to lithographs and
was the first Staffordshire manufacturer to supply high quality printed designs that
rivalled the aesthetic effect of hand painting. Dresden Spray, a modern

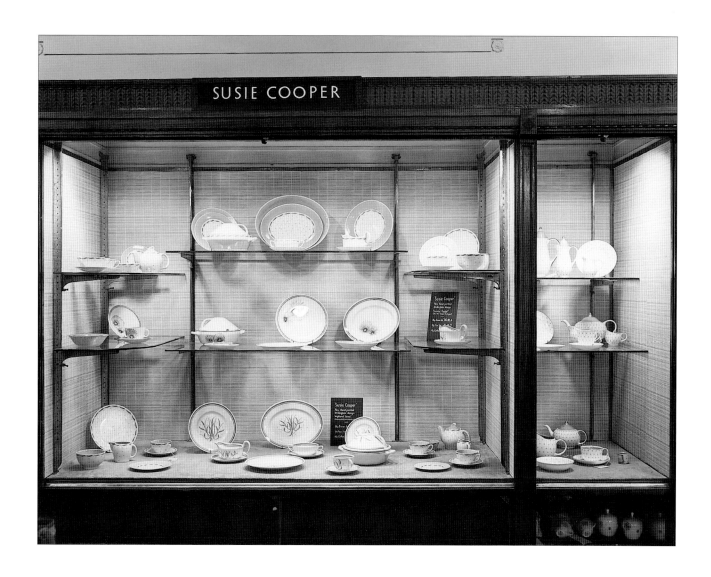

SUSIE COOPER

interpretation of a traditional Staffordshire posy pattern, shown in 1935, was an immediate success and remained in production until the late fifties (plate 12).[9]

Fondeville & Co., Susie Cooper's New York agents from 1936, sold the new printed patterns.[10] The American love of the quaintness of 'Pastoral England' was exploited to the full. The Endon pattern was described as 'a gay coloured garland of English garden flowers on a graceful swirl.'[11] The popularity of rather traditional patterns such as Endon, Woodlands and Patricia, on the Spiral shape (sold from 1938), demonstrates the conservatism of the American market of the period (plate 16). Although Spiral was popular with the export market, Falcon, marketed from 1937, proved a flexible shape for a number of decorative techniques, particularly sgraffito patterns (plate 17).[12]

By 1937, Susie Cooper had even reached Hollywood. In MGM's film *Captains Courageous*, based on Kipling's novel, two trays of Susie Cooper breakfast ware were shown. American set-dressers considered her pottery to be representative of upper-class British taste (plate 19).

At the Paris International Exhibition of the same year, the Susie Cooper Pottery was one of nineteen British pottery exhibitors.[13] Although she showed only five exhibits, 'her work was singled out for the distinctive excellence of its use of new

23. The Harrods exhibition of 1956 showing a range of Susie Cooper patterns such as Sienna Pastel (E/2318) in the centre and Highland Grass (E/2311) at the bottom, 1956.

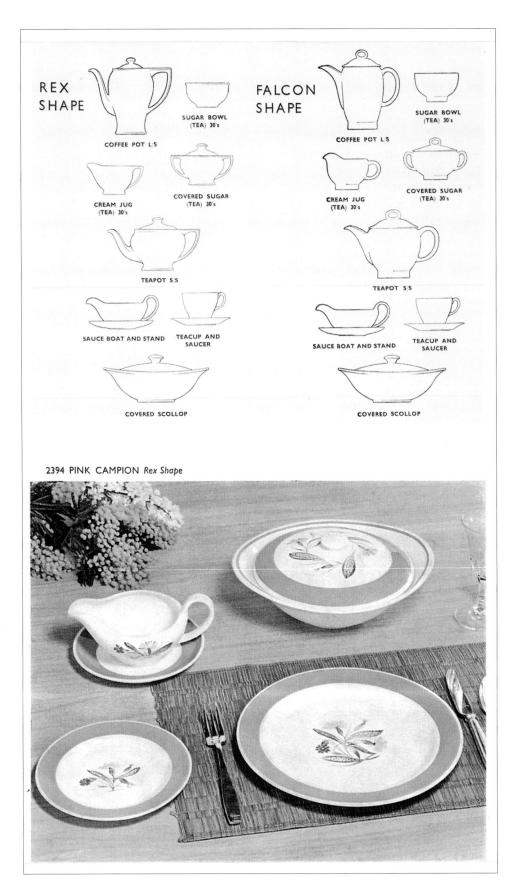

24. Part of a Susie Cooper catalogue illustrating the Rex and Falcon shapes, about 1960.

techniques.'[14] Susie Cooper kept ahead of her competitors by experimenting with decorative techniques or modifying existing practices to create new effects.

Her important public commissions of the period included tableware for the restaurant of Peter Jones, London and the 'prestigiously modern' Pioneer Health Centre in Peckham, South London. The Kestrel shape, ordered for Imperial Airways, flew from London to Paris.

Despite these triumphs, from 1939 wartime restrictions greatly affected the pottery industry. In particular, there were limitations placed on the ware produced and its distribution. Decorated ware for the home market was prohibited from June 1942. Thirteen members of Susie Cooper's staff were sent to work in 'essential services', many going to Swinnerton's Pottery, a Government Ordnance factory.[15]

The firm closed after a fire in 1942 but reopened after the war. Susie Cooper, highly regarded in her industry and by the critical establishment, was asked to sit on the potteries selection committee for the Britain Can Make It exhibition. Her patterns of the immediate post-war period are an extraordinary tour de force of colour, design and freehand skills. A new venture in bone china replaced her enthusiasm for earthenware, which was compounded by the changing relationship between her company and Wood and Sons Ltd. By the mid-1950s earthenware was largely decorated with the same transfer prints as those on bone china.[16] Freehand painting, briefly revived in the early 1960s with patterns such as Ferndown and Gooseberry, was uneconomical in comparison with the new covercoat printing technique. Despite the development of new patterns and a few new shapes, earthenware production was no longer the main focus of Susie Cooper's inventiveness, and it was entirely phased out in 1964.

FOOTNOTES

1. Gray's Pottery acknowledged her important contribution by incorporating her name on a special backstamp, very unusual in the pottery industry at the time.
2. Ann Eatwell's interview with Susie Cooper, 1988.
3. In 1934 the Council for Art and Industry Report recorded that 70,000 people were employed in the industry, 200 firms with a value of £4,250,00. A few larger firms with over 200 staff existed but most were small and independent.
4. Buyers' Notes, *The Pottery Gazette and Glass Trade Review*, June 1932, p.762.
5. Critchlow, D., Susie Cooper – An artist who brings beauty to many homes, *The Manchester Evening News*, 1 March 1933.
6. Information from Miss K. Sargent's interview with Susie Cooper, June 1983.
7. Burchill, F., and Ross, R., *A History of the Potters Union*, Ceramic and Allied Trades Union, 1977.
8. Benn, E., All set for a Fresh Look at Tableware, *Daily Telegraph*, 23 August, 1983, p.9.
9. Three transfer-printed floral patterns, Dresden Spray, Two Leaf Spray and Printemps, were illustrated in the North American *Crockery and Glass Journal* in August 1934. There were described as 'new treatments in pinks and that are excellently done.'
10. The association with Fondeville & Co. may date from 1933. See Chapter 13.
11. Information from the advertisement for the Endon pattern issued by Fondeville & Co. for the North American market.
12. The Spiral shape was designed specifically for the North American market.
13. Information from the *Pottery Gazette and Glass Trade Review*, August 1937, p.1058.
14. Information from Woodhouse, A., *Elegance and Utility*, Josiah Wedgwood and Sons Ltd., 1978.
15. Information from the *Pottery Gazette and Glass Trade Review*, May 1942, p.307.
16. The Susie Cooper bone china range is discussed in Chapter 7 of this book.

1. Kiln firemen, at the rear of the kilns at the Crown Works, 1930s. From the left, Les, Ted Orme, Albert Beech, Fred Adams, Jack Shufflebottom. The latter worked for Susie Cooper for over twenty-five years.

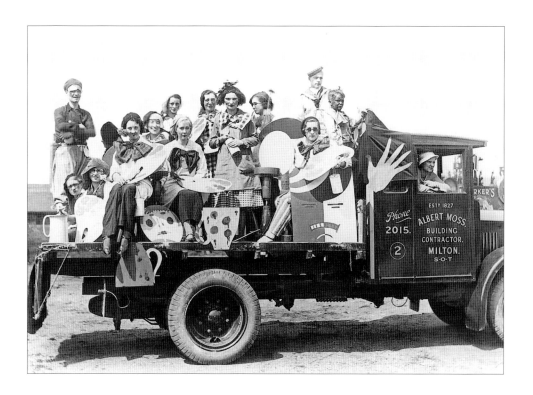

CHAPTER 4

FACTORY ORGANISATION AND WORKFORCE

Nick Dolan

The success of the Susie Cooper Pottery must rest largely on the excellence of design. However, the quality of the product was also the result of an efficient and well-run organisation. As Managing Director of the business, Susie Cooper was instrumental in creating the conditions that allowed her factory to succeed, but she would have been the first to acknowledge the important contribution of her staff to the manufacture of first class ceramics. In 1987, Bert Critchlow, who was with the firm from 1931-70, Company Secretary from 1950 and Financial Director between 1969-70, drew a table from memory of the type and number of employees and a plan of the organisational structure (see page 128). These documents give a valuable insight into the way the work in a small to medium-sized factory was organised in Staffordshire in the mid-twentieth century.

By 1939 Susie Cooper employed about one hundred staff, well over half of these being paintresses. Other roles included lithographers, secretaries and office staff, warehouse managers and packing clerks. In the mid-1930s the working hours were from 8am to 5.30pm on weekdays, and 8am to 1pm on Saturdays.[1] If a kiln had to be filled, the paintresses and some other staff would stay longer. On one occasion Susie Cooper had to use outside help in the production, to a tight deadline, of a

2. The Susie Cooper Pottery float, Crazy Day, Stoke-on-Trent Carnival, early 1930s. Not all the participants can now be named, but fourth from the left, with the palette and tartan bow, is Doris Pemberton; on her left, seated lower, is Bessie Brown and to Doris's right, Dora Lythe. Behind and between them is Mrs Wootten, the pre-war decorating manageress. Winnie Padin stands at the front with a checked bow. To her left, wearing glasses, is Louie Pickin, one of the original six paintresses.

3. The kiln at the Jason
Works, 1950s.

4. Worker spraying on glaze
at the Jason Works, 1950s.

particular set of ware. Six pupils from the Burslem School of Art were sent to the
Crown Works to help decorate 18 inch plaques in the Persian Market pattern.
While working there they did not see Susie Cooper.[2] The resulting wares were
displayed at the British Industries Fair in 1932, with Queen Mary acquiring from
the stand 'a jug, somewhat after the Persian style, the texture being matt, and the
design in black'.[3]

While few paintresses were members of a union, all the kiln-men were. Percy
Jones, Miss Cooper's third chief kiln-man (his predecessors being Jack
Shufflebotham and Jack Barrett respectively), received the standard union rate of
ten shillings for drawing and setting a kiln for a day. The Crown Works had three
upright coal-fired kilns, and the firing sequence was two kilns one day, and one the
next, as it took twenty-four hours to fire up a kiln, it being drawn the next day. The
kiln-men and their assistants worked on Sundays too. Some ware was lost in the
firing, and most unacceptable pieces were smashed, but the best of them were sold
to visiting buyers of 'seconds', called 'Junk-men'.

The decorating side of the pottery industry was dominated by women. The
occupation of paintress was seen as respectable, and the relatively low wages were
counterbalanced by the status of the paintress. Susie Cooper's paintresses
considered themselves particularly special, because of their involvement with
such a renowned pottery. When one particular girl gained employment at Susie
Cooper's Chelsea Works, her father, a miner, was delighted at the prospect of his
daughter having an association with this firm. Some girls, like Nora Dobbs, were
employed straight from school at the age of fourteen, although Susie Cooper's
most senior paintress, Alice Jones, had accompanied her from Gray's Pottery to
start the new factory.

5. Retirement party for Nellie Jones, a warehouse worker, early 1970s. Back row, left to right: Lily Yates, Winnie Carter (warehouse), Mr Hagan (Decorating Manager post-war), Bill Mould (polisher who worked for forty-one years with the company), May Lindsay, Freda Davies (bander). Front row, left to right: Nellie Brereton (warehouse), Ken Frost (packing clerk), Jim Moran (General Manager), Nellie Jones and Margaret (office).

6. Photograph of the entrance to the Crown Works with Mrs Mary Ellis, née Willis, and Mrs Christine Davis, née Burke, about 1959.

7. Alice Jones decorating a lid, 1959-63.

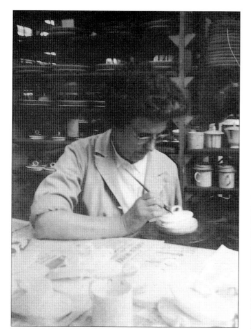

8. A float for Crazy Day, Stoke-on-Trent Carnival, early 1930s. Nora Dobbs is seated on the right.

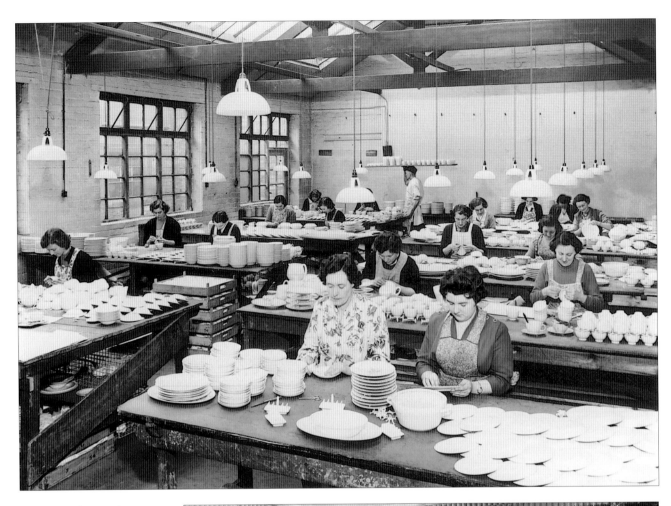

9. Lithographers applying transfer-printed designs on to the ware at the Crown Works, 1950s.

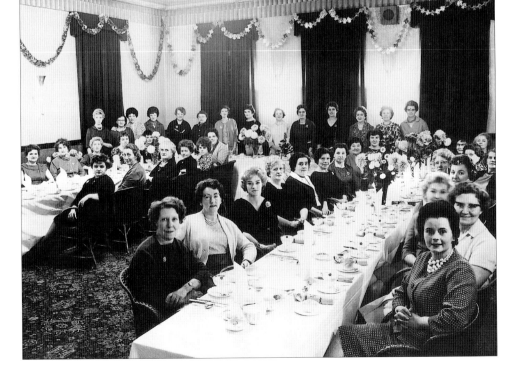

10. Evening celebration during the 1950s. Most of those present worked for the Susie Cooper Pottery. The company included banders, gilders, freehand paintresses, aerographers, lithographers and two or three warehouse workers. Nora Dobbs is standing at the back, second from right.

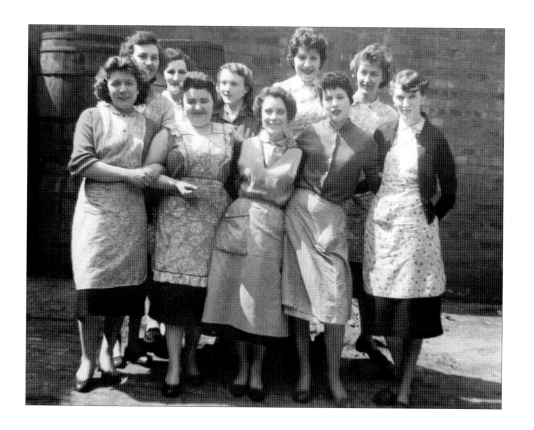

Paintresses were apprenticed for seven years, usually until the age of twenty-one, and had a small amount of money docked from their wages to pay for their training. For example, in 1932, a wage of six shillings had twopence taken off. After completing their apprenticeships they were paid on a piecework basis, making an assessment of their pay difficult. Their working speeds varied but the ability to paint thirteen dozen cups per day was considered good. The paintresses had to supply their own 'pencils' (brushes) and palette knives for mixing the powdered pigment. Many places sold them, including a newsagent in Newport Lane, Burslem. The knives cost 3/11d in the early 1930s.[4] The room in which the paintresses worked was quiet, the atmosphere being one of studious concentration. Susie Cooper had her office just off the room and sometimes worked with them.[5] This contrasts with the more informal atmosphere in Clarice Cliff's 'Bizarre' shop, where a wireless was apparently installed to stop the paintresses talking. Any talking in Susie Cooper's shop would have to be absolutely necessary, and undertaken in whispers.

11. A group photograph of factory workers, 1950s.

FOOTNOTES

1. Ann Eatwell's interview with Nora Dobbs, 26th March 1985.
2. Nick Dolan's interview with Mrs Phyllis Howe, 1983.
3. *The Pottery Gazette and Glass Trade Review*, April 1932.
4. Ann Eatwell's interview with Nora Dobbs, 26th March 1985.
5. Ibid.

1. A lithographic sheet for a range of nursery patterns including Horse and Jockey (E/1225), Noah's Ark (E/1226), Cowboy (E/1227), Golfer (E/1230) and Skier (E/1231) all about 1936.

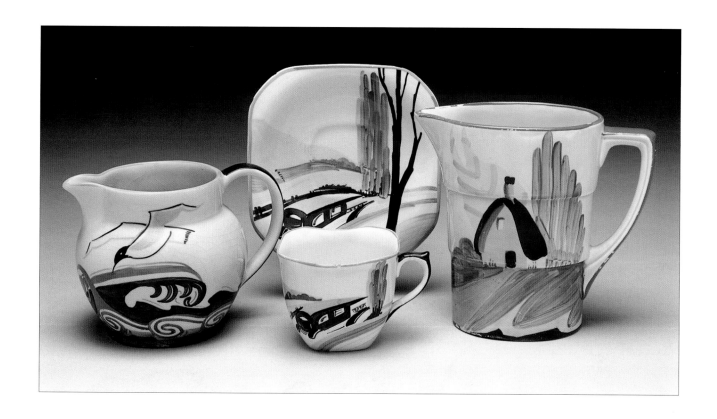

CHAPTER 5

SUSIE COOPER STYLE

Andrew Casey

When people say that such and such is 'typically Susie Cooper'
I don't know what they mean – I just see something which starts me off [1]

Susie Cooper made this remark to a newspaper journalist in 1968. Her distinctive style is so outstanding yet so very hard to define that even the pottery trade press found it difficult to sum up such an individual designer, noting 'an indefinable something about the majority of Susie Cooper's creations.' [2] There were many contributory factors that led her to create the innovative, tasteful and stylish ceramics that have proved so popular for over sixty years. Whatever the period, her designs were always in tune with contemporary taste thanks to her ability to anticipate the mood of the day.

From an examination of her entire career one can appreciate that it was her practical approach and an understanding of good design that defined the Susie Cooper style. Her strong beliefs about ceramic production were developed during her education at the Burslem School of Art. Formative influences include the inspiration of Gordon Forsyth's ceramic designs, her experience as both a decorator

2. A collection of short order patterns. Left to right: an earthenware Dutch jug hand painted with the Seagull pattern, about 1931-32. The Panorama pattern (E/306) decorated on a Cube shape cup and saucer and The Homestead (no pattern number known) on a stepped jug, height 5½in (14cm), about 1931-32. All shapes probably supplied by Wood and Sons Ltd.

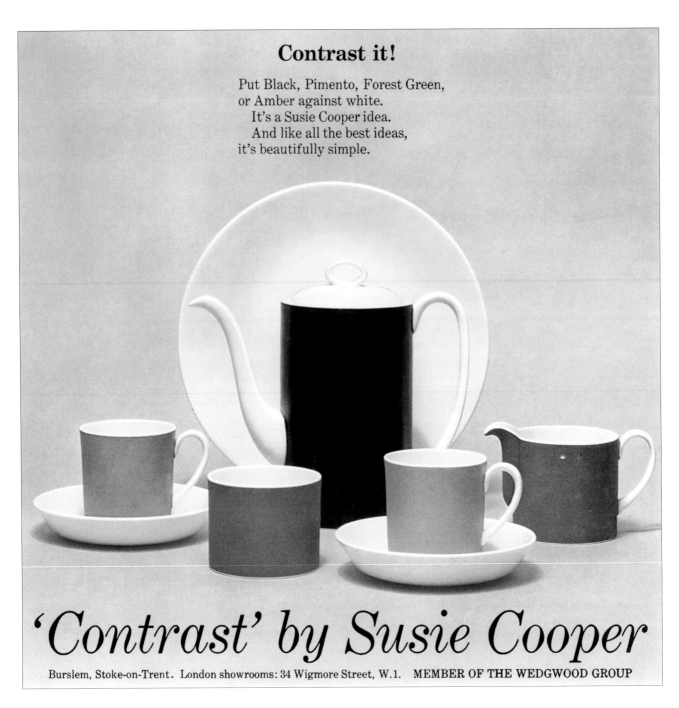

Contrast it!

Put Black, Pimento, Forest Green,
or Amber against white.
It's a Susie Cooper idea.
And like all the best ideas,
it's beautifully simple.

'Contrast' by Susie Cooper

Burslem, Stoke-on-Trent. London showrooms: 34 Wigmore Street, W.1. MEMBER OF THE WEDGWOOD GROUP

3. A Susie Cooper advertisement for the new Contrast range, designed in about 1965-66.

and a designer for the Gray's Pottery and her friendship with Edward Gray, who nurtured her skills during the twenties. As a decorator she developed an intuitive understanding of what could be done with freehand decoration. 'Things had to be done commercially; designs had to be priced to be produced at a certain rate. Being a paintress brought the importance of this home to me more quickly than would have been the case in any other circumstance.'[3] At the end of the twenties Susie Cooper took the bold decision to set up on her own as an independent designer.

The newly established Susie Cooper Pottery heralded the beginning of the true Susie Cooper approach, and a few years later, when the shapes were made to her own specifications, her unique style really came to fruition. Throughout her life her

inspiration came from two main sources – the natural world and her interest in the visual arts. Themes such as leaves, fruits, animals and flowers were repeated, using many different decorative treatments. Her interest in contemporary paintings, such as those by the French painter Paul Cézanne, gave her inspiration for modern patterns and styles. Her awareness and interest in modern art was always present. Family and friends recall that she went to see a Pop Art exhibition in London and later, the Salvador Dali Museum in Spain, with her son.[4] Her intuitive skill enabled her to carefully incorporate the latest ideas in the wider art world but to gently mix them with an English restraint to appeal to a larger market.

This original style responded to and was shaped by important changes in fashion, interior design and the new demands from her own generation. For instance newly married couples, living in small homes, did not necessarily want to purchase a full dinner service, so Susie Cooper introduced smaller sets, consisting of fifteen pieces. These were decorated with short order patterns such as A Nosegay (E/433) and The Homestead (plate 2).[5] In a similar fashion, some thirty years later, she produced Contrast, a mix and match range, that consisted of cups, bowls and coffee pots decorated in one colour, together with white plates and saucers. The company publicity summed up the approach: 'Contrast It – Put Black, Pimento, Forest Green

4. A collection of hand-painted earthenware shapes. The large plate, diameter 8½in (21.8cm), is decorated with the Scarlet Runner Beans pattern (E/241) from 1932, the side plate decorated with Symphony (E/155), the candlestick (E/153) and the milk jug (E/119). All items date from 1930-32.

5. A collection of geometric patterns. The large lemonade jug, height 7½in (19cm) is decorated with a Susie Cooper pattern (8215) from the Gray's period, about 1929. The coffee pot (shape name unknown but probably a Wood and Sons Ltd. shape) is decorated with pattern (E/110) from about 1930, and the earthenware beaker is decorated with a colour variation of the latter (E/276), from about 1932.

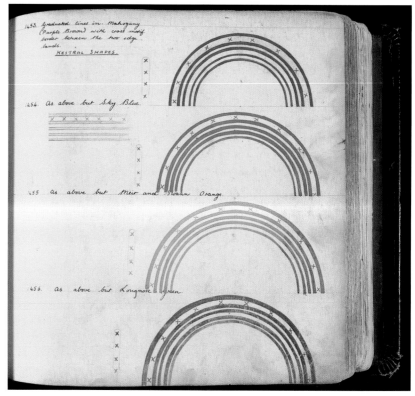

6. An illustration taken from the Susie Cooper pattern book showing the colour variations to a simple theme of narrow bands and crosses. (E/1453-1456), about 1938.

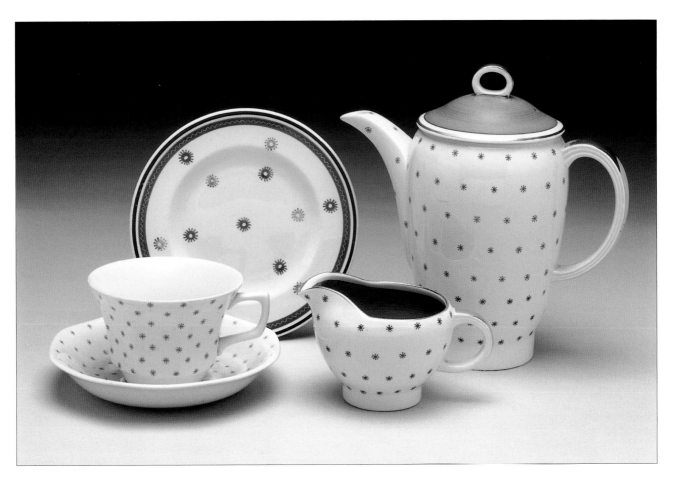

or Amber against white. It's a Susie Cooper idea. And like all the best ideas, it's beautifully simple.'[6] (plate 3)

From the very start she had identified a gap in the market between the costly decorative fine bone china for 'Sunday best' and the cheaper end of the market. Having chosen to work with earthenware, a less expensive body than bone china, she set about devising new hand-painted on-glaze patterns of stylised flowers, bands, abstract motifs and spots (plate 4). Whilst some of these were visually similar to her designs for Gray's, she skilfully moved forward to develop simple styles that required less applied decoration to ensure durability (some of the thickly painted geometric patterns produced at Gray's tended to flake) (plate 5). Susie Cooper commented that the space left around a pattern is just as important as the pattern itself and she also felt that customers should not have to pay for style. The combination of the earthenware body and simple on-glaze patterns gave her the capacity to 'achieve the maximum degree of effectiveness in pottery decoration by recourse to the simplest modes of expression.'[7]

She responded quickly to changing circumstances. For instance during the Second World War many of her lithographic sheets were destroyed, prompting her to swiftly create a new series of hand-painted patterns. From her experience at Gray's, she understood the importance of good shapes, as she had been dissatisfied with matching various blank wares bought in from different suppliers. The breakthrough to achieving her success was the agreement by Wood and Sons Ltd. to make her shapes. She considered all the practicalities of function and most importantly what forms of decoration her new shapes could take. Her first shape,

7. A group of shapes decorated with star patterns. From left to right: an earthenware cup and saucer printed with the Stardust pattern designed by Susie Cooper for W. Adams Ltd., about 1983; a side plate decorated with the hand painted Starburst pattern (E/2068) about 1946-47; a Falcon shape coffee pot, height 7½in (19cm), cover and milk jug decorated with a star print in blue with banded and gilt decoration (E/1688), about 1939.

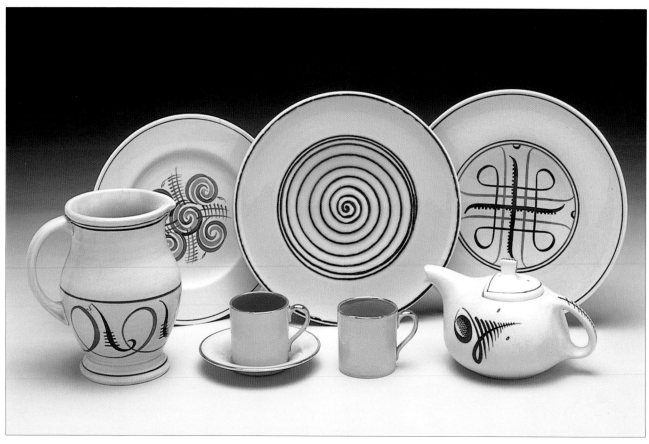

8. A group of earthenware patterns demonstrating Susie Cooper's experimentation with tube-lined decoration and coloured glazes. Back row, from left to right: plate decorated with blue scrolls under a blue glaze (E/545), plate decorated with a swirl motif tube-lined in black with a green glaze (E/678) and a plate decorated with a hand-painted pattern in underglaze black and brown with a green glaze (E/618) (this pattern was shown at the Dorland Hall exhibition in 1933). Front row: a Venice shape jug decorated in brown and black under a grey glaze (E/616), examples of coloured glazes and silver banding on coffee wares, coffee cup and saucer (E/528) and single cup (E/527). A Curlew shape tea pot decorated with an abstract motif on a matt glaze (E/653). Diameter of plates 4¾in (22.5cm).

Kestrel, was easy to clean and poured well, attributes that some manufacturers chose not to consider. This modern shape clearly reflected the influence of the international modernist movement. Whilst her contemporaries issued many shape ranges Susie Cooper saw little point in developing costly new ranges when one or two well-designed shapes were perfectly sufficient for her purposes. Moreover, she continued to use the flatware supplied by Woods. The trade press, in part, attributed her success to the fact that she was a woman and therefore understood what women wanted in the home and used comments such as, 'Miss Cooper designs for the ladies from a ladies standpoint, for she designs first and foremost to please herself.'[8] However, Susie Cooper was adamant that her approach to good design was through ideology and not biology.[9]

Susie Cooper had complete control of the many important aspects of ceramic production. As the business developed she recruited more freehand decorators direct from the local schools of art. In order to train them but still pay them a wage she devised the simple Polka Dot pattern. She said, 'that pattern was useful to us,

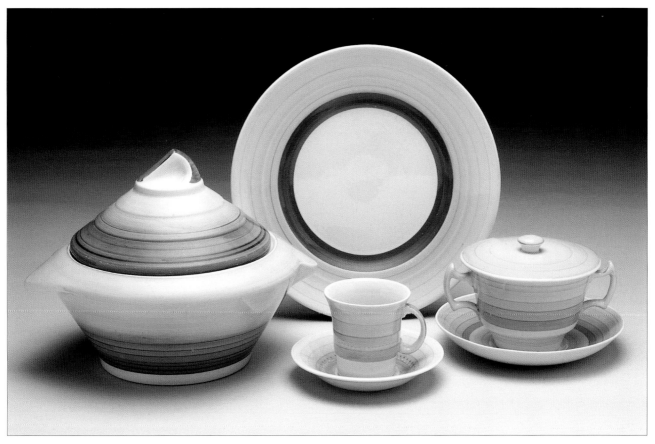

9. A collection of earthenware shapes decorated with variations of the Wedding Ring pattern. Soup bowl, cover and stand decorated with (E/625) from 1933, coffee cup and saucer (E/481), Curlew shape tureen and cover, height 6⅞in (17.5cm), and a dinner plate decorated with pattern (E/698).

because we trained the paintresses on it. It taught them to grind and handle colour, and, instead of having to wipe everything off and start again, once they reached a level of proficiency the items could be fired.'[10] The Polka Dot pattern, in three variations – tangerine (E/896), green (E/897) and blue (E/898), was exclusively supplied to the John Lewis Partnership. This utilitarian range proved popular for many years.[11] The spot motif evolved over the years, modified through various colour changes and treatments. During the fifties this pattern reappeared as a raised spot for the Quail shape, whilst still retaining the same aesthetic values and importantly, the benefits for training the paintresses.

Susie Cooper said on many occasions that the limitations of her workforce prompted her to design patterns that they were able to undertake. The limitations that some of her decorators had were not a hindrance to the development of her patterns – far from it, they actually gave her the challenge to create designs that were achievable for her team. There was no point in designing over-elaborate patterns that could not be executed on a commercial basis. To introduce or revitalise patterns she occasionally combined her more popular hand-painted motifs to create whole new pattern ranges with spots applied on top of banded ware, dashes forming border patterns in bright greens and blues and spots and scrolls running around the plates, handles and knobs. With a few extra applications of paint a spot could become a starburst or a stylised bud. Some of the best sellers

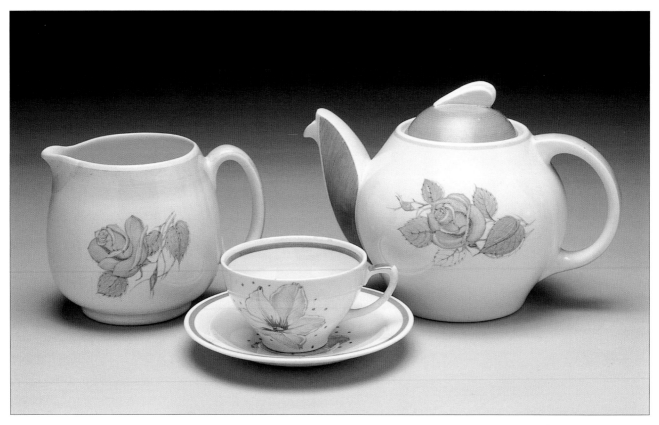

10. An earthenware Kestrel shape tea pot, height 4¾in (12cm), decorated with the transfer-printed Patricia Rose pattern (E/1894), a Paris jug (probably a Wood and Sons Ltd. shape) with shaded band in pink (possibly E/1903), and a cup and saucer decorated with one of a new series of printed floral patterns, about 1952-53.

11. A contemporary photograph illustrating a Jay shape earthenware tureen and cover, cup and saucer and dinner plate decorated with the Charnwood pattern. Designed by Susie Cooper for Wood and Sons Ltd., 1935.

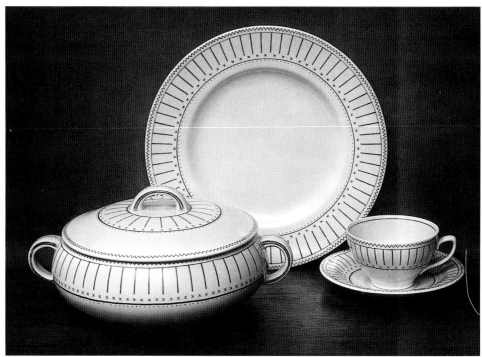

12. (Opposite) Examples of sgraffito patterns decorated on earthenware Spiral shapes. The two pattern ranges, Seaweed (E/2008) and three floral patterns, are aerographed in green with sgraffito decoration with painted in-glaze decoration. Designed in about 1942 and first produced in 1946. Diameter 3½in (9cm).

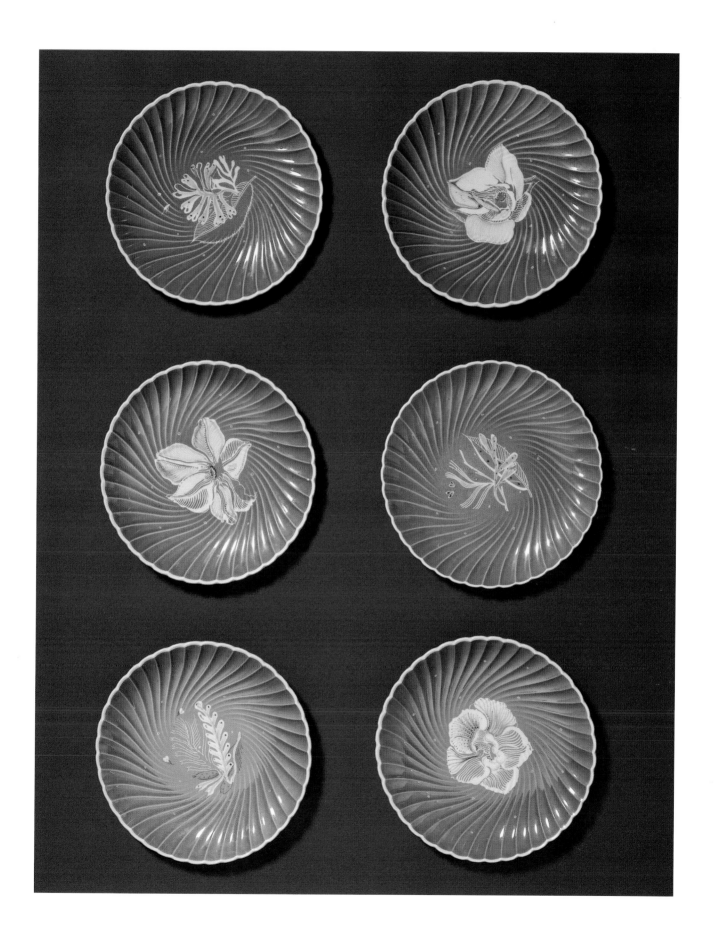

13. An earthenware Falcon shape tureen and cover and dinner plate decorated with a hand-painted stylised border pattern in green and brown (E/1827) from about 1939.

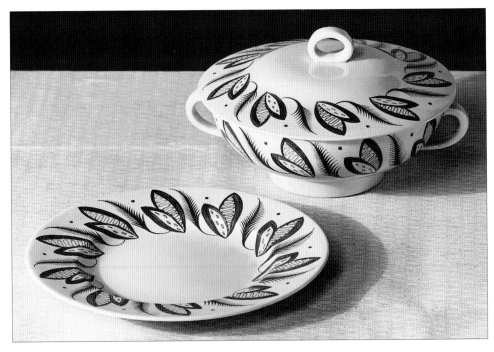

14. A view of the Susie Cooper trade stand at the British Industries Fair in 1938. Note the range of sets in patterns such as Cowboy (right) and sgraffito wares and vases (left).

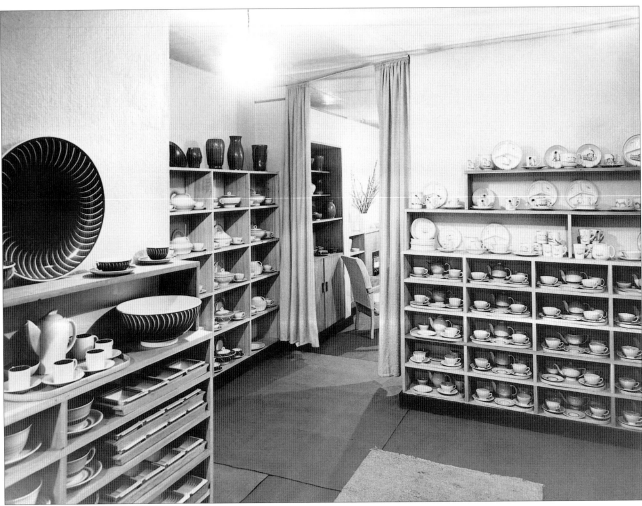

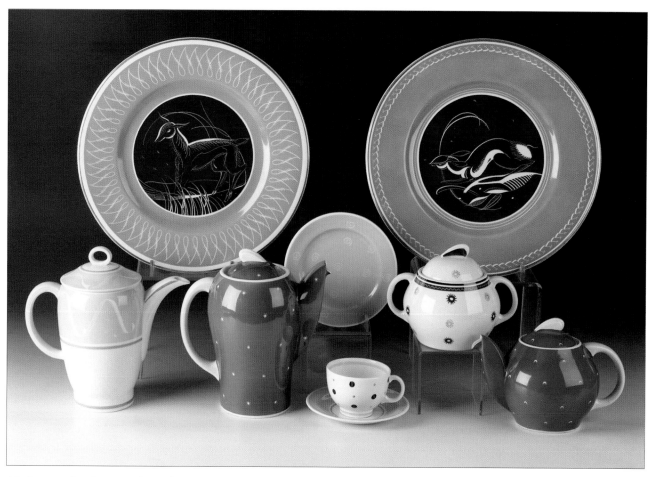

15. A range of earthenware shapes demonstrating the techniques of aerography and sgraffito decoration. The two service plates, diameter 11in (28cm), dating from about 1938, are less well known. Bottom from left to right: a Falcon shape coffee pot decorated with the 'Ribbon' pattern (E/1406) from about 1936-37, a Kestrel coffee pot decorated with a sgraffito pattern, 'Stars', about 1937-38, a side plate decorated with Scrolls (E/900) from 1934, a Falcon shape cup and saucer with rubber-stamped decoration of black spots with sgraffito decoration, probably late fifties, a Kestrel shape covered sugar decorated in the Starburst pattern (E/2069) from about 1947-48, and a Kestrel tea pot decorated with the sgraffito 'Crescents' pattern (E/1241) about 1936.

were modified and made into transfer prints for earthenware and later, bone china. Susie Cooper revived some of these early patterns, such as the star motif, in the early eighties for W. Adams Ltd. (plate 7).

Susie Cooper's approach to the design process was practical. It had to be for her to survive in such a competitive market. Not only did she work directly on to the pottery rather than on paper, but she kept ahead of her competitors by continued experimentation with materials such as coloured glazes. The results were often shown at important exhibitions, including the British Industrial Art in Relation to the Home exhibition at Dorland Hall, London in 1933 (plate 8). She was able to make something from nothing and demonstrated this time and time again during her career, whether it was by putting together trials for an overseas buyer or managing to put orders out, by creating hand-painted patterns, after a fire destroyed the valuable stock of lithographic sheets. She always made use of what was to hand at the factory, whether it was the skills of a particular decorator or a decorative

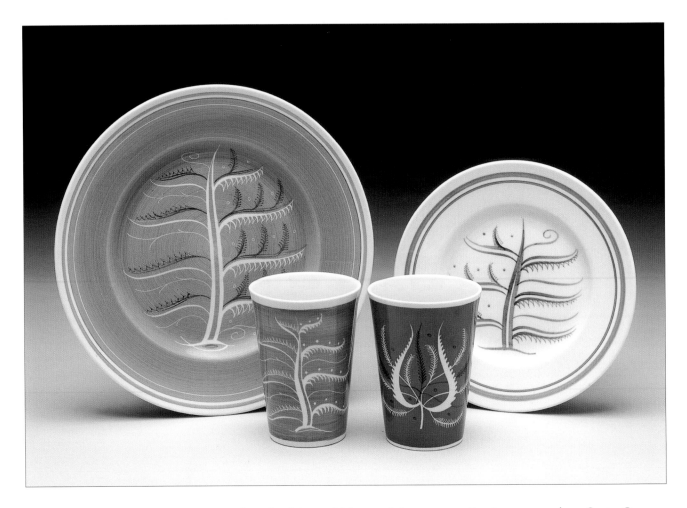

16. A collection of late forties patterns. Two examples of the Tree of Life pattern: a dinner plate decorated with solid banding in green with sgraffito and painted decoration and an earthenware beaker, height 4in (10.5cm), banded in brown with sgraffito decoration, both from about 1947-48. The Blue Fern side plate is a later hand-painted version of the Tree of Life pattern (E/2317), about 1956. The other beaker is decorated with a less common pattern, banded in purple with sgraffito decoration (pattern number unknown but a colour variation of E/2066), from about 1946.

process that she felt could be used for pottery. For instance, when Susie Cooper moved to the Crown Works, a number of the Bursley staff were skilled tube-liners, so seeing the potential of this, she designed some tube-lined patterns for tea wares, vases and a range of fancies.

Her practical approach, coupled with an intuitive ability to understand the market, created a strong combination that kept her at the forefront of the industry. Typically, she was one of the first to reject strident art deco colours and move towards a softer palette. She introduced the wash-banding technique that consisted of soft fawns, blues, greens and greys for a wide variety of tablewares. This range became so popular with newly-married couples that it was soon known as Wedding Ring (plate 9). The various subtle changes in colour allowed for many variations. A number of leading stores such as Peter Jones and John Lewis had exclusive patterns as 'open stock'.[12] The notion of the Susie Cooper style is evident here as the North American market tried to copy this range but could not achieve the same high quality.[13] She commented many years later that they did not have the right shapes to decorate on, thus emphasising the importance of both the pattern and shape working in unison.[14]

Keen to maintain her reputation as a creative potter, Susie Cooper later utilised the shaded banded technique to complement the introduction of transfer-printed centre motifs. This was not only an artistic decision but was also economical. She was very committed to keeping all her workforce in employment and did not wish to turn her entire production over to mass production. Therefore the mixture of

print and hand finishing gave an artistic balance. These printed patterns were introduced by necessity as worldwide demand for her products had grown considerably. Unlike other manufacturers, she carefully produced her own artwork and separations and took them to manufacturers that were sympathetic to her demands for high quality reproductions. These sheets were expensive and large runs had to be ordered to make them economical (plate 1). They set a new standard within the industry and propelled Susie Cooper into a whole new market.

Some of her more popular post-war printed floral patterns such as Magnolia (E/2284), Azalea (E/2278) and Gardenia (E/2282) evolved from early sgraffito designs first shown in the late 1940s. These patterns were used for bone china production at the same time. Again, the clear difference in her use of transfer-printed sheets was that she designed the motifs to fit the different sizes of wares, rather than simply placing them anywhere, which was often the practice with other manufacturers. The trade press recognised this and commented that, 'it is not merely a case of sticking a decoration on to a pot regardless of context'.[15] To add a final touch, Susie Cooper creatively placed smaller motifs, such as single buds or feathers, on the other side or inside the cup. Customers liked this attention to detail – very much part of the Susie Cooper style.

The close association with Wood and Sons prompted them to ask Susie Cooper to design for them (plate 11). As well as designing a range of stylised patterns for them and modifying a range of their shapes, she created Dresden Spray, a printed centre and floral border pattern for square plates. Unfortunately, Harry Wood felt

17. An uncommon large earthenware plaque, diameter 30½in (77.5cm), decorated with a stylised oak leaf motif, aerographed in green and mahogany with painted and sgraffito decoration, about 1948.

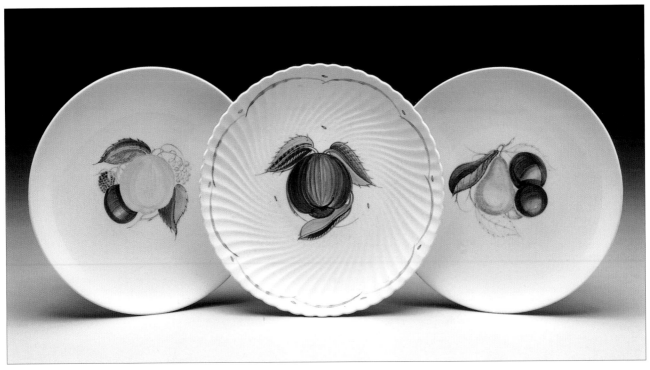

18. Three earthenware dessert plates decorated with fruit motifs. Centre, an uncommon hand-painted pattern on the Spiral shape, diameter 8⅞in (22.5cm). The two other plates, Pear and Plums and Yellow Plum, have a printed outline and are finished with hand-painted decoration. All from about 1938-40.

that the distinctive Susie Cooper style was too modern for them and as they were concerned that it wouldn't sell they rejected it. With her strong convictions and confidence she decided to do the pattern for herself.[16] It was a best seller for over twenty-five years. In retrospect it was stylistically different from similar patterns such as April, Cactus and Patricia Rose.

Despite the success with transfer-printed patterns, most manufacturers could not bear the long development period required for the production of this type of pattern from the initial order, based on samples, from the buyer and the point at which the order was delivered. Some manufacturers were also reluctant to take a risk by putting new stock out before market testing. Susie Cooper had to devise a way of overcoming this. One of her managers recalled 'this was achieved by not only instant design but instant production. It doesn't take long to get a delivery of a few pounds of colour for banding or aerography.'[17] Her experiments with various materials such as crayons were clearly her development of the instant design approach. These simple crayon bands, often combined with painted decoration, proved popular and allowed for both simple and more complex patterns, often on matt glazes. The trade press said, 'Form, decoration and even texture in the Susie Cooper ware are part of the considered scheme.'[18]

Susie Cooper also saw the potential relevance of aerographing and modified this to decorate her pottery during the mid-thirties. The range of colours included lemon yellow, mahogany brown, blue, may green, turquoise blue and salmon pink. She then combined aerography with sgraffito decoration. The first patterns tended to be on the same lines as Polka Dot but included simple scrolls, swirls, crescents and diamonds, each available in six colourways. Similar motifs were successfully exploited during the

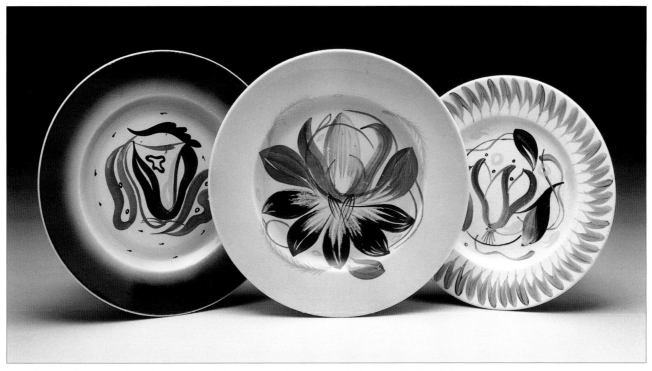

19. Three earthenware plates decorated with hand-painted patterns including a stylised leaf, from about 1949, a floral design under a grey-green glaze, about 1948-49 and the Tulip in Pompadour pattern (E/2180), from about 1949-50. Diameter of centre plate 9in (23cm).

mid-fifties on an outstanding range of giftwares in presentation boxes. As her decorators became more skilled they were able to undertake complex patterns of stylised feathers and fruits, shown at the British Industries Fair in 1938 (plate 14). These were complemented by a series of elaborate classically styled border patterns. Laurel borders were also used later on bone china, shown at one of the many British Industries Fairs.

During the late forties sgraffito decoration was combined with solid banding for a series of patterns, such as Tree of Life and Chinese Fern, with some additional hand-painted decoration[19] (plate 16). A rarely seen pattern of an oak leaf employed a wide range of decorative techniques (plate 17). During the late thirties Susie Cooper used fruit motifs such as grapes, vines and berries on a selection of dessert plates (plate 18), produced with four motifs to a set, and occasionally after-dinner cups and saucers, mainly for the North American market. More abstract designs in this period were also produced, but are uncommon today (plate 19). During the fifties fruit themes were successfully adapted for the popular Black Fruit pattern decorated on the Can shape, featuring multi-coloured interiors in the cups. To give a new twist to the theme she used scraperboards to give the linear design a rougher texture.

Another important influence on the Susie Cooper style was the export market. In particular, the North American agent suggested a number of speciality lines that Americans required for their tables and offices. These included water pitchers, after-dinner cups and saucers (usually aerographed with sgraffito decoration) and moustache cups. Occasionally there were some compromises to the Susie Cooper style. In response to the tastes of this important market she introduced the Spiral shape in earthenware, during the late thirties, and the Fluted shape in bone china

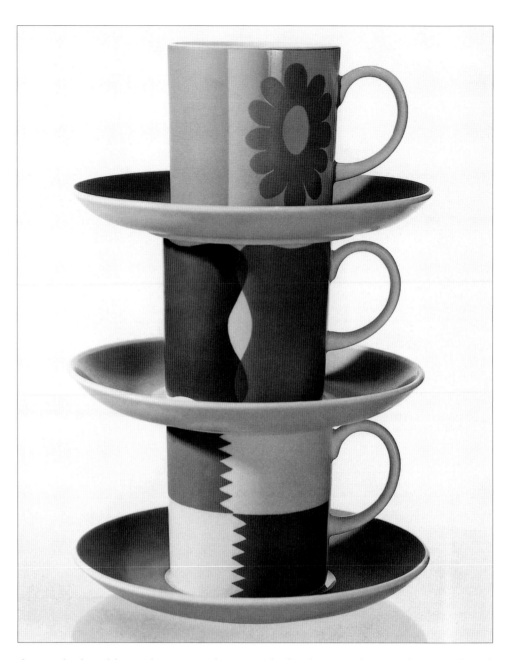

20. A publicity photograph of three bone china cups and saucers decorated with the Carnaby Daisy, Harlequinade and Heraldry patterns, about 1968.

during the late fifties. She was not happy with this form, as the fluted area gathered dirt and the shapes limited the kind of decoration that could be applied to them. Problems with applying transfer-printed patterns also proved frustrating for the designer.[20]

After the Second World War, Susie Cooper developed her bone china production and designed the Quail shape. This organic form was decorated with stylish yet simplistic patterns such as Wild Strawberry (C.486), Whispering Grass (C.608) and Teazle (C.871-872), designed to emphasise both the shape and quality of the body. There was a brief revival of hand-painted patterns on earthenware, such as Ferndown (E/2374), Blue Dahlia (E/2378) and Gooseberry (E/2391), but with the increasing demand from her international market hand painting became uneconomical. In many respects the advent of the higher quality cover coat printing process dictated the type of patterns that she could develop and which worked on certain shapes such as Can.[21]

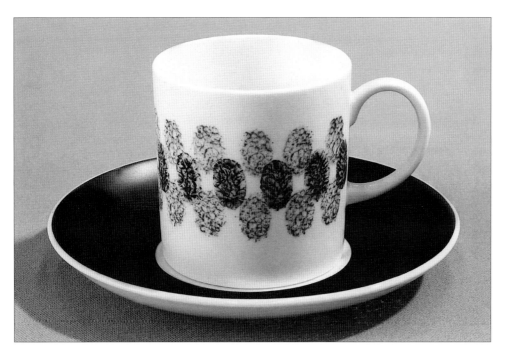

Following the takeover by Josiah Wedgwood and Sons Ltd. in 1966, the Susie Cooper style underwent a transformation. Having attempted to adopt the traditional Wedgwood style with patterns such as Perugia, without much success, the designer took the unprecedented step of visiting Carnaby Street in the heart of London. The Swinging Sixties and Pop Art inspired her to create a new style of decoration in tune with contemporary fashions. The resultant patterns included Carnaby Daisy (C.2114), Diablo (C.2150) and Gay Stripes (C.2142) (plate 20). She also experimented with sponged decoration (plate 21). The successes and frustrations of working under the Wedgwood management are discussed further in Chapter 8. After a period of working with W. Adams Ltd., in Tunstall, she retired to explore other avenues of creativity.

21. An uncommon pattern featuring sponged decoration. Designed by Susie Cooper for Josiah Wedgwood and Sons Ltd., about 1968-69.

FOOTNOTES

1. Reilly, V., Delicate Hand at the Potter's Wheel (Women at Work), *Staffordshire Telegraph*, 7 July 1968.
2. Buyers' Notes, *The Pottery Gazette and Glass Trade Review*, 1 October 1932, p.1251.
3. Susie Cooper, *Designer*, March 1979.
4. Information from Tim Barker, August 2001.
5. Buyers' Notes, *The Pottery Gazette and Glass Trade Review*, 1 October 1932, p.1249-51.
6. A Susie Cooper advertisement for the Contrast range. Private collection.
7. The Susie Cooper Pottery, *The Pottery Gazette and Glass Trade Review*, 1 June 1931, p.817.
8. Buyers' Notes, *The Pottery Gazette and Glass Trade Review*, 1 October 1932, p.1251.
9. Andrew Casey in conversation with Susie Cooper, June 1990.
10. Scott, M., Susie Cooper, *The Gazette*, 6 March 1993, pp.120-23.
11. Ibid.
12. For further information see: Eatwell, A., *Susie Cooper Productions*, Victoria & Albert Museum, 1987, p.104.
13. Susan's Red, *The Pottery Gazette and Glass Trade Review*, 1 March 1934, p.341.
14. Andrew Casey in conversation with Susie Cooper, June 1990.
15. Susie Cooper Pottery, *The Pottery Gazette and Glass Trade Review*, 1 August 1935, p.973.
16. Susie Cooper, *Designer*, March 1979.
17. Information from Ron Hughes, 1991.
18. Susie Cooper Pottery, *The Pottery Gazette and Glass Trade Review*, 1 August 1935, p.973.
19. Both these patterns were later revised during the fifties and renamed Blue Fern and Highland Grass respectively.
20. Andrew Casey in conversation with Susie Cooper, June 1990.
21. For further information on the cover coat printing process see: Eatwell, A., *Susie Cooper Productions*, Victoria & Albert Museum, 1987, pp.96-97.

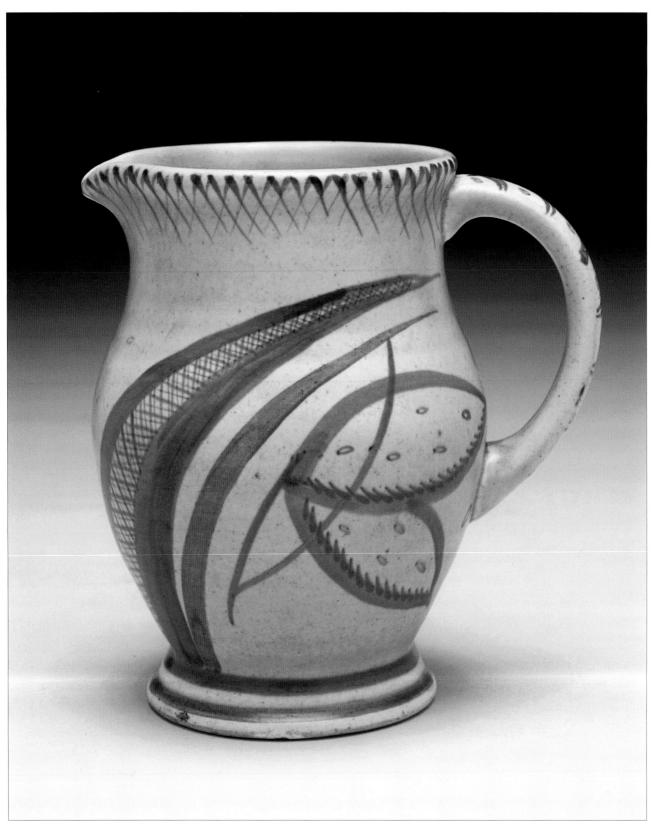

1. An earthenware Venice jug, height 6in (15.2cm), decorated with the hand-painted pattern (M81), in blues and browns with a blue glaze, 1932.

CHAPTER 6

SUSIE COOPER ART WARES

Julie Taylor

In the early 1930s, Susie Cooper began to produce a range of wares which celebrated the techniques of hand throwing and hand decorating. Often today described by design historians as 'studio wares', these took a variety of forms. This chapter sets out to categorise these different types, and examine the processes involved with their production.

Whilst hand painting held connotations of craftsmanship, it was nevertheless a regular feature of industrial ceramic production, particularly in smaller firms.[1] In the 1920s Susie Cooper had designed numerous patterns for hand painting at Gray's Pottery, as well as for her own pottery. In contrast, hand throwing was at the time a technique largely restricted to studio potters. Susie Cooper had of course already demonstrated her desire for personal control over the design of both shape and pattern, and this had been a major factor in the establishment of her own pottery. Her move into hand-thrown wares is a further extension of this interest in designing shapes, allowing her to explore a large range of designs without incurring the costs involved with industrial production.

The earlier art wares consisted of two main types; those with hand-painted decoration under a matt glaze and others with pictorial decoration carved into the

2. A display of Susie Cooper art wares showing a range of matt glazed and incised items. The printed numbers refer to the shapes. This display was probably mounted in her London showroom, 1933.

The handwritten notes in the image read:

325.

Incised. Ground Outside.
Jade 64/3. Harrisons.
Inside 6452.

FRONT OF KESTREL JUG.

326.

BACK OF KESTREL JUG.

INCISED. GLAZE '1240 CREAM'

3. The description book entry illustrating the drawing for the incised Townscape pattern (E/326) from 1932.

body of the pot, termed incised wares.[2] The incised patterns were given pattern numbers within the usual E prefixed number sequence used by the firm. The earliest known design, 'Acorn' (E/324), is from 1932. This was followed by 'Rams' (E/325) (plate 2, second right, top shelf) and Townscape (E/326) a stylised landscape (plate 3). The next known pattern is 'Squirrel' (E/345) (plate 5). At first, these hand-thrown pieces were also hand decorated using the technique of incising or cutting the pattern into the clay (plate 4). Interestingly though, it seems that the wares were later slip cast using moulds and that the decoration was partly moulded, then sharpened by hand (plate 7)[3]. Throwing-rings on the inside of the pot are sometimes a method of identifying a hand-thrown piece. Similarly, mould lines are a way of identifying moulded pieces. The incised wares, which take the form of large vases, bowls and jugs, usually have a plain matt glaze of green, blue, salmon pink, brown or cream. Compared to some of Susie Cooper's earlier work, these pieces are relatively plain, yet the carved decoration adds an elegant three-dimensional quality.

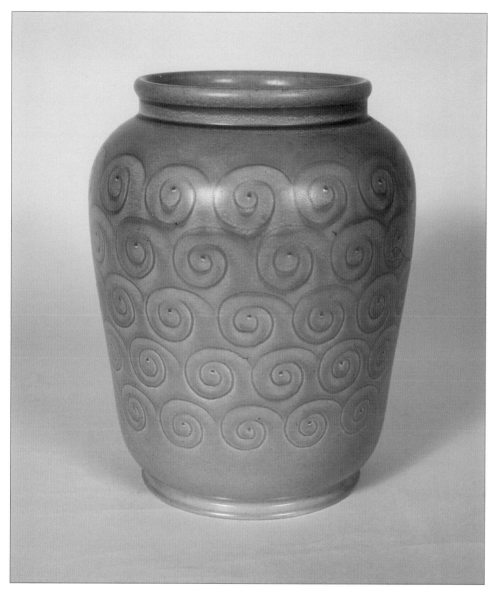

4. A hand-thrown vase, height 8⅞in (22.5cm), with incised decoration of circular motifs finished with a green glaze (Ref. 563), from about 1937-38.

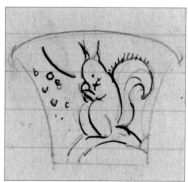

5. An illustration of the 'Squirrel' vase, entered into the company description book, 1932. A vase decorated with this pattern is illustrated in Chapter 16 (plate 3).

The hand-painted matt-glazed wares were produced in an extensive variety of patterns in conjunction with a wide range of shapes (plate 8). A promotional photograph from 1933 illustrates the range of hand-thrown shapes, and shows their factory shape numbers (plate 2), ranging between 116 and 161, though the sequence is incomplete.[4] These rarely seem to have been marked on the objects themselves, though examples are known which are marked with their shape number prefixed by the letter S.[5] The shapes are mainly jugs, vases and bowls, produced in a variety of sizes. The various painted patterns used in conjunction with the wares were numbered in a sequence prefixed with the letter M (presumably in reference to the matt glaze). The first of these, as recorded in the Susie Cooper pattern book, was M60 and the series continues to M184.[6] These pattern numbers are usually found painted on the base of the wares. The decoration of the wares is generally naturalistic, consisting of flowers and plant forms in subtle variations of browns, yellows, blues and greens (plate 1). Other painted patterns and glazes were occasionally used on hand-thrown wares, sometimes incorporating lustre (plate 9).

6. An earthenware vase, height 12in (30.7cm), with hand-thrown carved decoration and a matt salmon-pink glaze, about 1936.

The studio wares were displayed on Susie Cooper's stand at the British Industries Fair in January 1932. Incised wares such as the 'Rams' jug and a 'Squirrel' bowl were displayed along with hand-painted wares.[7] An article from the same year comments on the pieces being retailed at the time: 'For the current season, a particularly attractive series of thrown and turned vases, bowls, and candlesticks has been prepared, these being all hand made and decorated. Their colours and form have been evolved to pick up the tones and textures of the tiled fireplaces that form the focus of very many domestic decorative schemes of to-day. Another new

introduction is hand carved (sgraffito) decoration, of a kind that is proving extremely popular.'[8]

Susie Cooper is known to have designed many of these trade fair and exhibition display stands herself, ensuring that the items were shown in the intended context. That context was the contemporary interior (plate 10). The relationship of her pieces to the furniture and furnishings in these trade displays is significant as although the interiors are domestic, they are in the style of international modernism, showing her awareness of the principles of modernist design, uniting form and function. She combined good design and craftsmanship with the industrial process and marketed it as a highly successful product (plate 12). The studio wares helped to set another high standard for her long career in the industry and contributed to her esteem in the world of industrial design.

Following on from the earlier incised and hand-painted wares, the range was expanded to include more hand-thrown pieces with abstract decoration. The shapes of the later studio wares were given a number with a prefix 'Ref'. This sequence may be a continuation of the earlier shape series (see above) and probably started in the mid-1930s. The number sequence seems to start at 234 and the last seems to be 575 (dated 1938).[9] These Ref numbers are frequently found hand-

7. A large, moulded earthenware planter, height 9⅝in (24.5cm), with incised scroll design and finished with a matt green glaze, about mid-1930s.

8. A collection of hand-painted earthenware matt-glazed wares, from left to right: a round jug (shape S.177) decorated with the Orchids pattern (M72) and dated 1933; a small jug (shape S.142) decorated with stylised leaves in various colours (M67) and dated 1932; . The foreground vase is decorated with (M67) and dated 1933 (this pattern number may be wrong as the small jug has the same number). Both the three-handled vase, dated 1933, and tall jug, dated 1932, are decorated with the (M69) pattern. Height of tallest item 11in (28.2 cm).

incised on the base of the wares (plate 11), which generally take the form of large vases and bowls with a range of glaze colours, mainly blues, greens, cream and pink. These wares were hand-thrown, then decorated in a variety of ways, including lathe-turning, incising and occasionally with hand-applied decoration such as prunts and tube-lining. Such techniques, carried out in the same material as the pots, conform to modernist theories about decoration. Indeed, some of these later studio wares are similar to the work designed by Keith Murray for Wedgwood in the 1930s, sharing Murray's sense of architectural form, and exploiting an equivalent range of decorative techniques in association with similarly hand-thrown ware. Although these were not continued after the Second World War, Susie Cooper produced ornamented moulded vases in her new bone china body from the mid-

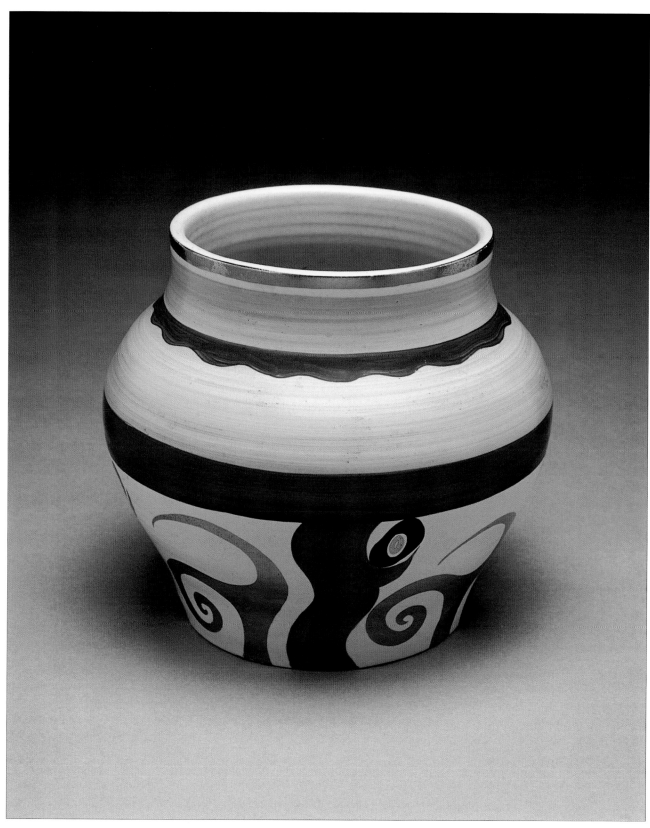

9. A hand-thrown vase, height 5⅞in (15cm), decorated with a stylised pattern, painted in
mahogany, black and silver lustre (E/548), dated on the base 1933.

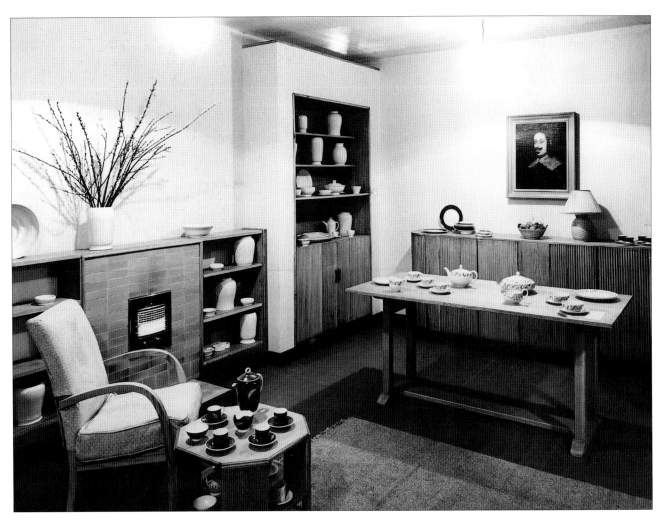

10. A photograph of the Susie Cooper trade stand at the British Industries Fair in 1938. Note the wide range of art wares, such as vases and bowls, displayed.

11. An example of the incised Ref mark.

fifties. Examples can be seen in Chapter 7.

In 1978 a number of the incised ware designs were reissued. The Squirrel bowl and some cylindrical vases are known to have been produced at this time and can be identified by '1978' incised on the base of the pot.[10] (See Chapter 10, plate 19).

These extraordinary art or studio wares are a significant group, as they demonstrate the wide range of shapes and decorative techniques employed by Susie Cooper throughout her career. They also show the success of hand throwing and hand painting in an industrial context.

GIFTS ·

SMARTNESS IS THE
KEYNOTE OF ALL
FESTIVITIES · BE
THEY THE INTIMATE
AFFAIRS OF A FAMILY
OR THE MORE FORMAL
OCCASIONS OF SOCIAL
INTERCOURSE · · ·
RIVALRY IS AN INCENTIVE
TO ENTERPRISE AND
THE EXPRESSION OF
INDIVIDUALITY CAN
RARELY BE INDULGED
EXCEPT THROUGH
SELECTION · · ·

· SUSIE COOPER POTTERY ·

CROWN WORKS
BURSLEM · · ·
STAFFORDSHIRE

12. An example of one of Susie Cooper's more stylish advertisements, placed in *The Sphere*
newspaper in October 1932. Note the moulded jug, beakers and dessert plates. The earthenware
lamp base is decorated with a hand-painted pattern of Tigers (E/340) in black, mixed grey, green
and orange.

FOOTNOTES

1. Pevsner, N., 'Pottery: Design, Manufacture, Marketing', *Trend in Design*, Spring 1936, p.16.
2. Throughout her career, Susie Cooper also produced hand-painted plaques and vases which, though art wares,
were not made in a series and are often one-off pieces unrecorded in the pattern books. Examples are illustrated in
other chapters.
3. Youds, B., *Susie Cooper, An Elegant Affair*, Thames & Hudson, 1996, p.28.
4. Information from the Susie Cooper price book, dated 1939.
5. Eatwell, A., *Susie Cooper Productions*, Victoria and Albert Museum, 1987, p.39, fig. 78.
6. Within this number range several incised wares were listed in the pattern book.
7. *Pottery and Glass Record*, January 1932, p.29.
8. Art Pottery that Appeals, *The Industrial World*, October 1932.
9. Information from the Susie Cooper price book, dated 1939, and research undertaken by Andrew Casey.
10. These items were thrown by Elwyn James and decorated by Susie Cooper.

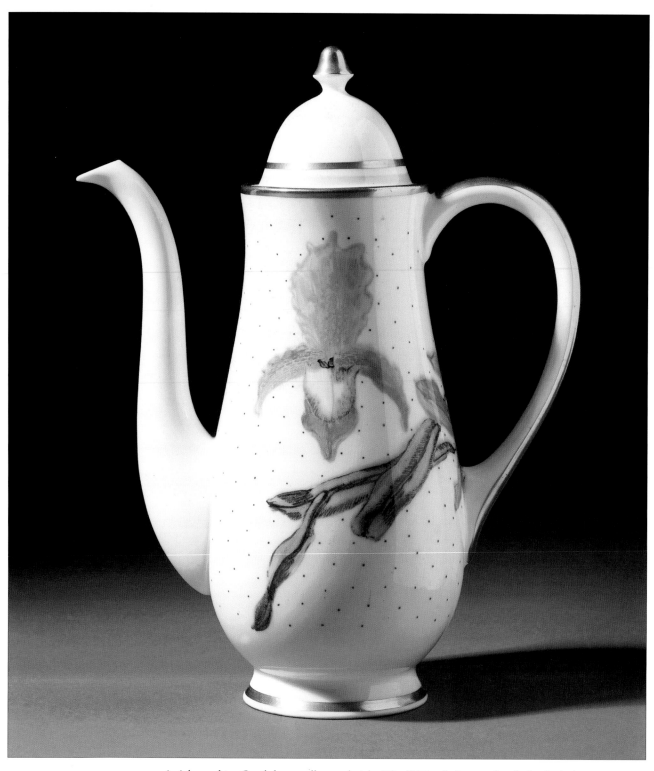

1. A bone china Quail shape coffee pot, height 9⅜in (23.7cm), decorated with the Orchid pattern (possibly C.176), in-glaze transfer-printed outline, painted in green, pink, yellow and brown with narrow band to edge and gilt decoration. This pattern was illustrated in the *Decorative Art Studio Year Book* in 1952. In-glaze was an expensive technique in which under-glaze enamel colours were painted on the glaze and then fired. The colours melted into the glaze giving an appearance of depth to the design. Susie Cooper always regretted that she had been unable to fully explore the potential of this medium.

CHAPTER 7

SUSIE COOPER BONE CHINA 1950-1966

Ann Eatwell

*China has always been associated with traditional designs.
I am trying to break new ground* [1]

In 1950, when many designers might have looked back on the substantial body of their work and prepared to coast into retirement, Susie Cooper reinvented herself. She became a manufacturer for the first time and she took on the challenge of designing for bone china.[2] Surviving documents show that £12,000 capital was raised for the new business of Susie Cooper China Ltd.[3] The company structure reflected a strong family commitment. Susie Cooper was Managing Director with C.F. Barker (her husband), K.R. Cooper (her nephew) and Jack Beeson (her brother-in-law) as company directors. A factory, Jason China Ltd. of Longton was purchased and C.F. Barker brought in the kiln builders Litholand to improve the oven capacity of the two bottle kilns. In addition, he reorganised production on the site, becoming an indispensable and full-time member of the team. Susie Cooper always attributed the creation and success of the fine bone china body to her husband.[4]

2. Susie Cooper designing the Black Fruit pattern in 1958. Black Fruit and Sunflower patterns were designed on scraper board. The lithographic print was developed straight from her original artwork which gave a sketchier, raw feel to the pattern.

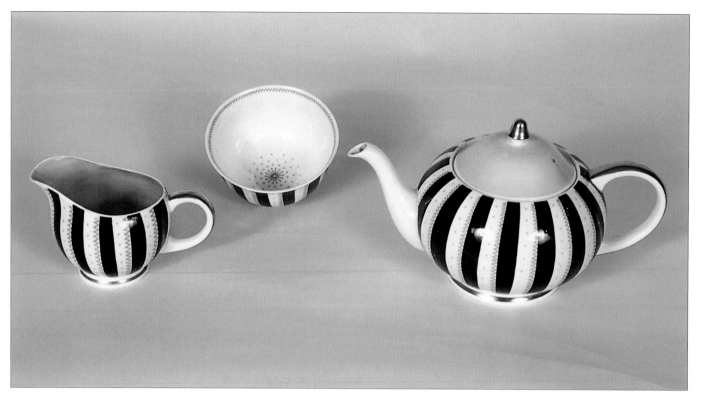

3. A bone china Quail shape tea pot, height 6in (15.4cm), sugar bowl and milk jug decorated with Regency Stripe. Printed in gold, painted in old gold and black with gilt decoration. This pattern range (C.1-5) was the first for bone china wares.

4. The new backstamp for bone china production used from about 1951 to 1966.

Apart from the excitement and risk of a new venture there were practical reasons for moving into bone china. Earthenware was difficult to get in sufficient quantity and quality after the war. Buying the Jason Works enabled Susie Cooper to have complete control over the supply of her product for the first time. She could also see that there was a gap in the market for contemporary, good value bone china. 'Susie Cooper has new ideas, too, about china design. In an industry as tradition-bound as pottery manufacture, she smilingly expects her new designs to be called "revolutionary".'[5] She later recalled 'I wanted to introduce china as a regular thing in the home, as opposed to using it only on high days and holidays.'[6]

Although in the early twentieth century hard paste porcelain was regarded as a medium for experimentation in Germany and Scandinavia, as well as in America from the 1940s through designers such as Eva Zeisel, this was not the case in England. Here, manufacturers claimed that home and export markets preferred traditional design. Susie Cooper was the first English manufacturer to challenge this conservatism in porcelain (bone china) styling.[7] Her designs were not as radical as some of the middle market earthenwares of W.R. Midwinter Ltd. and Alfred Meakin Ltd. but offered genuinely contemporary tableware for modern homes at significantly less than the cost of more traditional porcelains.[8] In *House and Garden* magazine (May 1960) a Susie Cooper Hyde Park tea service (twenty-one pieces) was advertised for £8 2s whereas a Royal Worcester Black Delecta tea set of the same size cost £12 15s 2d.

A new shape known as Quail, deliberately designed to draw attention to the fragility and elegance of bone china, was shown at the Festival of Britain in 1951.

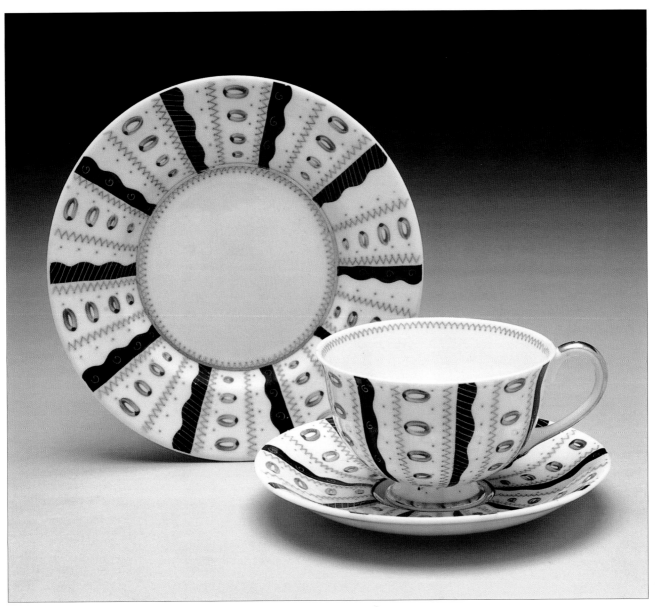

5. A bone china Quail shape cup, saucer and side plate, diameter 6½in (16.5cm), decorated with an abstract pattern. Painted in black, old gold and pink with gilt decoration. About 1951.

The shape appealed to contrasting consumer groups. The traditionalists admired the clarity and grace of the forms. The pear shape of the coffee pots and hot water jugs are reminiscent of English eighteenth century silver. New treatments of floral and leaf motifs, such as Gardenia, Azalea and Magnolia (also used on earthenware) and Crack Willow (plate 7) updated conservative designs. To a more adventurous public the shape appeared simple and unfussy. It could be decorated with the high quality minimalist patterns of Spiral Fern, Blue Star and Whispering Grass. The American market was particularly impressed by the later classic but more abstract designs such as Palladian and Romanesque (see Chapter 1, plate 14). The design press acknowledged the vigour and relevance of Susie Cooper's ideas. *Design* magazine praised the clean lines of Quail and the clear, modern colours that she used.[9]

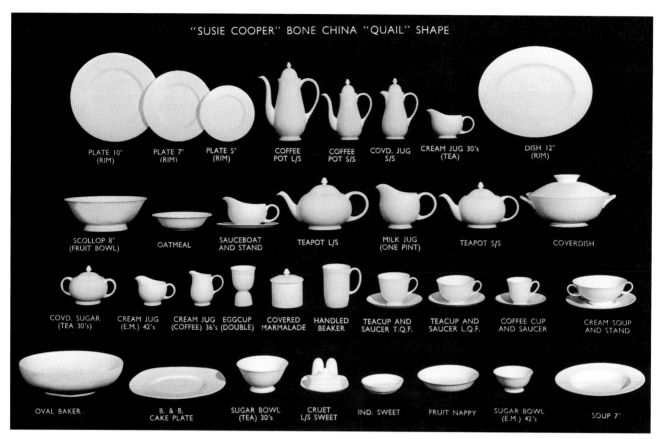

"SUSIE COOPER" BONE CHINA "QUAIL" SHAPE

| PLATE 10" (RIM) | PLATE 7" (RIM) | PLATE 5" (RIM) | COFFEE POT L/S | COFFEE POT S/S | COVD. JUG S/S | CREAM JUG 30's (TEA) | DISH 12" (RIM) |

| SCOLLOP 8" (FRUIT BOWL) | OATMEAL | SAUCEBOAT AND STAND | TEAPOT L/S | MILK JUG (ONE PINT) | TEAPOT S/S | COVERDISH |

| COVD. SUGAR (TEA 30's) | CREAM JUG (E.M.) 42's | CREAM JUG (COFFEE) 36's | EGGCUP (DOUBLE) | COVERED MARMALADE | HANDLED BEAKER | TEACUP AND SAUCER T.Q.F. | TEACUP AND SAUCER L.Q.F. | COFFEE CUP AND SAUCER | CREAM SOUP AND STAND |

| OVAL BAKER | B. & B. CAKE PLATE | SUGAR BOWL (TEA) 30's | CRUET L/S SWEET | IND. SWEET | FRUIT NAPPY | SUGAR BOWL (E.M.) 42's | SOUP 7" |

6. A Susie Cooper bone china shape sheet for Quail from about 1956, showing the range from tea ware to dinnerware and including the practical tureen which had a lid that could act as a separate serving dish if required.

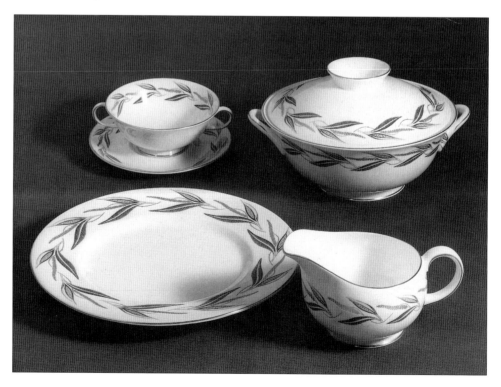

7. A contemporary publicity photograph of the Crack Willow pattern (C.975) on Quail shape bone china dinnerware, about 1959-60.

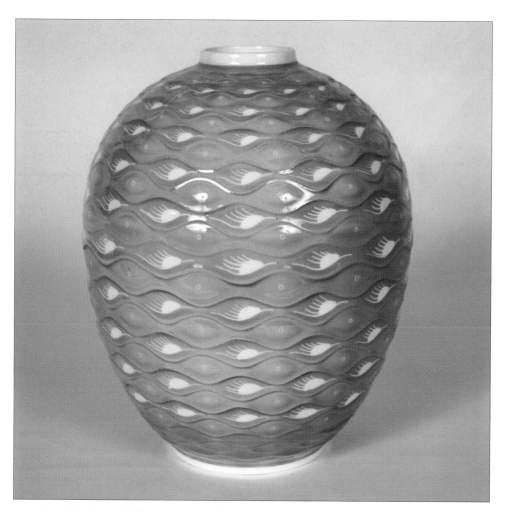

8. A bone china vase, height 7½in (19cm), moulded with aerographed decoration in salmon pink with sgraffito decoration of stylised buds. About 1956-57.

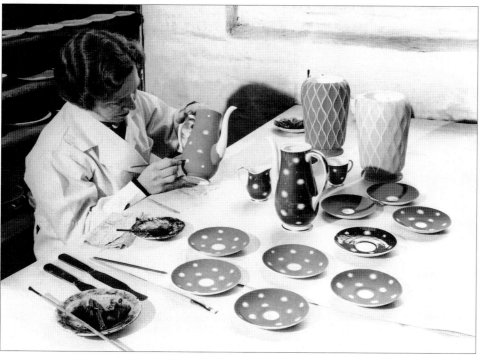

9. Nora Dobbs, a freehand paintress, applying sgraffito decoration to a Quail shape bone china coffee set, about 1956.

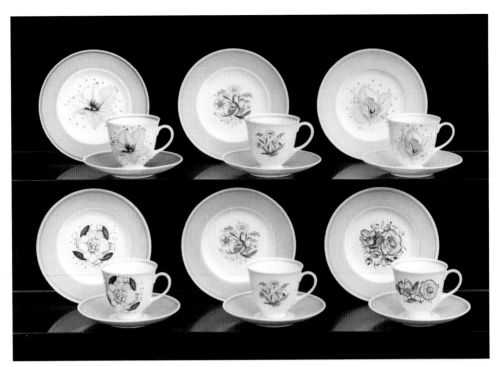

10. A selection of Quail shape bone china cups and saucers decorated with printed floral patterns such as Gardenia (bottom left), about 1958.

11. A contemporary photograph of an exhibition of Susie Cooper pottery at Harrods in 1956, showing new packaging designed by Susie Cooper, bone china vases, Lion and Unicorn designs on plates and cocktail trays, a copy of the plaque designed for the Bicentenary of the Royal Society of Arts and a figure of Queen Eleanor which was to have formed part of a new range of figures of Kings and Queens of England. Only a limited number were made and the figures never went into production. In conversation with Ann Eatwell in 1986, Susie Cooper stated that she had not modelled the figure herself.

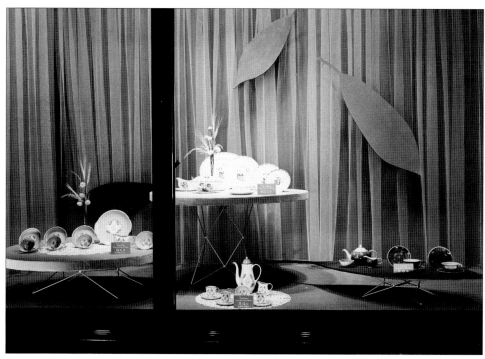

12. The Harrods window display, showing Quail shape bone china tea and dinnerware. From left to right: Gardenia, Blue Gentian on the table with Gardenia below and Scroll, from 1956.

13. An interior view of the exhibition at Harrods in 1956 showing bone china dinnerware decorated with the Parrot Tulip (C.621), Blue Gentian (C.674) and One O'clocks (C.612-615) patterns in the foreground with spot patterns in the background and crayon and painted and banded designs on earthenware to the right of the photograph.

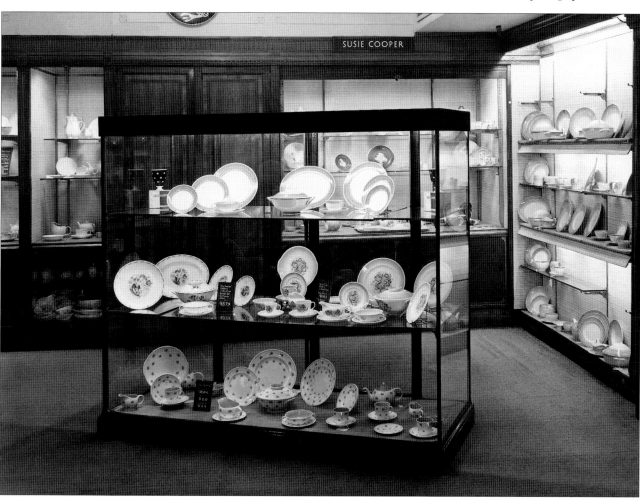

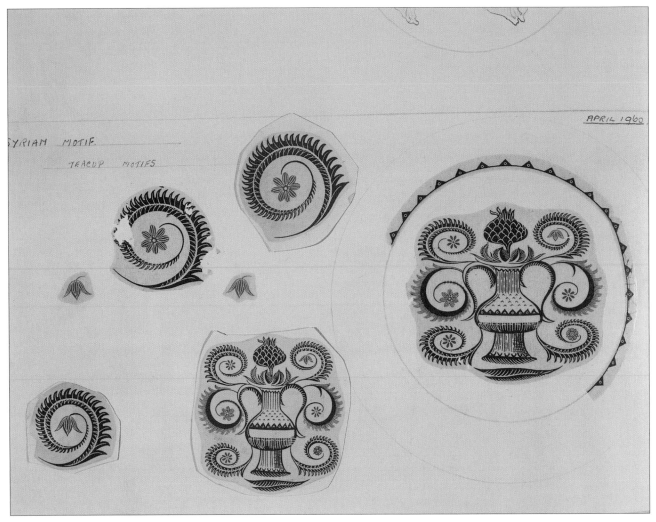

14. The Assyrian Motif pattern (C.1010), from the bone china pattern book, showing the print patterns of differing sizes for flat and hollowware shapes, about 1960.

Until the mid-fifties, the new firm made only bone china tea wares. The first bone china dinnerware design was shown at Harrods in 1956 (plates 12 and 13) but the small capacity of the Jason Works proved frustrating. Susie Cooper discovered that another factory, R.H. and S.L. Plant Ltd., had spare kiln space. She later described the subsequent decision to combine: 'when we outgrew that (Jason) we joined forces with Tuscan China. We wanted to do china dinnerware and they had a biscuit oven which wasn't in use, so it made sense to merge.'[10]

Perhaps the most important and influential shape of the period was Susie Cooper's Can shape, which was sold from 1958, anticipating the fashion for cylindrical forms such as Theo Baumann's Berlin shape for Rosenthal A.G. (1959) and David Queensberry's Fine shape for W.R. Midwinter Ltd (1962). She later described the impetus behind the design that '…grew from can-shaped coffee cups. There was great demand for the cups, so we designed the other pieces to go with them.'[11] This statement illustrates Susie Cooper's design process. Pragmatism, rather than theory, is at its heart, as well as the ability to predict trends. Her instincts were not wrong and Can became a versatile, functional form for

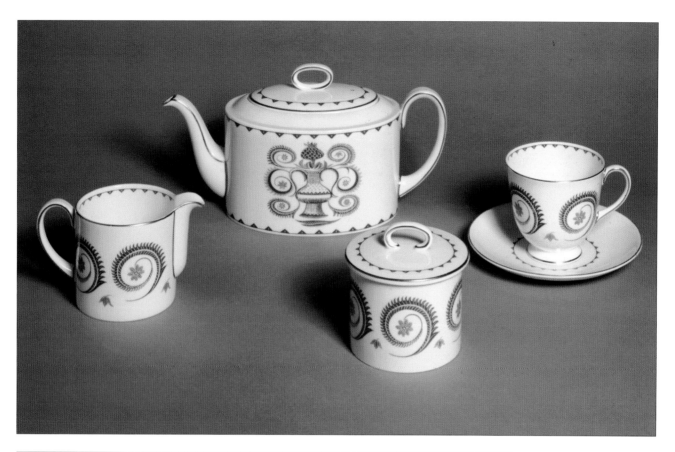

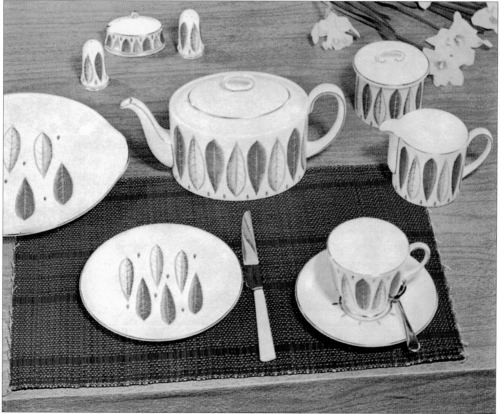

15. A Can shape tea pot, milk and covered sugar, and a Quail shape tea cup and saucer decorated with the Assyrian Motif pattern (C.1010), transfer printed with gilt decoration, from about 1960-63.

16. An illustration from a Susie Cooper Ltd. publicity brochure illustrating the Hyde Park pattern, 1960-62.

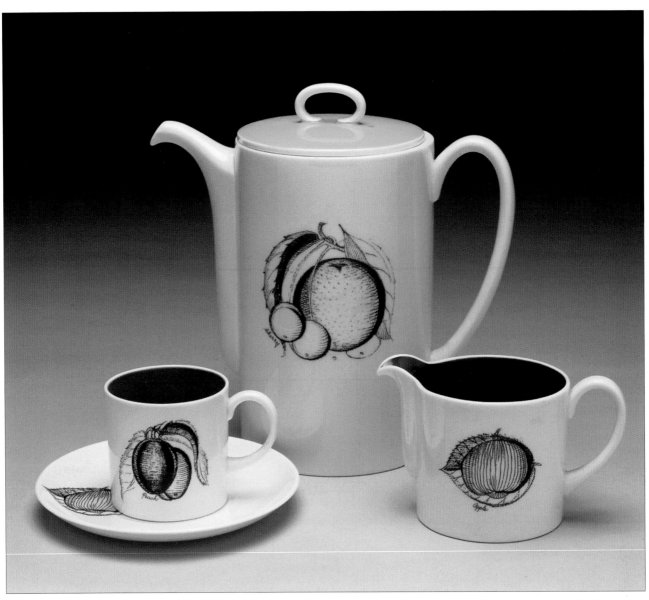

17. A Can shape coffee pot, height 8in (20.5cm), milk and sugar decorated with the Black Fruit pattern (C.893-989), from about 1958.

aerographed and printed designs. The shape stayed in production for over thirty years. It was for Can that Susie Cooper designed some of the most exciting and innovative patterns of the mid-twentieth century. Black Fruit, Assyrian Motif, Venetia and Classic Vista are English patterning at its supreme best.

Susie Cooper's international reputation for quality and classic contemporary design, in an English idiom, had a strong appeal abroad. She had supplied the American market since the 1930s and twenty years later, when America was setting the trend in modern ceramic design, it is significant that her work was widely appreciated there. An American buyer is reported to have said, 'Britain is losing the design battle. Except for Susie Cooper you haven't a designer who can keep up with modern American styles.'[12] Even with restrictions lifted on the sale of decorated ware to the home market

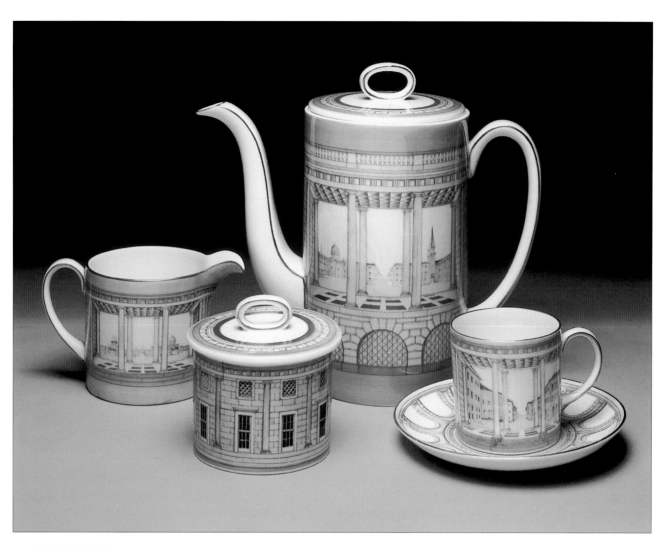

18. A selection of Can shape coffee wares decorated with the Classic Vista pattern (C.990), transfer-printed and banded in taupe and green with gilt decoration, about 1959. Height of coffee pot 8in (20.8cm).

19. Susie Cooper, Kenneth Cooper (her nephew) and Jack Robertson of Cassidy's department store of Montreal discussing a range of bone china for the Canadian market in 1962. These bought-in shapes with very traditional printed floral patterns demonstrate the compromise that a manufacturer and employer may make to keep a business in profit and the workforce employed. According to Susie Cooper, earlier Jason shapes such as Hampshire, Princess and Fluted sold well in London.

SUSIE COOPER

EARTHENWARE

RETAIL PRICES OF PRINCIPAL SETS and ITEMS

Hazelwood
Marigold
Pink Campion
Floriana
Ferndown

	£	s.	d.
Teaset, 21 piece	4	4	3
Teaset for Two	2	11	3
Coffee Set	3	8	6
Breakfast Set, 34 piece	7	7	3
Dinner Set, 26 piece	9	19	0
Dinner Set, 25 piece	8	17	0
Dinner Set, 32 piece (Scottish)	11	6	9
Fruit Set	2	0	0
Plate, 8" trade 10" actual		6	5
Plate 7" 9"		5	7
Plate, 5" 7"		3	7
Rim Soup, 7" trade 9" actual		6	0
Coupe Soup, 7" trade 7½" actual		5	4
Dish, 10" trade 12" actual		15	5
Dish, 12" 14"	1	1	11
Covered Scollop (Vegetable)	1	6	5
Sauce Boat		11	10
Sauce Boat Stand		3	3
Teacup		4	2
Teasaucer		2	2
Breakfast Cup		5	3
Breakfast Saucer		2	8
Cream Jug (Tea)		11	10
Cream Jug (Individual)		8	10
Sugar Bowl (Tea)		7	10
Sugar Bowl (Individual)		3	10
B. & B. (Cake Plate)		5	3
Teapot L/S.	1	7	4
Hot Water Jug	1	4	2
Coffee Pot L/S.	1	4	2
Coffee Cup		3	7
Coffee Saucer	1		8

20. The Susie Cooper Bone China Price List for January 1965.

21. (Opposite, top) A page from the 1960 Catalogue illustrating bone china shapes.

in 1952, her firm continued to export a large proportion of the total production. In 1955, the factory packing books show that thirty-nine per cent of the output was for export. The main markets, as before the war, were Australia, Canada, New Zealand and South Africa although Europe, particularly Norway, Sweden, Holland and Belgium, appears in the business records for the 1950s and 1960s. The phenomenal growth of output in the 1950s, reflecting the success of Susie Cooper's designs, can be seen in the same records which show that the total value of orders in July 1948 was £32,982, rising to £72,879 in 1960 for bone china alone.[13]

FOOTNOTES

1. Susie Cooper and William Adams, *Pottery Gazette and Glass Trade Review*, November 1966, p.1131.
2. She had designed decoration on a small amount of bone china at the Gray's Pottery.
3. Memorandum of Association, Private Collection.
4. The Jason Works had made unambitious tableware, mainly cups and saucers, and the first task of the new owners was to improve the body and the design of the bone china.
5. Warren, P., Susie Cooper, Artist in Pottery, *News Chronicle*, Monday 6th October 1952.
6. Marsh, M., If You Knew Susie, *The Independent on Sunday*, 8th November 1992.
7. The Festival Pattern Group used bone china tableware provided by Josiah Wedgwood and Sons Ltd. and R.H. and S.L. Plant to add printed designs based on crystal structure for the Festival of Britain in 1951. This initiative had no significant impact on the ceramic industry but may have contributed to the debate on modern patterning.
8. Unlike W.R. Midwinter Ltd., Susie Cooper did not introduce the rimless coupe plates favoured in the American market and the Quail range demonstrates that her sense of practicality balanced the influence of organic modernism.
9. *Design*, no.74, February 1955, p.11.
10. Susie Cooper O.B.E, *Designer*, March 1979.
11. Benn, E., All set for a fresh look at tableware, *The Daily Telegraph*, Tuesday August 23rd 1983.
12. Jones, M., Design for Selling, *The New Statesman and Nation*, March 27th 1954.
13. Business records, Private Collection.

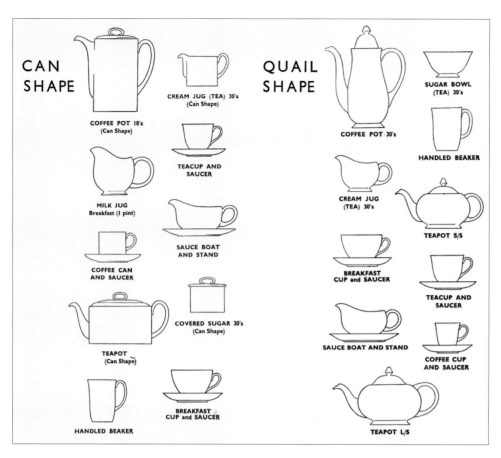

CAN SHAPE

COFFEE POT 18's
(Can Shape)

CREAM JUG (TEA) 30's
(Can Shape)

MILK JUG
Breakfast (1 pint)

TEACUP AND
SAUCER

COFFEE CAN
AND SAUCER

SAUCE BOAT
AND STAND

TEAPOT
(Can Shape)

COVERED SUGAR 30's
(Can Shape)

HANDLED BEAKER

BREAKFAST
CUP and SAUCER

QUAIL SHAPE

COFFEE POT 30's

SUGAR BOWL
(TEA) 30's

HANDLED BEAKER

CREAM JUG
(TEA) 30's

TEAPOT S/S

BREAKFAST
CUP and SAUCER

TEACUP AND
SAUCER

SAUCE BOAT AND STAND

COFFEE CUP
AND SAUCER

TEAPOT L/S

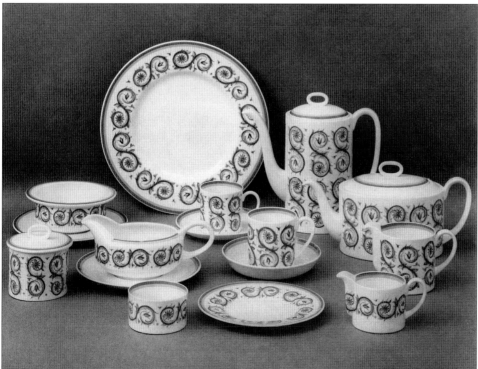

22. A publicity photograph of Can shape tablewares decorated with the Venetia pattern (C.2039), about 1965-66.

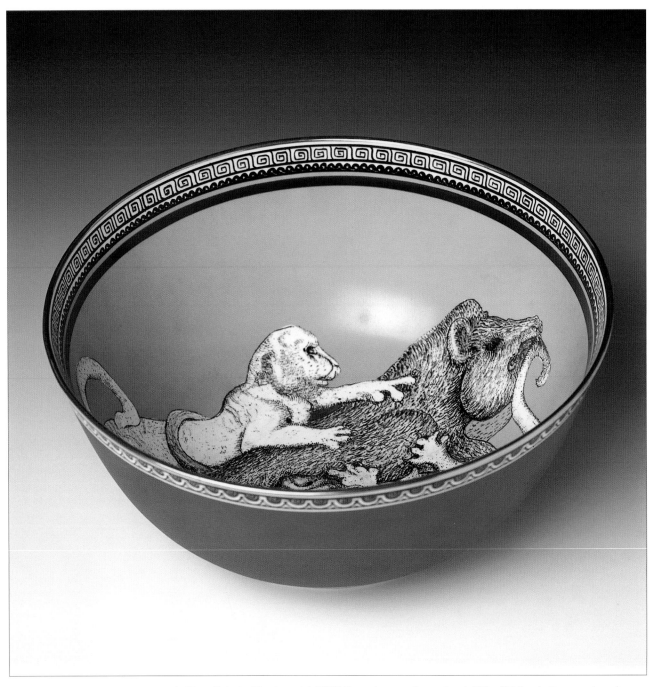

1. Tiger Cubs in Combat with Wild Boar, decorated on a bowl, 9⅝in (24.5cm) diameter, based on a bronze of the Western Han Dynasty, about 1976. Unlike the Chou Dynasty pattern, it was not listed in the pattern books.

CHAPTER 8

SUSIE COOPER:
A MEMBER OF THE WEDGWOOD GROUP
1966-1980

Sharon Gater

The year 1966 was a watershed in Susie Cooper's life and career. Eight years earlier, the Susie Cooper Company had merged with R.H. and S.L. Plant. Now both companies were acquired by the Wedgwood Group, which sought the well-established hotel ware business of the latter, together with the fine quality of Susie Cooper's tableware.

The entire North Staffordshire pottery industry was undergoing a radical transformation whereby progress was seen to lie in expansion achieved through the merging of multiple companies. Susie Cooper, approaching her mid-sixties, might well have been expected to use this development as a neat juncture at which to retire. However, it is doubtful that she gave much consideration at all to such a possibility. She was convinced that hard work and the stimulation of the creative

2. Susie Cooper surveying a variety of bone china coffee pots in the Can shape, adopted by Wedgwood, 1969.

3. Sir Arthur Bryan.

4. The purpose-built design studio on the Barlaston factory site, overlooking surrounding parkland.

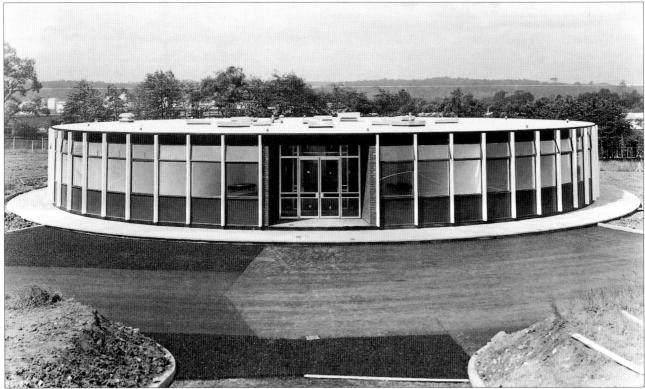

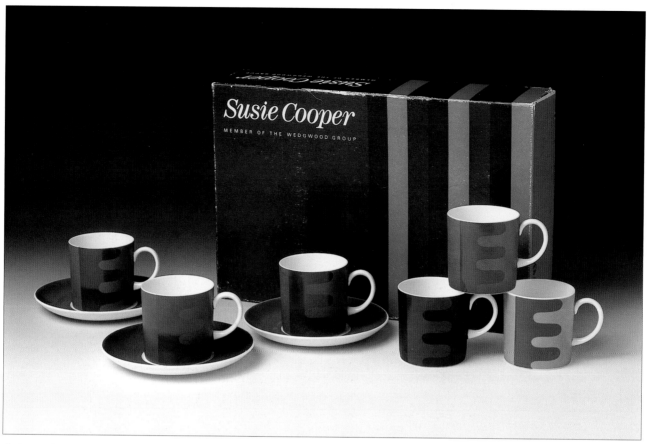

5. A set of six bone china coffee cups and saucers decorated with the covercoat pattern Pennant (C.2151), with the original presentation box, about 1969. Diameter of saucer 5½in (14cm).

processes would ensure longevity – a belief which was indeed verified by her own example. Most fundamental, however, was an innate drive to design, which remained with her throughout her entire life, almost as naturally as drawing breath.

Instead, 1966 signalled the beginning of one of the most prolific, diverse and technically-challenging periods of her professional life. Nevertheless, aspects of her new situation were also the source of much personal frustration. Since 1929, she had enjoyed a growing sense of autonomy as an independent potter, deciding the range of shapes to be produced and designing the patterns with which they were decorated. Even the latter reflected her factory manager's understanding of the varied abilities of the decorating personnel to produce designs which were lithographed, hand-painted, wash-banded, etc. Using her own image to personify the elements of elegance and utility early on in her career, she had quite literally overseen the creation of the ware which bore her name, from its raw state to the finished product. Now, not only was her authority no longer sacrosanct, but following the closure of the Crown Works in December 1980, Susie Cooper lost the easy access to manufacturing processes on the factory floor whereby she could experiment with the new ideas that occurred constantly to her. Her entire workforce had consisted of eighty-one, whereas that at Wedgwood's Barlaston site numbered almost two thousand.

The acquisition of all the companies to be absorbed into the Wedgwood Group

6. The backstamp used for Wedgwood bone china incorporating the name of Susie Cooper.

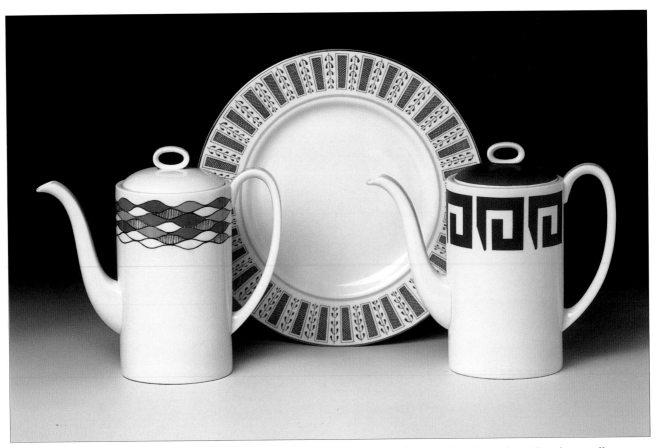

7. Susie Cooper's interpretation of some classical themes. Two bone china Can shape coffee pots decorated, right, with Keystone (C.2131-2134), based on the antique Greek Key motif, and left, Columbine (C.2174), both from about 1968-69. The plate is decorated with the covercoat pattern Persia (C.2019), from about 1969, but designed about 1963.

was orchestrated by Sir Arthur Bryan, newly-appointed to the post of Managing Director (plate 3). The decision to choose a successor from outside the ranks of the Wedgwood family had been taken with great confidence by Josiah Wedgwood V and was supported whole-heartedly by his fellow directors. Interestingly, Susie Cooper stated on several occasions that earlier in her career Wedgwood, who she held in high esteem, had often suggested that she should in some capacity design under the Wedgwood name but that she had declined. Now, Sir Arthur was equally enthusiastic that Susie Cooper's talent could be advantageously applied to the Wedgwood name. His reflections on the occasion of her ninetieth birthday confirm that he had great respect for her complete dedication and quest for perfection, even adding that although she appeared gentle and shy she was 'quite ruthless in the achievement of her ends both in standards and in quality.'[1]

At the same time, he acknowledged that Susie Cooper's worth to Wedgwood lay not only in her design skills. Years of determination to produce her own shapes and designs and market them successfully, combined with a strong sense of responsibility to provide employment for her workforce, had taught her the skills of organising each department of her factory accordingly.

On more than one occasion, the highly-trained lithographers and decorators of the Crown Works came to the aid of the parent company in order to meet the

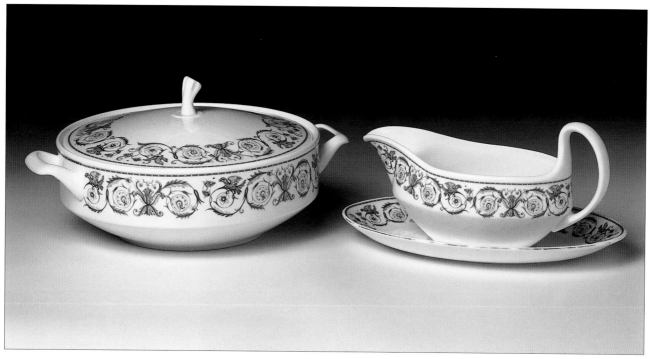

8. The Perugia pattern, designed by Susie Cooper and applied to the Orbit shape which was designed by Robert Minkin, 1968.

market demands for such Wedgwood patterns as Kutani Crane, Colonnade, Columbia, Ulander and Florentine. Wedgwood factory pattern books also indicate that the decoration of Gold Marguerite coffee percolators for Russell Hobbs took place at Susie Cooper's own factory. Robert Minkin's[2] Ice Rose percolator (also for Russell Hobbs), was accompanied by a boxed Can cup and saucer modelled by Susie Cooper, creamer designed by Russell Hobbs and Nordic shape sugar by Tuscan. Other joint projects, including an order of Coupe shape ware for the Qantas airline, were shared between Susie Cooper, Wedgwood and Tuscan.

While such skills were invaluable, it was not for this that Sir Arthur had sought to bring Susie Cooper products under the Wedgwood banner. Indeed, her eagerness to complement the company's classical reputation became immediately visible in the style of surface patterns which she began to evolve from 1966 under the Wedgwood backstamp. Significantly, in 1967, the February issue of the *Pottery Gazette* carried an advertisement for Athena proclaiming: 'Susie Cooper says go gay, go Greek.' Aimed at retailers, the advert goes on to describe its combination of 'lively flowers in cyclamen with a subtle green motif taken from classical Greek art', and to suggest that it is likely to appeal to 'the young in heart' and the 'refined in taste'.

Susie Cooper's willingness to adapt and to embrace the whole concept embodied in the new Bone China backstamp, claiming Susie Cooper as a 'Member of the Wedgwood Group', is thus visible from the very beginnings of this, a new chapter in her life (plate 6). However, equally admirable is the way in which she tenaciously adhered to her own original aim, established right at the outset of her career – to bring good, contemporary design within the reach of the younger consumer. Ironically, her growing reputation, culminating in her own backstamp (an accolade then paid only rarely by Josiah Wedgwood and Sons Ltd.), would in itself have defeated the object of offering ware designed by her as cheaply as she

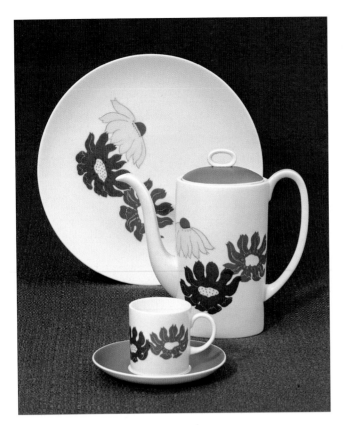
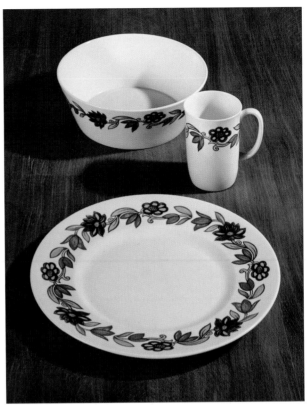
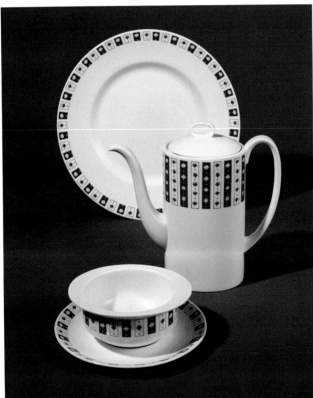
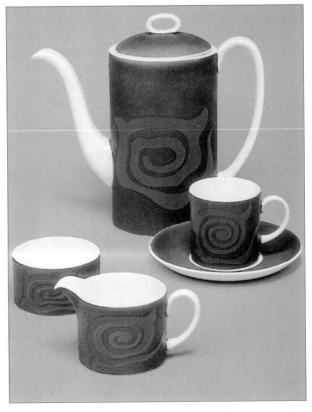

9. A selection of Susie Cooper patterns for Wedgwood. Clockwise, from top left: Florida (C.2166) from 1970. Art Nouveau (C.2071) from about 1966, Nebula (C.2136-2138) and Neptune (C.2105), both from 1968.

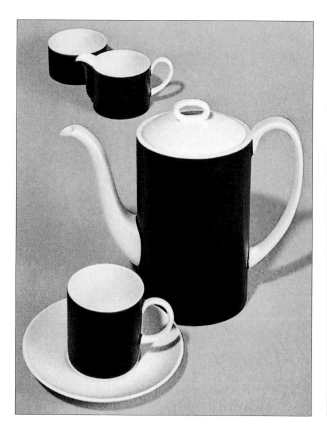

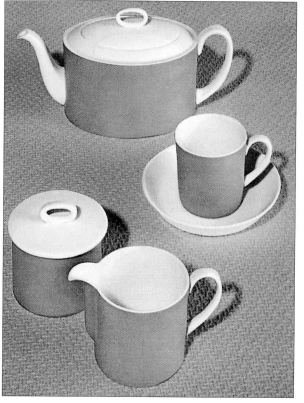

10. A range of bone china patterns: Contrast (C.2068), Iris (C.2212) from about 1979, Amber (C.2095) from 1967 and Diablo (C.2150). The patterns illustrate the juxtaposition of matt and shiny surfaces.

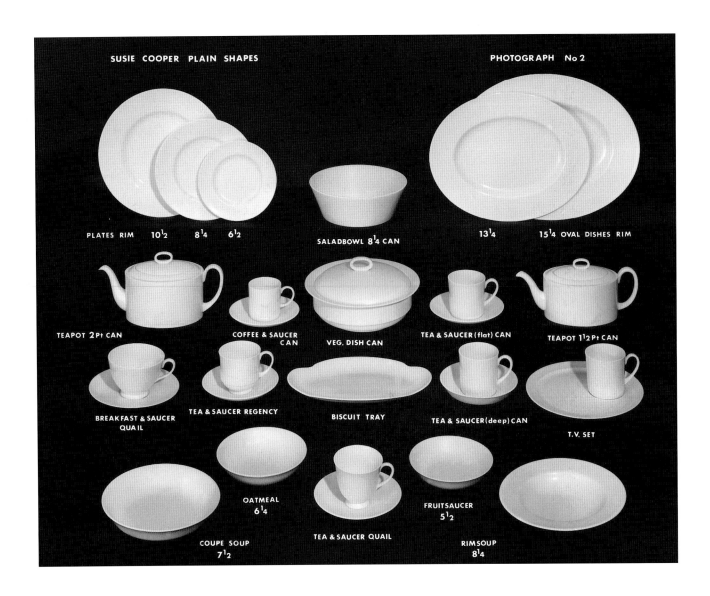

PLATES RIM 10$\frac{1}{2}$ 8$\frac{1}{4}$ 6$\frac{1}{2}$

SALADBOWL 8$\frac{1}{4}$ CAN

13$\frac{1}{4}$ 15$\frac{1}{4}$ OVAL DISHES RIM

TEAPOT 2 Pt CAN

COFFEE & SAUCER CAN

VEG. DISH CAN

TEA & SAUCER (flat) CAN

TEAPOT 1$\frac{1}{2}$ Pt CAN

BREAKFAST & SAUCER QUAIL

TEA & SAUCER REGENCY

BISCUIT TRAY

TEA & SAUCER (deep) CAN

T.V. SET

OATMEAL 6$\frac{1}{4}$

FRUITSAUCER 5$\frac{1}{2}$

COUPE SOUP 7$\frac{1}{2}$

TEA & SAUCER QUAIL

RIMSOUP 8$\frac{1}{4}$

11. A company photograph illustrating the various bone china 'Plain shapes'.

would have wished. Such was the disadvantage of her growing renown.

With the benefit of over thirty years' hindsight we are now able to reflect on the cultural atmosphere which prevailed during Susie Cooper's early years with Wedgwood and to assess the influences which played a part in her constantly evolving style. In its wider context, the 1960s was a time of space exploration culminating in the historical landing on the moon in 1969. Mercury, Neptune, Andromeda and Saturn, designed by Susie Cooper two years earlier, reflected the truly contemporaneous nature of her work.

Somewhat less ethereal however, but still encapsulating so perfectly the icons of an age, was the celebrated series of designs inspired by a trip to London suggested by Sir Arthur. Often, Susie Cooper would recall how she subjected herself to the psychedelia of the Kings Road, Carnaby Street and other famous landmarks of the Metropolis in the 'Swinging Sixties', after which she came back to her studio and, in her own words 'went to work'. The results were launched towards the end of 1967 with Heraldry, followed by Carnaby Daisy, Harlequinade, Nebula, Diablo and Pennant in 1968 – all of which were available in Harlequin sets – i.e. contrasting colourways (plate 5). Not only was each pattern equally dynamic in its use of

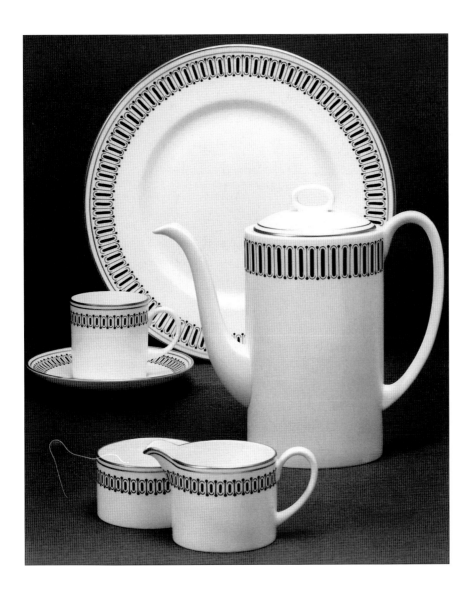

12. A range of bone china shapes decorated with the Colosseum pattern (C.2204), from 1971.

abstract shapes and vivid colour contrasts, but Susie Cooper also used them as a vehicle to show how ceramic materials (in this case, 'covercoat') could be utilised to accentuate different textures, giving an added dimension to the surface pattern.

Susie Cooper's ceramic interpretation of the sixties' style exemplifies perfectly the way in which she imbibed the spirit of the age and delivered a product which was both stylistic and practical. Indeed, her gift lay in capturing the essence of prevailing trends so that her contribution to the artistic as well as to the commercial world extended over the seven decades of her career.

Much has been said of the prolific nature of Susie Cooper's work and this is certainly borne out by the number of designs entered in her own pattern books as well as those belonging to the parent company. Rough sketches, recording ideas percolating through her mind's eye but not yet having reached a conclusion, could be left in her studio for months, even years, until a purpose arose for them to be completed. Upon joining the Wedgwood Group, her efforts gained pace as she concentrated on producing tableware patterns which would complement Wedgwood's image. Needless to say, only a percentage of these ever went into production and so it is proof of her industry that, in 1968, almost thirty of her

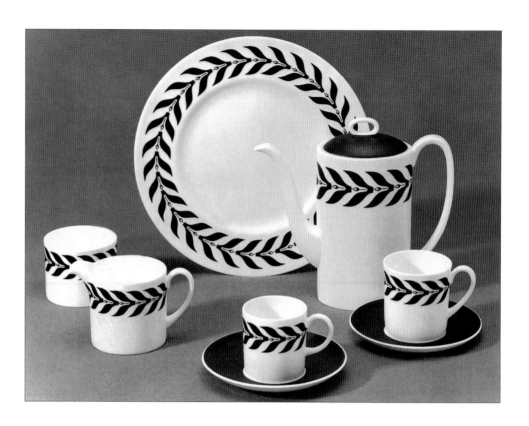

13. The Cressida pattern
(C.2172), from 1970, recalling
the classical Laurel motif.

designs (from Glen Mist to Bridal Bouquet) were in general production. For a sales
catalogue to contain so many designs by one artist would appear to be
unprecedented in the entire Wedgwood history, again re-affirming her artistic
talent and her knowledge of market requirements.

Not all of the patterns and shapes which carried Susie Cooper's name however,
were brand new. The Can shape, which enjoyed many years of success as a vehicle
for Wedgwood designs, had in fact been introduced by her in 1958 for her own
bone china body. Glen Mist (C.1035), the sole remaining Susie Cooper pattern,
currently produced exclusively for the Japanese market, made its debut in 1960.
Other designs which easily made the transition between these two phases of Susie
Cooper's career included Persia (C.2019), Venetia (C.2039) and Classic Vista
(C.990), the perfect architectural proportions of which were in no small part due
to the collaboration of her architect husband, Cecil Barker.

Merging with the Wedgwood Group gave Susie Cooper the opportunity to
develop her interest in classical motifs. For instance, in the case of Perugia, we
learn that 'Miss Cooper felt the fundamental classic quality of this decoration made
it especially suitable for Wedgwood', although she had 'given it a more than usual
informal treatment to give it a younger appeal'. Its source was quite authentic,
deriving from a stone carving in a Perugian Italian Renaissance church of the mid-
fifteenth century (plate 8).[3]

Given that Susie Cooper was so keen to enhance the classical image first nurtured
by Wedgwood and Bentley in the eighteenth century, one of her most outstanding
and successful designs for the company, namely Cornpoppy (1971), conveys a
contrasting mood. This pattern, almost Oriental in the stark contrast between the
scarlet poppy and its touches of black against the white bone china, demonstrates
possibly more than any other, her claim that a well-designed article of pottery
contributes to the interior design of the home (plate 14). It is impossible not to

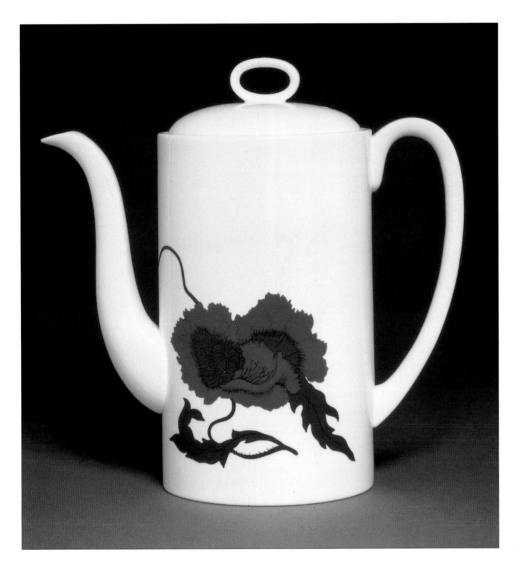

sense the joy of the artist in this floral motif with its flowing lines and vibrant colour, unrestrained by the rimless Coupe shape. Of course, Susie Cooper had always been famous for her depiction of flora but this was quite a departure from the combination of gentle pastel colours and creamy earthenware body of the 1930s.

Like the rest of the nation, Susie Cooper was captivated by the London exhibition of Tutankhamun in 1972, which sparked off a trend for all things Egyptian. Her contribution was a range of tableware with assorted Egyptian motifs, called Ashmun.

In 1972, Cecil Barker died and Susie Cooper resigned as a Director of her own company. Free of the responsibilities accompanying this position, she began to concentrate less on tableware patterns for general production in favour of more specialised items, produced in smaller numbers. Probably for the first time in her life, she could allow design to take precedence over all other aspects of her multi-faceted occupation. This, however, also involved focusing on her skills as a technician. From this period dates the series of large bowls inspired by the cultures of ancient dynasties. The 'Chou Dynasty' bowl, based on the style of the Chinese Warring States of the fourth or early third century, used the covercoat medium to emphasise the difference between textures. Exploration of this medium resulted in

14. A bone china Can shape coffee pot, height 9in (23cm), decorated with the covercoat pattern Cornpoppy (C.2176), from about 1971.

15. A contemporary photograph of the Charisma pattern (C.2184), banded in black and silver on the Can shape, 1971.

some unique, almost three-dimensional effects best seen in designs like Tiger Cubs in Combat, with Wild Boar, based on a bronze of the Western Han Dynasty, Yunnan, of the second or early first Dynasty (plate 1).

1977 and the Royal Silver Jubilee once more gave Susie Cooper the opportunity to turn to her choice of medium as a way of promoting the significance of her designs. The result was a range of silver lustre (sometimes enamelled) giftware. Her close association with the parent company, Josiah Wedgwood and Sons Ltd., lasted until she decided to base her studio at William Adams, Tunstall in 1979.

Sir Arthur Bryan sought to bring Susie Cooper into the Wedgwood Group because he had a vision of two great names and, indeed, two great products of the ceramics industry being allied together. In contrast, Susie Cooper could never completely reconcile herself with the increasing recognition afforded her by the media and the world of design alike. The concept of ware that she had taken pains to design for functional purposes being exhibited in museums, remained quite puzzling to her. She was, after all, accustomed to being a working potter in every

sense of the phrase. She certainly did not entertain any illusions of grandeur and while she was elegant and petite, her most fundamental characteristic, together with grit and determination, was practicality. She really was the epitome of 'Elegance and Utility'. It is therefore not difficult to see why this period of her career was so problematical in certain areas and yet, even in Susie Cooper's own opinion, this was also one of the most productive times. It would be a grave error to overlook this fact and to criticise the work she produced while a member of the Wedgwood Group.

When she was well into her eighties, and leaving the Potteries for the Isle of Man, Susie Cooper was not retiring, merely embarking on the next stage of her career. She went ready-armed with many ideas, assuring all as she departed that Susie Cooper had no intention of stagnating. Needless to say, no-one needed convincing of that fact.

16. A large bone china bowl, diameter 9⅝in (24.5cm), with decoration based on motifs from the Chou Dynasty (C.2207). A combination of covercoat, aerographing, sgraffito, banding and painting techniques were used on this pattern, about 1976.

FOOTNOTES

1. Sir Arthur Bryan, Chairman of the Wedgwood Museum Trust, in an address to the Associates of the Wedgwood Museum, 1992.
2. Robert Minkin, Des.R.C.A., F.S.I.A.D. Designer at Barlaston 1955-86. Design Director from 1979.
3. Reply to customer (Mrs. J.A. Bowyer) enquiry, 21st July 1970.

1. Susie Cooper in her studio at W. Adams Ltd., 1985. Note the range of patterns from all periods on show.

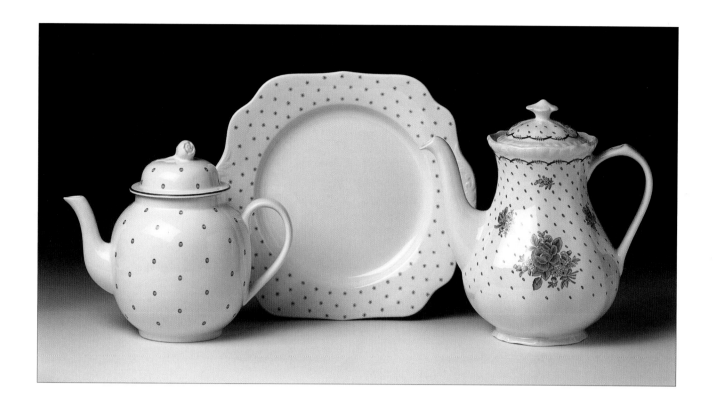

CHAPTER 9

SUSIE COOPER AT WILLIAM ADAMS LTD.

Sharon Gater

Memories of Susie Cooper
John Ryan

William Adams built his factory at Greengates, Tunstall, the most northerly of the six Potteries towns, in 1773. Almost two centuries later the company to which he had given his name became, like Susie Cooper, a member of the Wedgwood Group.

Tunstall was, of course, where Susie Cooper had made her first attempt to establish her own business in 1929, before the repercussions of the Wall Street Crash forced her to give up her first premises. In 1980, circumstances allowed Susie Cooper to return to her home-base when, on the closure of the Crown Works, she was given a choice as to where she would like to establish her studio.

The Wedgwood factory itself had opened a completely new design studio – a 'round-house' echoing the famous architectural feature of the old Etruria works. However, the concept of placing a purpose-built studio separate from the rest of the factory, thus accentuating the importance of design, opposed Susie Cooper's own understanding of the process. She was happiest when 'in the clay', having ready

2. Susie Cooper patterns for W. Adams Ltd. The Polka Dot pattern, in both green and blue, revived for the special 'Britain Salutes New York Festival' in 1983, was hand-painted on standard Adams shapes (left). The earthenware plate is decorated with the printed Stardust pattern, and a coffee pot with the April pattern.

access to the materials of her craft.

Furthermore, she listened to the advice of John Ryan, the Managing Director of Wedgwood's earthenware division, who had evidently followed her work closely and drawn certain conclusions from his observations. He felt, for instance, that the element of softness which so often characterised her work was lost in the stark contrast created by the white bone china. At Adams, Susie Cooper would be working once again on the earthenware body.

In addition, John Ryan was familiar with the technical facilities which the factory could offer to the designer. Of all Wedgwood's subsidiaries, peculiar to this factory was access to a working 'hot' shop where printed and enamelled patterns could be prepared on the premises. The processes in that department included the Murray-Curvex machine for the decoration of biscuit (unglazed) flatware, and roller printing for the hollowware. Such methods were in danger of becoming obsolete but certain aspects of Susie's designs, especially those which consisted of all-over prints, were particularly compatible with these techniques.

Susie Cooper therefore chose William Adams Ltd., which brought her back into the realms of earthenware, a medium with which she so enjoyed working. The benefits of her expertise were also to influence Philip Gibson, the sole resident designer, together with a number of freelance designers who were quick to absorb the lessons she could teach them – in particular, to work directly on to the pot, whether drawing directly on to the surface or applying to it a sketch of a proposed pattern.

Officially, Susie Cooper was to work on a part-time basis but needless to say, her enthusiasm ensured an almost daily attendance during which time she initiated new patterns and revived old ones. New customers such as Tesco, for whom she designed Inspirations (G.7736) in 1982, and Boots, whose order for Meadowlands (P.7916) appeared one year later, reflected the changing markets for exclusive patterns while the revival of 'Blue Polka Dot' for Tiffany's, also in 1983, demonstrates the universality of the appeal of Susie Cooper's output.

In 1982, the year of Susie Cooper's eightieth birthday, 'Stardust' and 'April' were introduced to mark the occasion. These were ideal examples of the co-operation between the designer and the manufacturer (plate 2). However, not all of her designs were applied to Adams' 'Hexagonal' shape. Indeed, the application of Blue Daisy (PL.7920) to Adams' Simple shape Micratex range of oven-to-table ware was designed to fit the needs of 'High tech. cooks and hostesses requiring speed in kitchen preparation and elegance at the table'[1] (plate 4). The shape, designed by Peter Wall and launched at a joint trade show with Creda in 1984, was further developed by Philip Gibson to include casseroles, ramekins, soufflé, baking, roasting and pie dishes. When Adams launched the new Micratex range, publicity material declared: 'two of the patterns have been designed by Susie Cooper O.B.E., R.D.I., doyenne of British pottery designers and a senior member of the Wedgwood Group's team of designers. Florida is a vivacious update of a pattern created in the 1930s and Blue Haze is a 1984 original.'[2] In the latter part of her career, Susie Cooper's collaboration with Adams in effect re-emphasised her own enduring desire to produce ware that was functional and yet at the same time, aesthetically pleasing.

In contrast, however, before moving to the Isle of Man to make a new home with her son, Tim, Susie Cooper turned her attention once more to the 1930s and the 'Kestrel' shape, with the production of breakfast sets in lithographed versions of 'Spiral Fern', 'Yellow Daisy' and 'Polka Dot'. Furthermore, she almost came full circle when as late as January 1986, she attempted to reproduce lustre giftware redolent of the Gray's period. Sadly, commercial production of the range met with insurmountable technical difficulties and so it never went ahead.

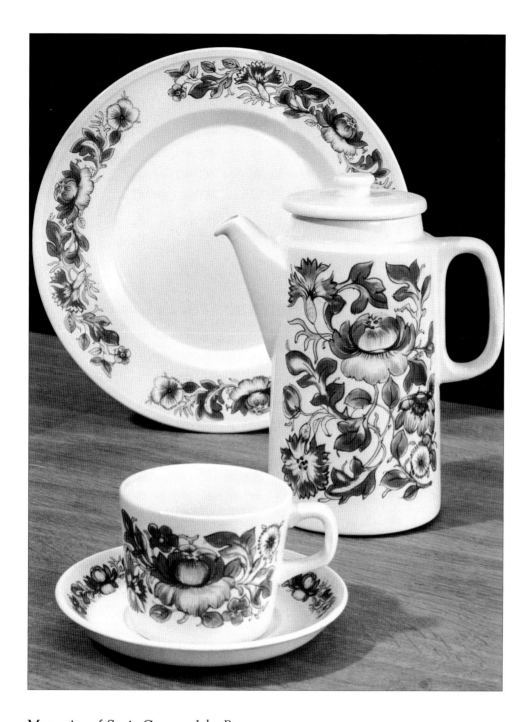

Memories of Susie Cooper *John Ryan*

The first time I met Susie Cooper was purely by chance. I was introduced to her by a colleague and visited her in her studio at the Crown Works in Burslem. I did not know what to expect but was soon fascinated by her character and bearing. The studio was a joy to see with its stylish furniture from the 1930s and '40s. Its contents captured the various phases of Susie's career and time stood still. The room was alive with the various projects that Susie was working on but our initial discussions centred on a large sideboard in the studio that had been designed and built by her husband Cecil Barker and which contained many examples of her designs from the

3. A transfer-printed pattern on Robert Minkin's Wayfarer shape. Designed by Susie Cooper for William Adams Ltd. in 1967-69.

1930s onwards. It is unlikely that many people had seen this collection or even realised that it existed. I was extremely privileged to be able to pick up and examine the pottery and hear her thoughts on what had inspired each piece. What I expected to be a short visit in fact took several hours and in that time much conversation and exchange of views took place. Susie was quite sharp and to the point – very keen to discuss current design trends and the state of the pottery industry at that time.

The overriding impression of Susie throughout this discourse was of her enthusiasm and vitality. Her appreciation of good quality earthenware and keenness to continue to work within the industry was strongly expressed. It was quite apparent that she was seeking the right environment in which to achieve this. The desire to provide well-designed quality products to all levels of society was as strong then as it must have been in the 1920s. Susie demonstrated the manner in which her designs were produced and crafted, using techniques that were disappearing from the industry. She painted a design directly on to a pot itself for me. Other patterns were firstly painted on to card from which pin-pricked paper stencils were created of the design outline. These she fixed to a pot and dusted it with graphite, leaving the pattern outline ready for hand painting. The stencils were saved to be used as pattern fits for various items in the range. Picking up an unfired clay pot, she drew an exquisite leaping deer directly on to its surface with a pointed tool in a flowing action so precise and effortless. These activities then and on many subsequent occasions were a delight to observe and the passing of time has not dimmed this memory.

At the conclusion of the meeting there was a realisation that each of us could benefit from a joint operation and this was the start of a friendship that was to last until Susie Cooper's death. We agreed to replicate her working environment at the Adams factory by moving her studio lock, stock and barrel to its new location, complete with fixtures and fittings. An additional feature that Susie Cooper was very pleased with was the provision of a working area away from her design studio called 'The Garrett', a small room in an elevated part of the old Adams factory where she used to physically prepare her designs for pre-production. At times this became the nerve centre of her activities and was always full of colour and the paraphernalia of the working artist.

Susie Cooper settled at Adams very quickly and her down-to-earth practical involvement and interest in the day-to-day activities of the business were valued by all. For my part, the most enduring memories are the daily discussions and chats about Susie Cooper's designs and their impact on the Adams business. She was very keen to encourage the younger members of the design team and her involvement in customer visits to the Adams factory became an established part of factory tours and discussions. The visiting buyers were pleased to sit and talk to Susie Cooper and she was a great ambassador for Adams. She often provided hands-on demonstrations and design interpretations of what a buyer was trying to achieve – for example, in the case of 'Meadowlands' produced for Boots, 'Blue Polka Dot' for Tiffany of New York (both introduced in 1983), and the fine re-interpretation of a 1935 pattern which she called 'Florida' (1985). There was a compatibility between Adams shapes and bodies with Susie's early pattern books that enabled her to revive some of her designs. Looking back, I remember many hours were spent discussing, designing and producing samples for a vintage Susie Cooper range of lustre giftware for Wedgwood which alas, to our great disappointment, was never introduced.

The association with Adams helped to retain Susie Cooper's talent and impact within the industry, giving her the opportunity to continue her creative work in the

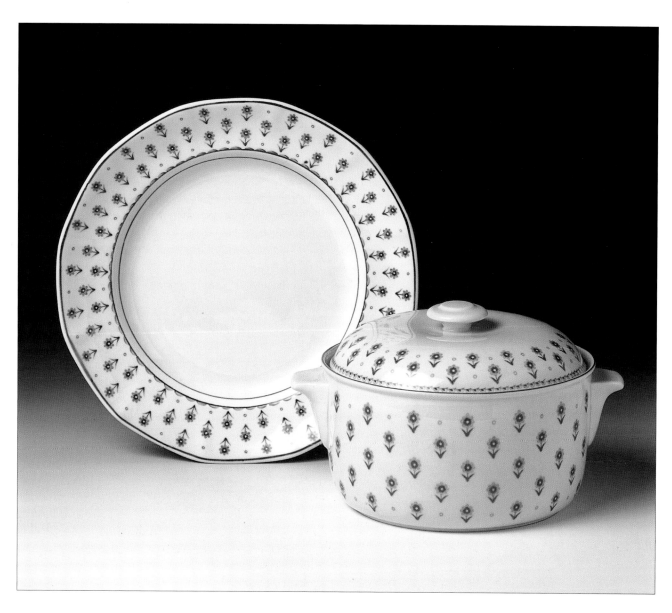

factory environment that she truly loved and valued. Perhaps it was instrumental in leading to some of the excellent work that she did when she moved to the Isle of Man.

We met occasionally after Susie Cooper retired from Adams, most enjoyably when I visited her and her son Tim in the Isle of Man where she was actively engaged on the renovation of her house and was very busy on design projects. She was proud of her design studio, which as I recall was on the top storey of the building and we laughed about the number of stairs Susie was required to climb to reach it. She politely reminded me that she was still quite capable of getting up and down a ladder if necessary. To all of us who knew her well this tough determined side of her character never wavered.

4. A dinner plate and a Micratex covered vegetable dish decorated with the Blue Daisy pattern, designed for William Adams Ltd. from 1982. A Blue Daisy coffee set was priced at £38.60 in March 1983 with individual items such as a tea cup and saucer priced at £3.95.

FOOTNOTES

1. Sales leaflet promoting the introduction of new patterns including Florida and Blue Haze.
2. Ibid.

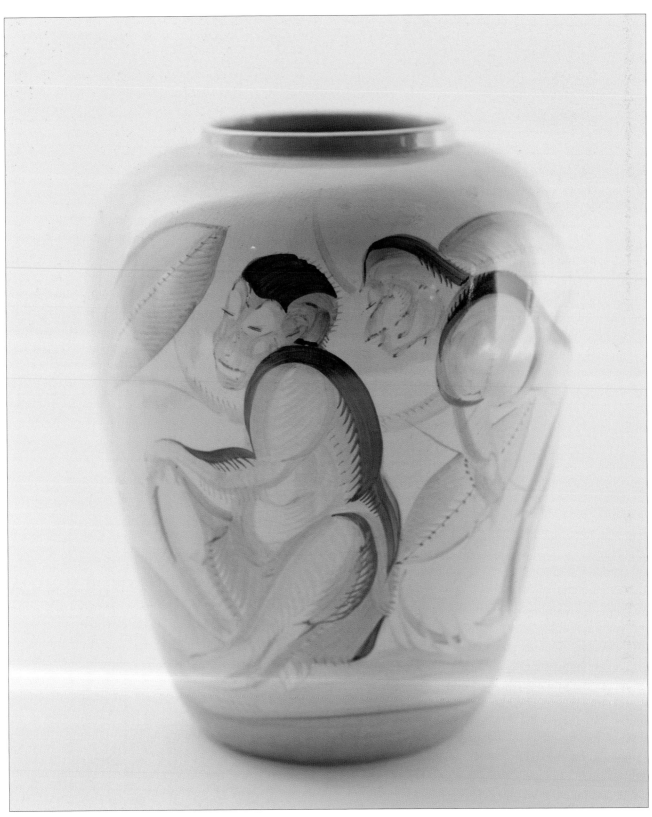

1. A rare earthenware hand-painted ginger jar/vase decorated with a stylised monkey. This vase was purchased by the Musées Royaux d'Art et d'Histoire, Brussels. It would originally have had a lid (see plate 4). The base is marked 'Susie Cooper England 1933'.

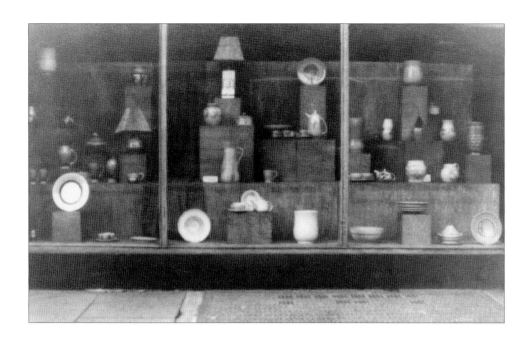

CHAPTER 10

UNKNOWN CERAMICS

Ann Eatwell

…that proves what I feel about pottery. It is a practical and lasting form of art. Not everyone can afford original paintings, but most people can afford pottery [1]

Susie Cooper's mission, often stated, was to provide high quality design in practical art works for the home. These were tablewares and decorative vases, bowls, lamp bases and plaques to be used to create a modern, sophisticated and integrated interior. With the passage of time these objects have become historic examples of classic twentieth century design and art works in the fullest sense of the term. The growing distance between the creation of these classics and the present, as well as the gradual loss of the human connection of memory and experience, is weakening our understanding of the design and manufacturing process, and of the function and meaning of the ceramics for previous generations. Susie Cooper's pottery is becoming the 'unknown ceramics' of tomorrow.

Among the many good reasons that exist to explain the gaps in our knowledge, some of the following are important to remember. Kathy Niblett has pointed out in Chapter 2, on the Gray's period, the difficulties of assigning designs for that factory to Susie Cooper. Once she started her own business, her long and full career leaves researchers with an enormous task of sifting through the surviving ceramics and other designs as well as the extensive archive materials which are still coming to light. The disparity in the production output of the designs, the customisation of

2. A view of the exterior of the Woburn Place showroom in London, about 1933.

3. An interior view of the showroom, about 1933.

4. A group of hand-painted earthenware pieces decorated with stylised animals such as a leaping deer (left), monkey (centre, top) and pig (right). According to one of Susie Cooper's workers these were, at the time of the Second World War, stored in a large cupboard at the end of the showroom and were destroyed during the Blitz.

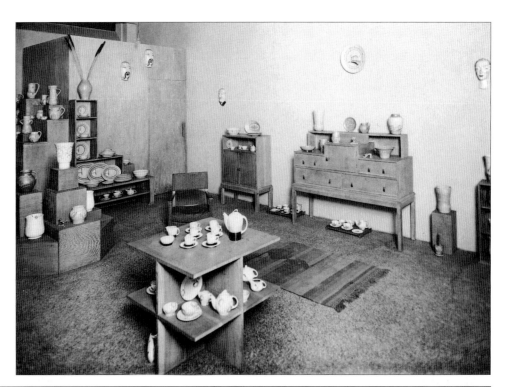

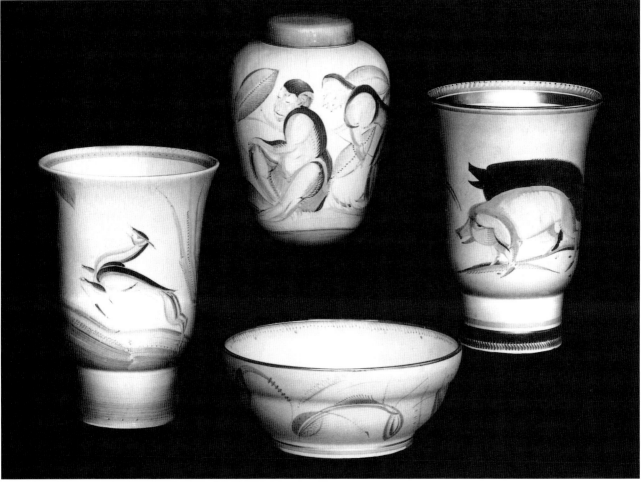

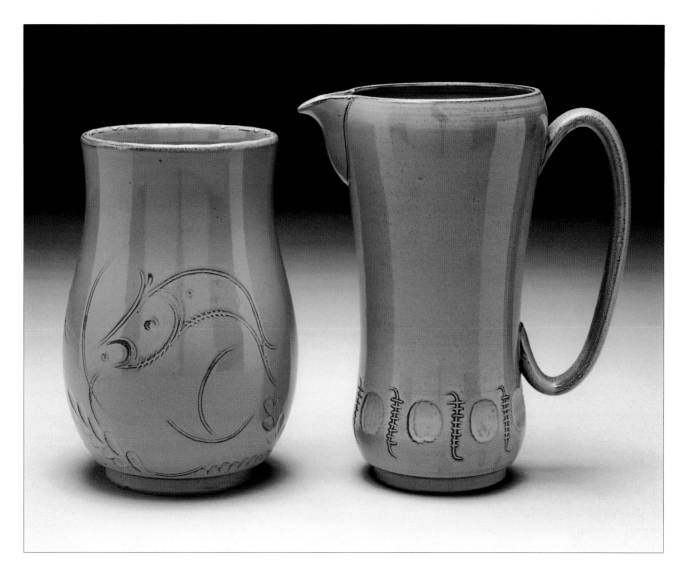

patterns for certain retailers and export markets, the varying survival rates of the designs, the less common pieces, the new discoveries, the later reproductions, the similar copies of her patterns by other factories, are all factors which determine the current understanding of her work. This essay, with accompanying images and captions, attempts to explore some of these issues using previously unpublished contemporary photographs, ceramics from private collections and archive material.

Newly discovered photographs from the 1930s, such as the snapshot of the shop front at Woburn Place, show unknown vase forms, patterns and lamp base shapes (plate 2). The shop's interior provides a further opportunity to look for the unusual (plate 3). Susie Cooper designed a small range of napkin rings, one can be seen on the piece of furniture against the wall in the British Industries Fair stand of 1933 illustrated on page 194. Do these still exist?[2] Another photograph shows vases and a bowl that are thought to have been lost in the Blitz when the showroom at Holborn Viaduct was destroyed (plate 4). An identical vase to that painted with a monkey is now in the Royal Museum of Art and History in Brussels (plate 1). Is it the same vase or did Susie Cooper paint two identical vases with this subject? Rare face masks can be seen in contemporary photographs and now exist in Museum collections.

5. Two red-bodied hand-thrown art wares, a vase decorated with stylised fish and seaweed (Ref. 384 or 389) and a tall handled jug, height 9½in (24cm), with an incised border to base (Ref. 356). These uncommon wares probably date from about 1935.

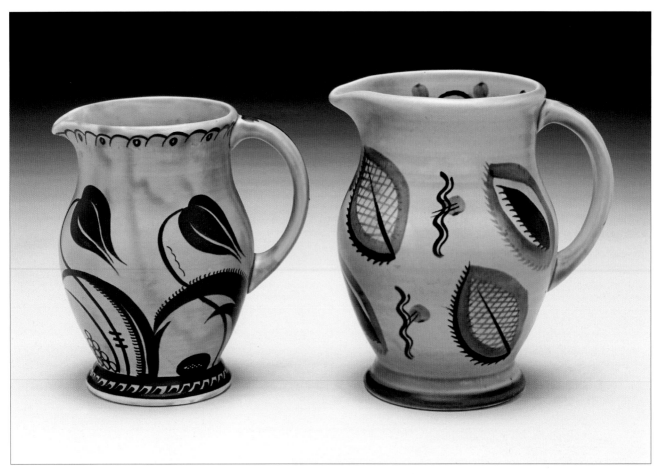

6. Two earthenware Venice jugs decorated with hand-painted stylised patterns, left painted in black and dipped in jade green glaze (E/346) and right (E/349), height 6⅝in (17cm), about 1932.

7. An earthenware beaker, height 3½in (9cm), printed in black with hand-painted decoration in orange, for Croydon Corporation, 1933. The reverse side reads 'CROYDON JUBILEE 1833-1933' in black with yellow inside beaker and dash border to edge.

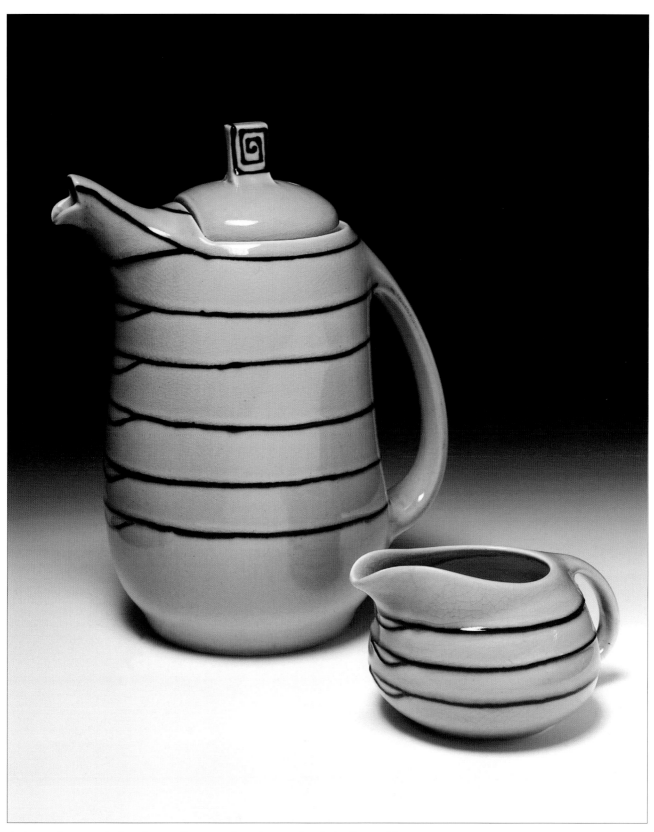

8. An earthenware Curlew shape coffee pot and jug decorated with the Dropped Lines pattern (E/681), tube-lined in black with a celadon green glaze, about 1933.

Ash Tray.
In Chrome Green, Gladioli Greens
(light and Dark) Tangerine, Blythe Blue,
Emerys Lilac and Black.
E644 Outlined in Chestnut Brown.

Lettering in Chestnut Brown
IMPERIAL

E645

Ash Tray in.
Gladioli Light Green, Chrome Green,
Tangerine Jaffa, and Black
Outlined in Chestnut Brown.

ROYAL

9. A pattern book entry illustrating a selection of hand-painted ashtrays, possibly specially commissioned by hotels and restaurants, about 1933.

10. The Sepia pattern (number unknown), probably hand painted, on an earthenware Falcon shape tureen and cover, tea pot and plate, about 1937. This photograph was used by the Susie Cooper Pottery as a trade advertisement in *The Pottery Gazette and Glass Trade Review*, September 1937.

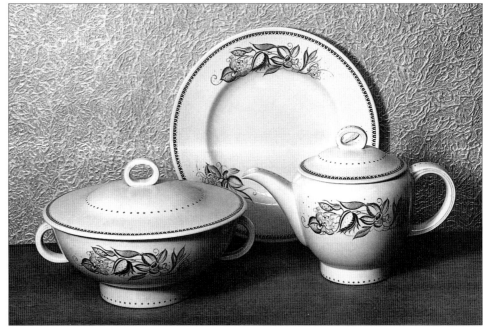

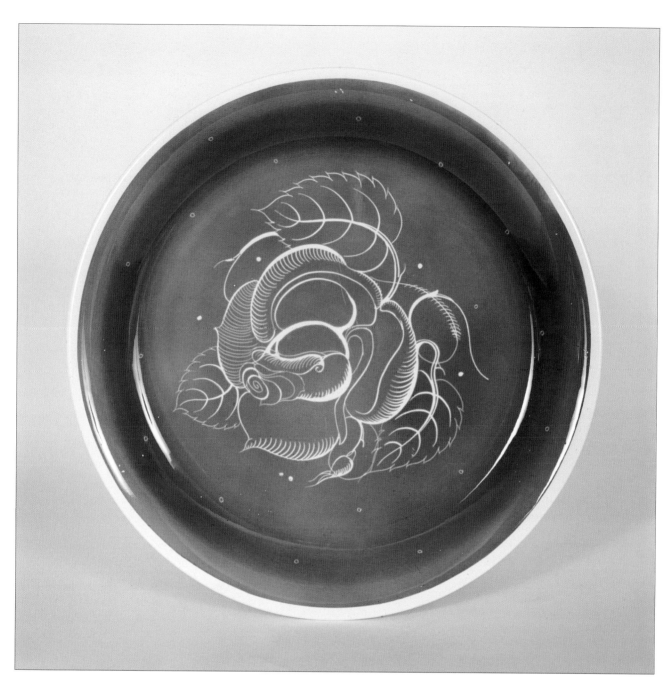

Unusual patterns or colour combinations are found in archive photographs and on the surviving objects themselves and add to our knowledge of the variety and complexity of the designs. The pattern books held in the Wedgwood Museum and archive material in public and private collections can assist with identification and dating. For example, the Susie Cooper Pottery received a number of prestigious commissions from business and public organisations as well as from foreign governments. Some of these we know about from the surviving ceramics, such as the commemorative mug for Croydon Council (plate 7), and some from archive material, as the designs for bone china tableware for the Canadian government demonstrate (plate 18). Institutions, from the venerable House of Lords to the newly-built modernist Peckham Health Centre (1935) and the Peter Jones

11. A large earthenware plaque, diameter 12⅛in (30.8cm), decorated with a stylised rose (E/2130), aerographed in green with sgraffito decoration, about 1947.

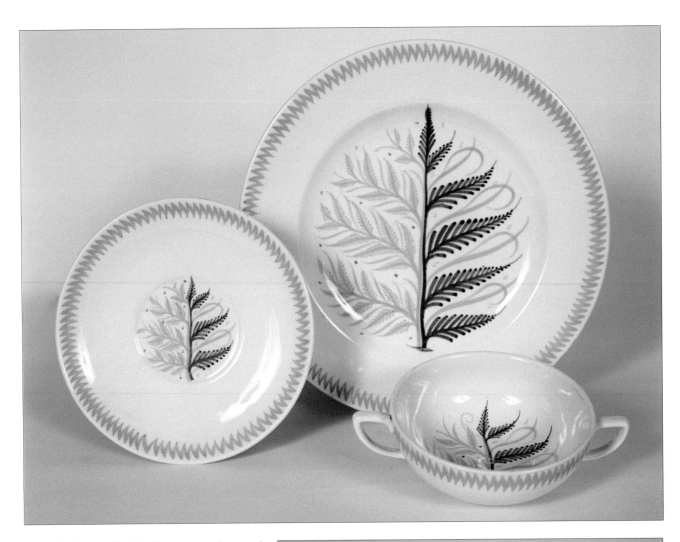

12. A hand-painted stylised tree pattern decorated on a dinner plate, soup bowl and stand, pattern (E/2005). This less well-known design was shown at the 'Britain Can Make It' exhibition in 1946 and illustrated in the official catalogue. A 26-piece dinner service was priced at £7-8-0, a tea set (21 pieces) was 53/4d and a coffee set, 40/-. Diameter of plate, 8⅞in (22.5cm).

13. Two unusual moulded bone china vases, height 7½in (19cm), one aerographed in salmon pink and decorated with sgraffito decoration and the other a hand-painted trial design, about 1956-57.

14. An uncommon design on an earthenware plate, diameter 8⅛in (25.5cm) hand painted with a seed-pod motif in underglaze blue and brown, probably 1957-58.

Restaurant (1936), as well as Imperial Airways, ordered specially designed ceramics.[3] The wares made for these commissions have yet to be discovered.

Many people are still using Susie Cooper pottery today. Not all of them know that they are. The Meadowlands and Inspiration patterns of the 1980s were sold under the Adams backstamp that did not name Susie Cooper as the designer (plate 16). These patterns sold to a mass market through the large supermarket chain Tesco and the high street chemist, Boots. At about the same time, Tiffany's of New York took two patterns, one a re-interpretation of a banded design and the other of spaced blue spots (plate 17).[4]

Not all the art pottery dates from the 1930s to the 1950s. As well as reviving or reworking tableware patterns, Susie Cooper revived some carved vases, bowls and plates at the time of the first retrospective exhibition of her work in 1978 (plate 19). The squirrel bowl and green dishes with floral designs were also revived at the

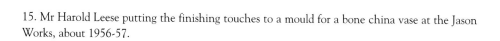

15. Mr Harold Leese putting the finishing touches to a mould for a bone china vase at the Jason Works, about 1956-57.

141

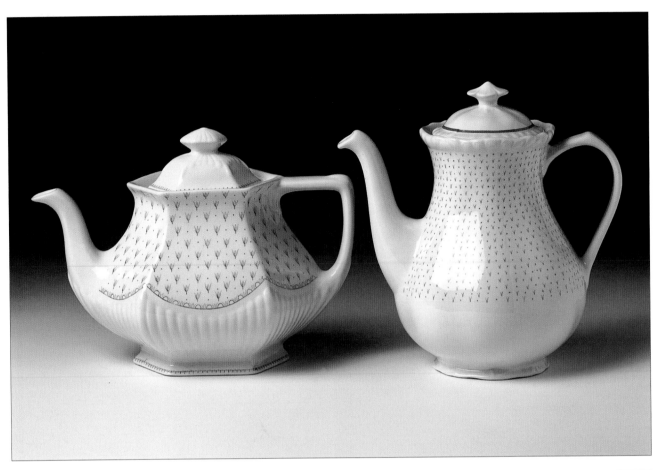

16. An earthenware tea pot decorated with the Meadow-lands pattern and a coffee pot with the Inspiration pattern. Designed by Susie Cooper for William Adams Ltd., about 1983-84.

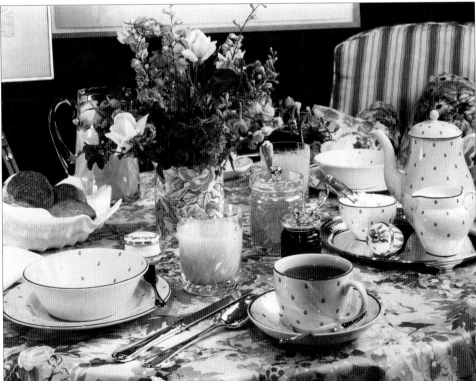

17. A contemporary photograph of the display of the Susie Cooper Polka Dot pattern in the 'Britain Salutes New York Festival', 1983.

18. A technical drawing of a range of crested ware on bone china made for the Directorate of Clothing and General Engineering, Department of National Defence, Ottawa, Canada (drawing no.ID895). The range includes two serving dishes and bowls. It is dated 16 March 1967 and the crest was added on 15 February 1968. An example of this tableware is known to exist.

19. A hand-thrown vase, height 11in (28cm), with incised decoration of stylised ferns and grasses. The form was modelled by Elwyn James and decorated by Susie Cooper. This was produced as part of a special range of art wares and tablewares for the Susie Cooper 'Elegance and Utility' exhibition held at Sanderson's Gallery in London in 1978.

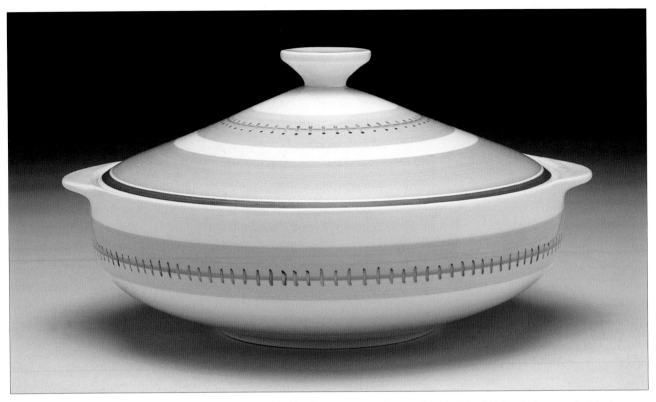

20. An earthenware Diablo shape tureen and cover, length 9½in (24.2cm), decorated with the hand-painted Simplicity (E/2426) pattern, from 1964. During the early sixties Susie Cooper designed the Diablo range of earthenware shapes. Several patterns, such as Modesty (E/2420), dated in the pattern book 20 March 1964, Lady Penelope (E/2423) dated June 1964, and Simplicity were used on this shape. According to Kenneth Gleaves, who worked at Wood and Sons Ltd. at the time, the range consisted of various tablewares such as tea, coffee and dinner wares. A tea pot, milk, covered sugar and gravy boat are also known to exist.

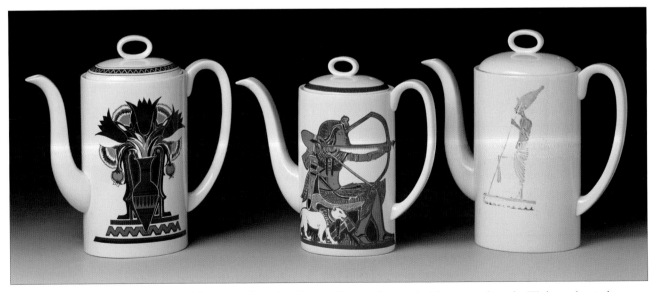

21. Three bone china Can shape coffee pots decorated with patterns from the Wedgwood period. Ashmun (C.2206), centre, is from about 1974-76. Thebes (left) was not put into production and the other pattern, Papyrus, is a trial design. These are rare and pattern numbers and dates are unknown.

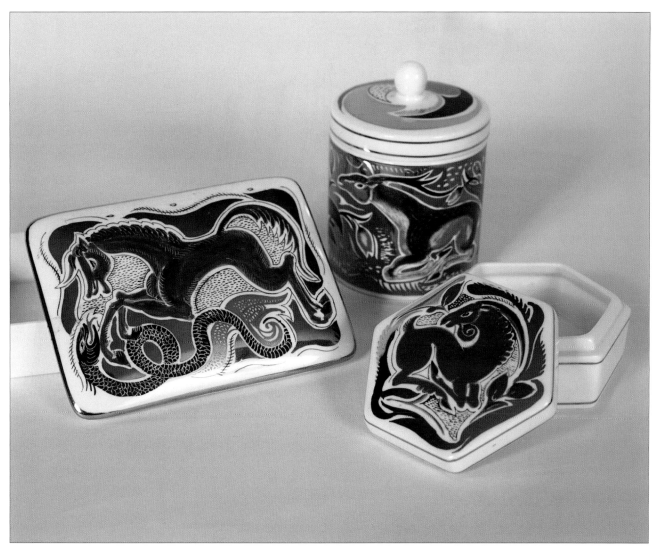

22. Bone china giftware: The Recumbent Deer pattern (top). The cigarette box and cover, length 5⅛in (13.2cm), is decorated with the Horse and Serpent pattern. The latter motif was later used for one of Susie Cooper's seed paintings exhibited in 1990/91.The hexagon-shaped box has a long–horned goat design on the lid.

time. Most are clearly dated. Throughout her life, Susie Cooper experimented. Trial pieces are more common than might be expected. Some are in public hands, such as the Wedgwood Museum, through the generosity of Susie Cooper, although many are in private collections. Finally, newly identified rare and unexpected patterns or shapes, such as Diablo, can add to our knowledge of the profusion and vitality of Susie Cooper's designs (plate 20).

FOOTNOTES

1. Glover, M., Susie Cooper, No. 1 woman in world of pottery, *Evening Sentinel*, 16 September 1971.
2. Some of the napkin rings were moulded in the form of terriers (see Woodhouse, A., *Susie Cooper*, Trilby Books, 1992 p.65) and dragons (interview with Susie Cooper, *The Manchester Evening News*, Wed. March 1st, 1933).
3. For more information on the possible styling of the designs see Woodhouse, A., *Susie Cooper*, pp.81-82 and p.85; Youds, B., *Susie Cooper, An Elegant Affair*, Thames and Hudson, 1996, pp.38-9.
4. Seen for sale in Tiffany's, New York by Ann Eatwell in 1984-5.

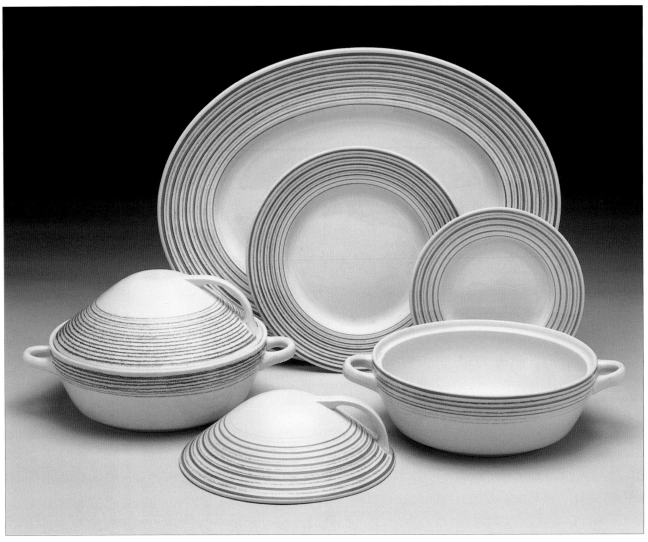

1. A selection of dinnerware shapes decorated with crayon line patterns, banded in underglaze crayon and enamel colour. The pattern was introduced in about 1934 but continued in production after the Second World War. The Kestrel tureen lid could be used as a separate serving dish, demonstrating the Modernist tenet 'Fitness for Purpose'. Length of tureen (with handles) 10⅝in (27cm).

CHAPTER 11

SUSIE COOPER:
THE FIRST MODERN CERAMIC DESIGNER?

Greg Stevenson

Out of the Twentieth Century there is growing a new spirit and idealism.
The only works and their creators who can be classified within the term
'modern' are those who have contributed to the expression of this spirit and
those ideals which are peculiarly of our time [1]

Britain has never been known as the home of modernism. A glance through domestic interiors of the 1930s illustrates the fact that we largely failed to embrace the Modern Movement, opting instead for chintzy interiors and ceramics to match. Few people were buying ceramics during the period, and the ceramic industry was in severe decline with potbanks (pottery factories) closing every week. Those with the money to buy pots tended to err on the side of caution by buying traditional lines such as the 'Blue Willow' that their mothers and grandmothers had bought before them. The younger generation, who wanted something more contemporary, tended to buy gaudily enamelled earthenwares on awkward geometric shapes – the kind of ceramics that made Clarice Cliff well known (plate 3). 'Jazz Age' designs that nodded to continental art movements were available from many of the hundreds of small potbanks operating from Stoke-on-Trent. By the time Susie Cooper launched her Kestrel range in the spring of 1932, Britain

2. A Susie Cooper advertisement from 1933, 'Expressing Modernity'.

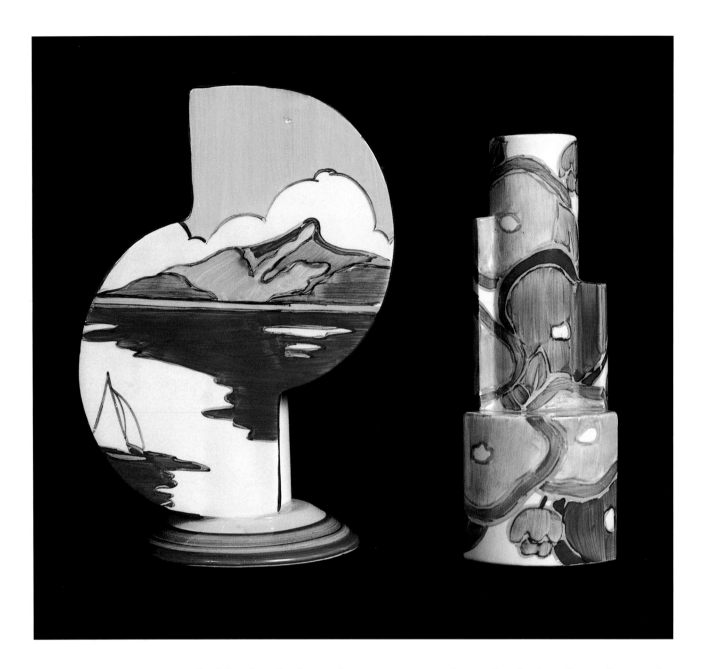

3. Two examples of the work of Clarice Cliff (1899-1972) for A.J. Wilkinson Ltd. Shape 464, 9⅜in (24cm) high, decorated with the hand-painted Gibraltar pattern, from 1931 and a vase (shape 511) decorated with the Chintz pattern from 1932. Cliff's designs appeared modern yet were not the product of a Modernist design process.

had developed a fine tradition in imitating the modern look without adopting the wider philosophy. In architecture, domestic design and ceramics our attempts at the modern, such as the art deco style, were mostly restricted to superficial mimicry.[2]

The middle classes were constantly reminded of British failings in modern design by a vanguard of noisy art critics and writers including Herbert Read, John Gloag, Nikolaus Pevsner and Serge Chermayeff. The Design and Industries Association had been organising lectures and publications since 1915 to try to influence the buying habits of the nostalgic Britons. In 1919 the British Institute of Industrial Art had been formed by the Government to raise the standard of design. In 1930 the Society of Industrial Artists and from 1931 the Gorell Committee on Art and Industry joined the ranks of those who wanted to take British design forward. Yet by 1932 a series of BBC radio programmes on 'Art and Design' was broadcasting the virtues of the German Bauhaus School to a Britain that was really quite happy

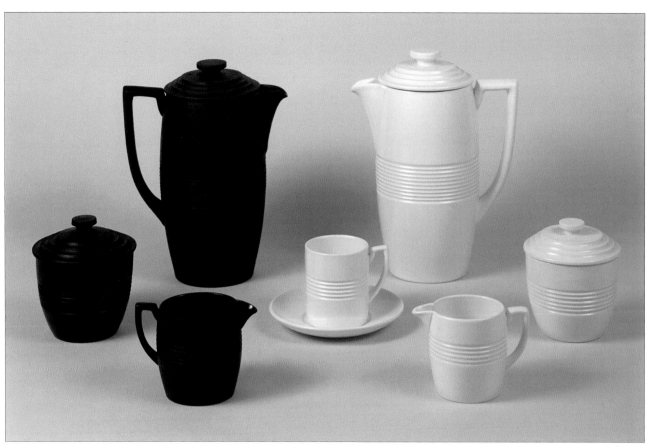

4. Two examples of the Keith Murray coffee set produced in Moonstone and Black Basalt by Josiah Wedgwood and Sons Ltd., from about 1934. Height of coffee pot 7¼in (18.4cms). Although celebrated by design critics, these 'modern' ceramics were awkward to use and stained easily.

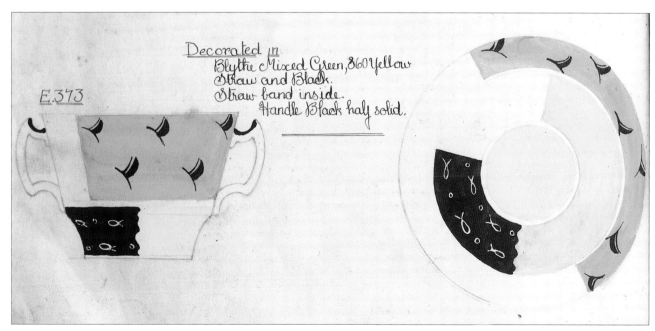

5. An illustration from the Susie Cooper Crown Works pattern book illustrating one of her modern patterns (E/373) from about 1933. Although this pattern would have appealed to contemporary taste, the design was too fussy to have fulfilled Modern Movement ideals.

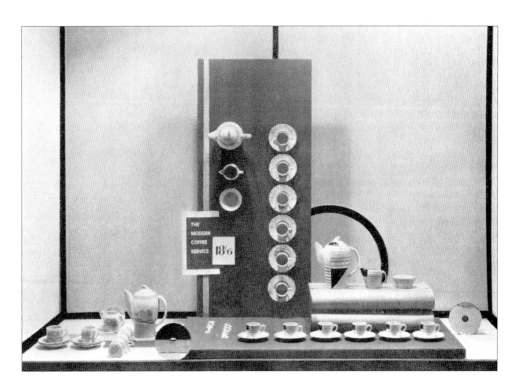

6. A window display of Susie Cooper pottery showing a modern floral pattern, Campanulas (E/307) (left) and a modernist pattern, (E/279). About 1935.

to have chintz on their tablecloths and chintz on their tea sets.[3] Only ten per cent of manufacturers even employed a designer,[4] and 'one could count on the fingers of one hand the number of retail businesses that were really interested in design.'[5]

A few potbanks did toy with the ideals of the Modern Movement that promoted utility and simplicity in design, aesthetics shaped from the production process as well as affordability. Johnson Brothers Ltd., for example, produced some remarkably simple and affordable tablewares that attracted the compliments of Gordon Forsyth. T.G. Green's 'Cornishware' was in production right through the inter-war period, and by chance matched the tenets of Modernism, even though it sold itself on a 'homely cottage' image. Josiah Wedgwood and Sons Ltd. risked going modern with Norman Wilson, Keith Murray and Eric Ravilious (from 1936). Murray's engine-turned matt-glaze range became the modern favourite of virtually every art critic in the capital (plate 4), yet at prices as high as £15 10s for a dinner set they could never fulfil the need for 'good design for all'.[6] Further, their 'machine age aesthetic' was in fact the result of considerable handwork, and some of the matt glazes proved impractical for tableware when they absorbed stains.

Then there was Susie Cooper. Aged just twenty-seven, she established her own potbank, invested considerably in having new shapes and patterns produced, and launched her own distinctive brand of modern ceramics on to the market. She could have taken the safe option of buying in cheap whiteware and applying her own designs. She could have launched with a range of 'safe-bet' traditional patterns that would be perennially popular. She could have paid her paintresses to knock-out stock on-glaze enamel decoration similar to the then popular lines of Clarice Cliff – but she didn't. All the evidence would suggest that Susie Cooper wasn't in the game simply to make money – she really did want to do something different by introducing affordable, modern design to the British ceramics market (plate 7). Her approach to design, she claimed, 'was as much about ideology as biology'.[7] In 1930 the first Susie Cooper advertisement appeared in the trade press, illustrating the modern values at the heart of her business. In 1933 another company advertisement proclaimed that

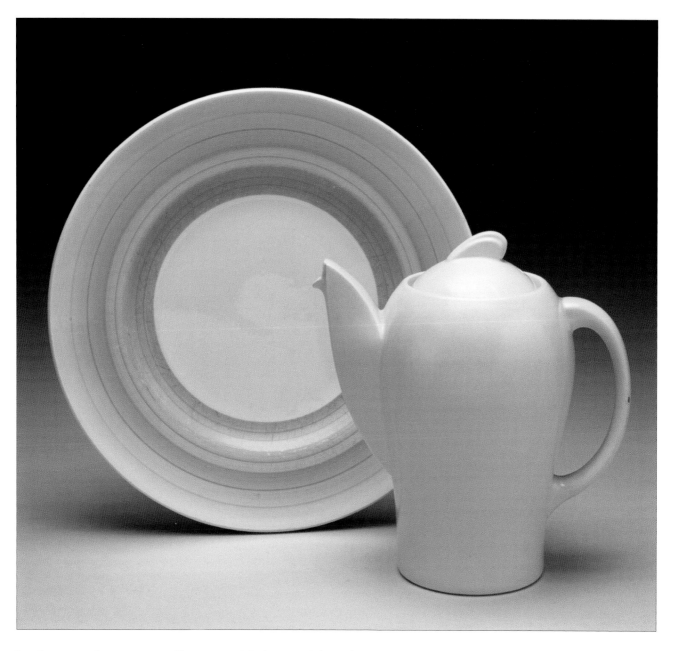

her latest productions were 'Expressing Modernity' (plate 2).[8]

In March 1932 Susie Cooper launched the Kestrel range, claiming that 'Its simple lines are sufficient recommendation of its usefulness'.[9] The shape was an instant success and lent itself to a range of decorative techniques, patterns and lithographs until at least the late fifties (plate 7). So what was it that made Cooper's ceramics so different, so modern? Simply put, she produced ceramics that worked, and worked well. Her tea pots don't drip. Her cups fit their saucers perfectly. Every piece is perfectly weighted to allow for ease of use and stacks well in the cupboard. Handles (on Kestrel cups and jugs) are positioned 'upside down' to enable effective handling. The Kestrel tureen has a lid that can be used as a separate serving dish. Decoration was generally reserved and elegant – applied to complement the form rather than obscure it, and it was often underglaze to prevent scratching. Her work suited modern life – it was easy to clean, easy to use, easy to store, and was available

7. An earthenware Kestrel shape coffee pot, height 7½in (19cm), decorated with an aubergine glaze and an earthenware dinner plate decorated with a Wedding Ring pattern (E/698). The aubergine glaze treatment was introduced in about 1938.

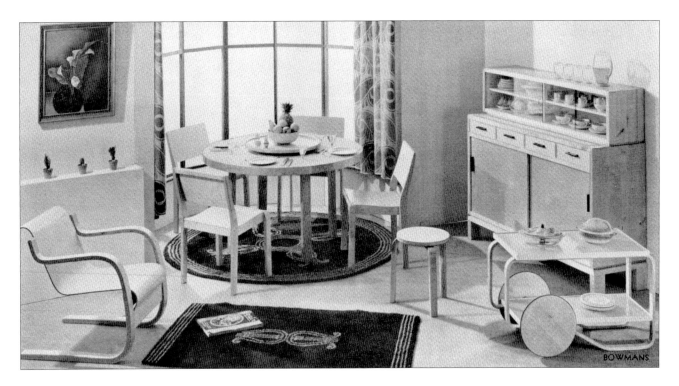

8. A contemporary interior featuring Susie Cooper Kestrel tureens and plates and modern furniture designed by Alvar Aalto. This 1935 room setting from Bowman's department store illustrates that Susie Cooper was recognised as a pioneer of British Modernism.

in small place-settings to suit smaller families that often had only two children. None of this was earth-shattering stuff, but it was enough to mean that she gained a reputation for good, modern design that would last beyond her lifetime. Having recently witnessed a Kestrel coffee pot that has been in daily use for sixty-five years, I have no question about the strength of her designs. Susie Cooper could design well, and design well she did.

The trade press and design 'Establishment' warmed to her simple shapes and subtle decoration. Her Kestrel pots were soon on display in virtually all major department stores, and usually in modern and modernistic room settings. Bowman's store (second only to Heal's for promoting modernism in London) proudly displayed her tureens on the breathtakingly modern dining furniture by Finnish architect Alvar Aalto in 1935 (plate 8). Gordon Forsyth featured Kestrel in his seminal text, *Twentieth Century Ceramics*, in 1936.[10]

Susie Cooper stood out from her contemporaries in that she passionately believed that she was making a contribution to modern living. When asked in 1933 if she wanted to go to London to make a name for herself, she replied: 'So many people get their training in their native place, only to desert it as soon as they begin to make their way. It never seems fair to me. I shall just stay in the Potteries, and do what I can for them.'[11] She revealed that she developed the Graduated Black Bands pattern to keep one girl in employment who could only do banding (plate 9).[12] Susie Cooper was committed not only to providing good design for professional people with taste and not much money but also to making modern design work for the people of Stoke-on-Trent.

Whilst some designers simply used the modern aesthetic to 'tart up' their ranges with a contemporary line, Susie Cooper was committed to the principle of improving lives through a working environment that was fair to all. Not every piece of Crown Works pottery was a modernist masterpiece (we know from interviews that Susie Cooper herself felt that some of the fussier decorated patterns compromised her design ideals), but every piece was well designed and well

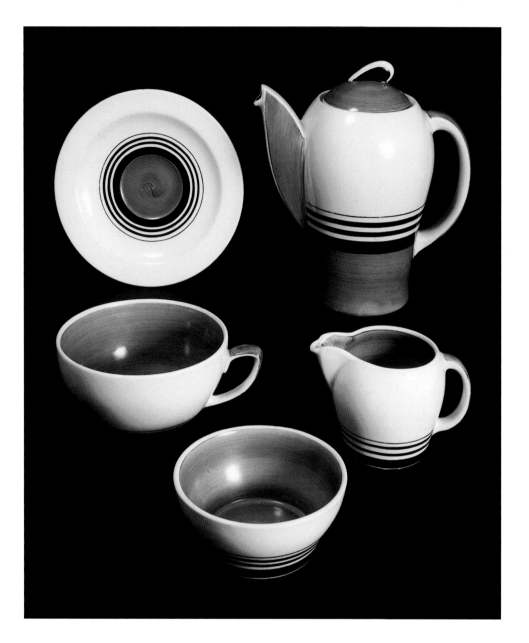

executed. In an interview for the 'Pottery Ladies' documentary in 1985 Susie Cooper informed us that she had been 'designing for the people and the circumstances.'[13]

Britain was changing in the early 1930s. Millions of people were moving to new homes in the suburbs with electricity and kitchens fitted with 'all mod cons', and the lucky ones even had a car in the garage. Wireless sets in almost every home, and a proliferation of fashion magazines, meant that people were aware of the latest fashions in Paris, Berlin and New York. The younger generation began to break free from the stuffy Victorian and Edwardian interior designs that still clung to most British homes. With new houses to decorate people began to experiment in the new, modern style. These improved living standards, coupled with new social freedoms, meant that many found themselves living in what they called the 'Modern' world. The world seemed different to them, and the future seemed bright. Some of those changes were brought about by domestic ephemera. Modern-looking

9. A collection of earthenware tablewares decorated with graduated black bands (E/501), from about 1933. This pattern was developed to keep one girl in employment. Susie Cooper was committed to making modern design work for the people of Stoke-on-Trent.

10. 'Stillness', a typical modern British villa, designed by architect Gilbert Booth in 1934.

pots became symbolic of the new domestic life enjoyed by the suburban middle classes. Buying Susie Cooper's pots meant, by the mid-thirties, taking part in the modern way of living. She herself was a modern woman – running her own business and designing her own pots.

Simply put, Susie Cooper was the closest that British industrial ceramics got to being modern in the inter-war years. Unlike the fussy output of the majority of earthenware manufacturers of the time, her ceramics were designed to work well, and were intended to provide good modern design at accessible prices. Possession and display of her work was a social act of allying oneself with the concept of being modern. Yes, the pots looked great, and worked even better – but they had the designer label underneath that informed the reader that the owner had good, modern taste. Having Susie Cooper's simple, elegant designs on the breakfast table or dresser was, in a way, having a ticket to what was understood then as being the bright, new age. Modern British ceramics embodied the ideals of modern life, and worked as social symbols when employed in the home. As a woman running her own business, and designing both ceramic shapes and patterns, and then selling them at affordable prices, Susie Cooper was the first British modern ceramic designer.

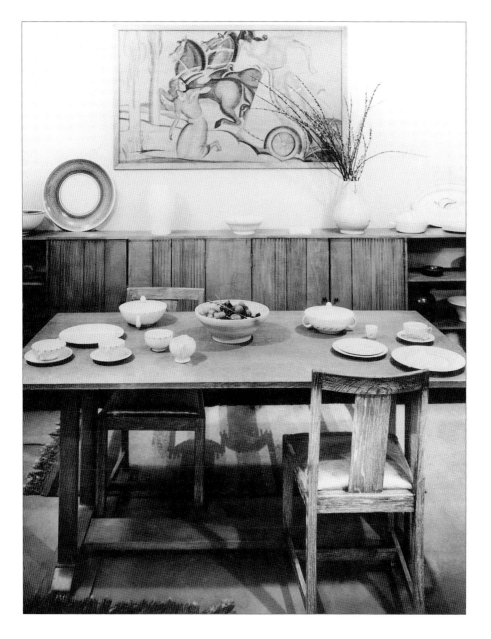

11. The Susie Cooper trade stand at the British Industries Fair of 1938. Note the panel that was hand painted by Susie Cooper but was destroyed during the Blitz.

FOOTNOTES

1. Architect and designer Serge Chermayeff introducing his lecture, 'A New Spirit and Idealism', given at Heals department store, London, 26th October 1931.
2. For further information see: Stevenson, G., *Art Deco Ceramics*, Shire Books, 1998.
3. For further information see: Stevenson, G., *The 1930s Home*, Shire Books, 2000.
4. Pevsner N., Pottery: Design, Manufacture, Marketing Trends, in *Design* No. 2, 1936, pp.9-18.
5. Josiah Wedgwood V in the *Pottery Gazette and Glass Trade Review*, 1932: p.515.
6. A dinner set decorated with the Irish pattern on moonstone was exhibited at the 1935 Medici Gallery for £15 10s (source: original catalogue). Standard lines were cheaper at between 10s and 24s a vase, but even these prices were at the top end of the market.
7. Information from an interview by Andrew Casey with Susie Cooper, June 1990.
8. A Susie Cooper advertisement. *The Pottery Gazette and Glass Trade Review*, January 1933, p.28.
9. Information from the 'Susie Cooper Her Productions' catalogue, 1932.
10. Forsyth, G., *Twentieth Century Ceramics*, The Studio Ltd., 1936.
11. Critchlow, D., 'Susie Cooper – An artist who brings beauty to many homes', *The Manchester Evening News*, 1 March 1933.
12. Information from an interview by Andrew Casey with Susie Cooper, June 1990.
13. Information from the 'Potteries Ladies' television programme made by Channel Four in 1985.

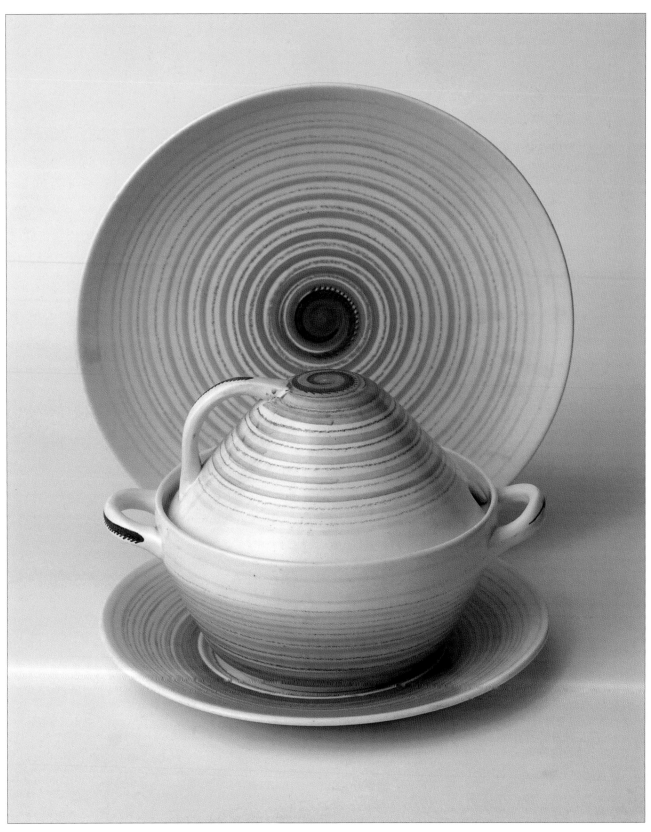

1. An earthenware Kestrel shape sauce tureen, cover and stand painted in underglaze dark brown and brown crayon lines with an aubergine glaze (E/1031). Designed by Susie Cooper, about 1935.

CHAPTER 12

SUSIE COOPER IN CONTEXT
Women and Design in 1930s Britain

Cheryl Buckley

To the historian interested in the relationship between women and design, Susie Cooper is exemplary. Her role as manufacturer and designer stands out amongst her contemporaries, as she demonstrated great ability in reading the market, understanding the skills of her workforce, recognising the technological possibilities and limitations of industrial ceramics manufacture in Stoke-on-Trent, and balancing all these to produce designs which combined 'form and fashion – characteristic of the twentieth century'[1] (plate 1). Drawing comparisons with other designers, it is tempting to see Susie Cooper as uniquely talented, above her rivals, however in this essay I want to argue against this view to some extent. Instead, I want to show how her work and roles as designer and manufacturer responded and contributed to the social, economic and cultural changes, which characterised

2. A Susie Cooper portrait by the studio of the London-based photographer, Cleo Cottrell, about 1938.

3. A portrait of Clarice Cliff, about 1930-32.

Britain between the wars.

I met Susie Cooper, along with a number of other women ceramics designers, almost twenty years ago when I began my doctoral research.[2] These professional (mainly middle-class) women, including Susie Cooper, Freda Beardmore, Agnete Hoy, Star Wedgwood and Grete Marks, exuded a strong sense of their own personal identities. Without question they had benefited from the social and cultural changes which characterised British society following the First World War. Several had been to art school, they had travelled, joined professional organisations, and most importantly, they had jobs, which they enjoyed. The social class of these women mattered a great deal in terms of their access to better opportunities, but as others have shown, even women from the working-classes (particularly young single women) enjoyed more personal freedom and employment opportunities than hitherto.[3] As this book of essays makes clear, Susie Cooper's ability as a ceramic designer didn't just appear as if by magic, nor was she simply imbued with it as a native of Stoke-on-Trent; indeed it had been almost a coincidence that she had gone into ceramic design and not into fashion. Rather, it was as a single woman in her early thirties that her abilities as designer and manufacturer became most apparent, as she gained confidence and learned to follow her own judgements, even if these sometimes seemed at odds with those of others.

After over twenty years of researching aspects of twentieth-century British design and of exploring issues of gender in relation to design theory and history as well as ceramics and fashion, I see Susie Cooper as a woman of her time. She was one of a number who operated effectively in the world of design between 1919 and 1939; there were the architects, Elisabeth Scott, Betty Scott and Norah Aiton, Sadie Speight, Jane Drew, and Gillian Harrison; the textile designers, Marion Dorn, Enid Marx, Ethel Mairet, Joyce Clissold, Phyllis Barron and Dorothy Larcher; the furniture and interior designers, Betty Joel, Syrie Maugham, and Judith Hughes.[4] There was also a large group of women designers of industrial ceramics (Clarice Cliff, Millicent Taplin, Star Wedgwood, Agnete Hoy, Freda Beardmore, Grete Marks), as well as others working in studio ceramics (Katherine Pleydell-Bouverie, Norah Braden, and Lucie Rie).[5] There were also women such as Elizabeth Denby, Ida Copeland and Mrs Darcy Braddell, who served on key committees examining

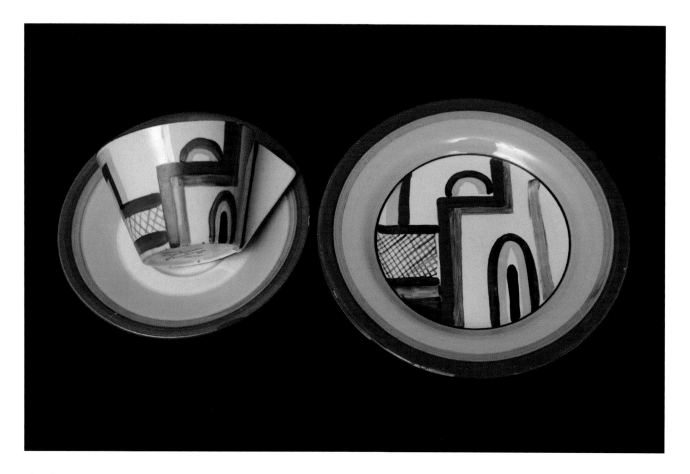

the design of housing and the design of goods for the home, and there were women tutors at the Royal College of Art and the Central School of Arts and Crafts. However, women's progress in design was uneven during this period, and the roles of Susie Cooper and of these other women epitomise the complexities and contradictions inherent in women's lives in inter-war Britain.[6] As Jonathan Woodham has argued, although women were acknowledged more often in some spheres of design activity than in others, and although their roles as consumers of design products were recognised as the 1930s progressed: 'The fact that the acknowledged expertise of women was often largely predicated around the home, its organisation, furnishings, decoration, kitchen design and equipment was perhaps instrumental in marginalising its true value in the face of continuing male domination, and thus masculine values, in professional design circles in the interwar years in Britain.'[7]

The professionalism of design and the designer was certainly on the agenda for a number of reasons at this time, including low pay, poor status, and the need for appropriate design training. There was also a perception that professional designers would improve the quality of British manufacturing goods. Some women designers were part of this process of professionalisation (Susie Cooper is a case in point through her activities with the Society of Industrial Artists), however other women worked in various industries designing products without either the status or remuneration associated with the professions. As Woodham notes, women tended to design products associated with the home, and I agree with his view that to some extent their activities were marginalised as a result of this. However I also believe that new and increased opportunities emerged for women designers as the home

4. An earthenware Conical shape cup, saucer and plate decorated with the hand-painted pattern Tennis, from the Bizarre range. Designed by Clarice Cliff for A.J. Wilkinson Ltd., 1930-31.

market for domestic goods expanded in the 1930s, and that women, for reasons which were undoubtedly patriarchal, were perceived to have a facility for designing objects for the home which ultimately benefited them in some ways.

The period 'between the wars' was characterised by political, social and economic insecurity. Britain was haunted by the spectre of wars – of one recently ended and one looming. The sheer scale of death of young men between 1914 and 1918 had dented confidence and belief in modernity and progress, and by the early 1930s the rise of fascism across Europe provoked further unease and insecurity. Equally important was the economic uncertainty which dogged Britain throughout the 1920s and 1930s, as pre-war export markets for traditional goods (such as ceramics) were never fully regained. Fierce competition from abroad adversely affected British manufacturers' abilities to export their goods, but it also increasingly threatened the home market. This was compounded by world-wide depression from 1929 which blighted traditional manufacturing industries (including ceramics) until the mid-1930s. For those who were young, including Susie Cooper who was twenty-eight in 1930, a seismic shift occurred during these years which irrevocably changed attitudes towards the older generation, but also towards their own personal roles and responsibilities. Perceptions of marriage and sex, work and the family, education and leisure contributed to the shift in the individual consciousness; and to many of the older generation, the young seemed uncaring and selfish.

Even those who recognised the extraordinary changes which had taken place experienced unease about the young. Writer and feminist Winifred Holtby struggled to understand the motivations of young women, even though her instinct was to defend their right to self-determination.[8] As someone who had fiercely enunciated and defended their rights during the campaign for the vote, she acknowledged their apparent selfishness and lack of civic or political engagement, but she attributed it to the economic conditions of the slump and the failure of governments to articulate a better world for the young in the aftermath of the First World War. As a representative of a generation shaped by left-wing politics and feminism, Holtby feared that the hard-won freedoms for which her contemporaries had fought were being squandered by a younger generation intent on personal gratification. Images of young women from both the working-class and middle-classes concerned merely with the pleasures of the cinema, the dance-hall, and 'lounging on the edge of the bathing-pools' compounded this and were anathema not only to Holtby, but also, for different reasons, to an older, more conservative generation.[9]

Looking back on the 1930s with the benefit of hindsight, we can see that this assessment of young women's lives is a partial one, coloured inevitably by personal preoccupations and historical circumstances. It is difficult when reading Holtby's *Women and a changing civilisation*, written in 1934, to reconcile these perceptions with the activities of women in the ceramics industry. It was undoubtedly a relatively privileged group of women who worked as designers, but many young working-class women were able to choose reasonably paid work in the ceramics industry rather than enter the restrictive paternalism of domestic service. Perhaps Holtby's judgement of these changes was clouded by what seemed at the time to be the younger generation's pursuit of hedonistic pleasures that somehow went against the grain for those who had lived through the trauma of the First World War? The historian Sally Alexander argued in an influential essay that it was a characteristic of the left and the older generation of feminists to dismiss and trivialise women's interest in fashion, dancing, and cinema between the wars. She quotes the novelist, John Sommerfield, who criticised women's 'synthetic Hollywood dreams, their pathetic silk stockings and lipstick, their foolish strivings'.[10] Whereas one can argue

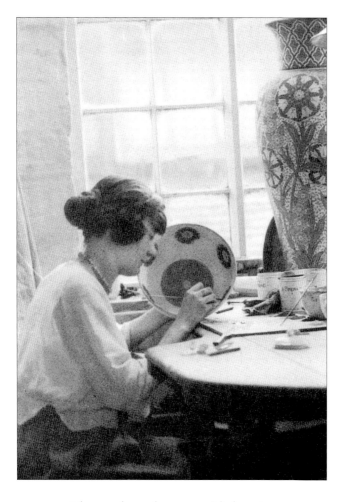

that this engagement with popular culture provided an important arena in which young women could begin to imagine different lives for themselves than those that their mothers had experienced.

It is intriguing in this respect to consider contemporary visual images of Susie Cooper and her contemporaries. Invariably stylishly and glamorously dressed, fashion was a visual representation of their changing roles and expectations. Star Wedgwood, Susie Cooper, Freda Beardmore, Millicent Taplin, Clarice Cliff and Grete Marks were potent role models for young, professional women whose ambitions and expectations were at odds with those of their mothers and grandmothers. When one thinks of Cliff, she was the archetypal modern young woman – driving a motor-car, owning her flat, dressing stylishly, living her life unconventionally – but at the same time, maintaining a highly successful career as an industrial ceramics designer. Equally revealing are images of Susie Cooper, such as her portrait by Cleo Cottrell's studio of 1938 (plate 2), which captured a young woman on the threshold of an impressive career, confidently posed and elegantly attired. This was the woman who attended debates at the Society of Industrial Artists and whose contributions to discussions about ceramic design and manufacture were comprehensively reported in *The Pottery Gazette and Glass Trade Review*. Working in a predominantly patriarchal industry in which gender divisions had been entrenched in the manufacturing process and reinforced by a plethora of restrictive practices instigated and maintained by powerful male-dominated trade unions, Susie Cooper was emblematic of the far-reaching changes which had begun

to transform the ceramics industry following the First World War.[11] This photograph depicts a young woman with courage, ability, and a strong sense of her own value and intelligence, one quite at odds with those young women upbraided by Holtby.

Gendered labour divisions were endemic in the ceramics industry of Stoke-on-Trent, and in effect they were the physical and material embodiment of patriarchy, which aimed to differentiate jobs on the basis of sex. However, these divisions were systematically undermined between 1919 and 1940 by women eager for new work and by manufacturers keen to reduce labour costs as the needs of capitalism for cheap workers were prioritised over the patriarchal desire to keep women separate in unskilled poorly paid jobs.[12] Ultimately male trade unions and their members lost out as women demonstrated that they could continue to do the jobs which they had undertaken during the First World War for significantly lower wages than men (although still paid better than women had hitherto been). Crucially, as gender divisions in the ceramics industry were re-drawn, women maintained their dominance in the decorating sections in which they had traditionally outnumbered men. They also increased their numbers in those sections of production which had been previously controlled by men, for example as makers of ware (as operators of the semi-automated jigger and jolley machines and as casters). Women doubled their numbers as dippers and glazers of wares; and they also increased their number as Managers and Employers, and as Foremen and Overlookers – the category which included Susie Cooper. Most importantly we can see that gender divisions in the ceramics industry began to be recast in the period 1880 to 1919; but they changed most dramatically between 1919 and 1939. More women worked in sectors of the pottery industry previously described as 'men's'; more women had access to semi-skilled work; and there were more women in positions of power and influence. The material and ideological basis of patriarchy was being redefined by a combination of women's efforts, economics, labour relations and new practices brought about during the First World War.

Inevitably such changes brought conflict and contradiction. There was resistance to women's increased visibility in the workforce, but, 'Aspirations too were changing. Most strikingly, advertising and the cinema, playing on fantasy and desire, enabled women to imagine an end to domestic drudgery and chronic want.'[13] Susie Cooper's contemporaries were also able to imagine a different world. Most well known is Clarice Cliff (plate 3), whose rise to Art Director at A.J. Wilkinson Ltd. has been well documented. Like a handful of women who became designers in the ceramics industry, Cliff came from a working-class background, but due to the changing social context of the period, transformations to work practices in the industry, and also due to sheer ability and hard work, she moved from painting pottery to designing it, promoting it and managing the factory. With great flair and business acumen, Cliff produced a number of designs which captured the public imagination, and perfectly epitomised popular forms of modernity in Britain in the 1920s and 1930s (plate 4). Freda Beardmore had an important and influential designing role at E. Brain and Co.'s Foley China, and with Clarice Cliff at A.J. Wilkinson Ltd., was responsible for translating the modernist designs of a number of avant-garde artists, including Laura Knight, Vanessa Bell, Paul Nash and Duncan Grant, to domestic tableware patterns in the mid-1930s as part of the 'Harrods experiment'.[14] Millicent Taplin moved from free-hand paintress to designer and, along with Star Wedgwood, made important contributions to the new approach to design and manufacture at Josiah Wedgwood and Sons Ltd., as a younger more forward-looking management team took over in the early 1930s (plate 5).

Significantly, these women articulated design solutions, which represented women's changing aspirations and expectations within the home. They designed for the new home-owning classes who wanted different products to symbolise their modern progressive lifestyles. Between 1920 and 1939, the housing stock of Britain improved substantially due to a combination of government intervention and capitalist enterprise. Overall 4.5 million houses were built; 1.5 million in the 1920s with state subsidies and almost three million in the 1930s, built mainly by speculative builders for owner-occupation.[15] These new houses and their residents required furnishings, appliances and domestic items, which included ceramic tablewares. For manufacturers attempting to rebuild their businesses following the depression, this represented an important new market as they struggled to regain their previous pre-eminent overseas trading position and as foreign competition intensified.[16] The 'breakfast-in-bed' tableware sets pioneered by Susie Cooper epitomised the needs of this new domestic market as increasing informality characterised people's lives in semi-detached suburbia (plate 7). With more modest social expectations and a greater concern for practicality as domestic servants proved hard to find, people purchased smaller sets of domestic pottery, which could be added to and changed relatively easily. But most importantly these designs epitomised the particular qualities of modernity and modernism in Britain in the 1930s, and in this respect, the work of Susie Cooper and her contemporaries stands out. These women designers, with Susie Cooper at the forefront, were attuned to the needs of the female consumer who demanded different products for use in the modern, middle-class home. Their design solutions had to combine decorative traditions intrinsic to industrial ceramic manufacture, with the new design language of European modernism, which became increasingly influential in Britain as the 1930s progressed. Most manufacturers of industrial ceramics were highly ambivalent about modernism, and they depended on designers of the calibre of Susie Cooper to transform the reductive and ascetic language of modernism into one with visual appeal and market compatibility. Susie Cooper showed great skill

6. A collection of earthenwares including a Kestrel shape tea pot and Falcon shape cups and saucers decorated with the printed Beechwood pattern, about 1953. This pattern was originally hand painted in the 1930s.

7. An earthenware Spiral shape breakfast in bed set on a wooden tray. Designed by Susie Cooper, about 1938-39.

in producing new ranges of domestic tableware, which drew on emerging modernist design discourses, whilst remaining distinctively 'decorative', whereas Clarice Cliff synthesised modernist and Art Deco design elements to produce a hugely popular decorative style. At the same time, Josiah Wedgwood and Sons Ltd., the well-established and highly prestigious company, enhanced its economic viability by producing some designs that looked back to its eighteenth-century decorative traditions, and others which drew on modernism, to provide ceramics for the burgeoning domestic market for modern tablewares.

In retrospect Susie Cooper was particularly well attuned to the changing context in which she worked as a designer in Britain in the 1930s. Not only was she highly innovative as a designer, particularly in articulating a British response to modernist design, which showed sensitivity to the needs of the consumer, but also she was a symbol of the ways in which women's roles were changing. She was one of a number of women, relatively privileged, but nonetheless talented, who were at the vanguard of ceramic design in Britain in the inter-war years. She remains an effective role model for young women designers, but also for women such as myself, who are inspired by her remarkable energy, enthusiasm, and commitment to her chosen career.

FOOTNOTES

1. Trethowan, H., 'Modern British Pottery Design', *The Studio*, Vol.106, 1932, p.184.
2. See 'Women Designers in the North Staffordshire Pottery Industry, 1914-1940', Ph.D thesis, University of East Anglia, 1991. Some of the material which formed the basis of this appeared in Buckley, C., *Potters and Paintresses. Women Designers in the Pottery Industry, 1870-1955*, The Women's Press, 1990.
3. See the following articles, books and essays for an introduction to the debates about women's roles in Britain between the wars: Giles, J., '"Playing Hard to Get": working-class women, sexuality and respectability in Britain, 1918-1940', in *Women's History Review*, vol.3., no.1, 1994; Alexander, S., *Becoming a Woman and other essays in 19th and 20th century Feminist History*, essay 'Becoming a Woman in London in the 1920s and 1930s', Virago, 1994; Holtby, W., *Women and a changing civilisation*, John Lane, 1934; Kingsley Kent, S., *Making Peace. The Reconstruction of Gender in Interwar Britain*, Princeton University Press, 1993; Beddoe, D., *Back to Home & Duty: Women Between the Wars, 1918-1939*, Pandora, 1989; Pugh, M., *Women and The Women's Movement in Britain 1914-1959*, Macmillan, 1992; Spring Rice, M., *Working-class Wives*, Virago, 1981; Roberts, E., *A Woman's Place. An Oral History of Working-class Women 1890-1940*, Blackwell, 1984; Jephcott, P.A., *Girls Growing Up*, Faber and Faber, 1942.
4. For further information I suggest: Seddon, J. and Worden, S., *Women Designing. Redefining Design in Britain between the Wars*, University of Brighton, 1994; Walker, L., *Women Architects. Their Work*, Sorella Press, 1984; Walker, L., *Drawing on Diversity. Women, architecture and practice*, Royal Institute of British Architects, 1997; Boydell, C., *The Architect of Floors: modernism, art and Marion Dorn designs*, Schoeser, 1996; Peto, J. and Loveday, D., *Modern Britain 1929-1939*, Design Museum, 1999.
5. For further information see Buckley, C., *Potters and Paintresses. Women Designers in the Pottery Industry, 1870-1955*, The Women's Press, 1990; Vincentelli, M., *Gendered Vessels. Women and Ceramics*, Manchester University Press, 2000.
6. For an interesting insight into women's participation in design training at the Royal College of Art, London see Cunliffe-Charlesworth, H., 'Women and Design Education: The Royal College of Art' in Seddon and Worden, *Women Designing*, pp.11-15.
7. Woodham, J., 'Women, Design and the State in the Interwar Years: a Case Study of Elizabeth Denby and the Council for Art and Industry', in Seddon and Worden, *Women Designing*, p.45.
8. Holtby, W., *Women and a changing civilisation*, John Lane, 1934, p.115.
9. Ibid. p.119.
10. Alexander, S., 'Becoming a Woman in London in the 1920s and 1930s', in Feldman, D. and Stedman Jones, G., *Metropolis. London. Histories and representations since 1800*, Routledge, 1989, p.246.
11. For more information on the sexual division of labour in the pottery industry, see Buckley, C., 'The noblesse of the banks: craft hierarchies, gender divisions and the roles of women paintresses and designers in the British pottery industry, 1890-1939', in *Journal of Design History*, vol.2, no.4, pp.257-273; and Buckley, C., 'Design, Femininity, and Modernism: Interpreting the Work of Susie Cooper', in *Journal of Design History*, Vol.7, no.4, pp.277-293.
12. The 1921 and 1931 censuses provide some useful information about the relationship of the sexes to different areas of work during the period of this study, although the correlation of these is not completely straightforward because of changes in the classifications of work. *Census of England and Wales, 1921, County of Stafford*, HMSO, 1923, Table 16, v, ii) Makers of Bricks, Pottery & earthenware. *Census of England and Wales, 1931* Occupation Tables, HMSO, 1934, Table 16, i) Makers of Bricks, Pottery & Tiles.
13. Alexander, S., 'Becoming a Woman in London in the 1920s and 1930s', in Feldman, and Stedman Jones, *Metropolis*, p.247.
14. For more information see Pelik, R., 'The Harrods Experiment', *Ceramics*, August 1987, pp.33-41 and Eatwell, A., 'A Bold Experiment in Tableware Design', *Antique Collecting*, November 1984.
15. See Mowat, C. Loch, *Britain Between the Wars 1918-1940*, Cambridge University Press, 1955, p.458.
16. In 1929 the value of exports of domestic pottery was just over £3m, in 1930 it was c£2m, and in 1931 it was just over £1.5m. Although this increased to almost £2.5m by 1938, overseas trade was overtaken in importance by the home market which represented twice the value of exports by the mid-1930s. See Haggar, R.G., Mountford, A.R., and Thomas, J., *The Staffordshire Pottery Industry* in Greenslade, M.W., and Jenkins, J.G. (eds.), *The Victoria History of the County of Stafford*, Vol.2, University of London Institute of Historical Research, 1967, p.46. See also Machin, D.J., and Smyth, R.L., *The Changing Structure of the British Pottery Industry 1935-1968*, Department of Economics, University of Keele, 1969.

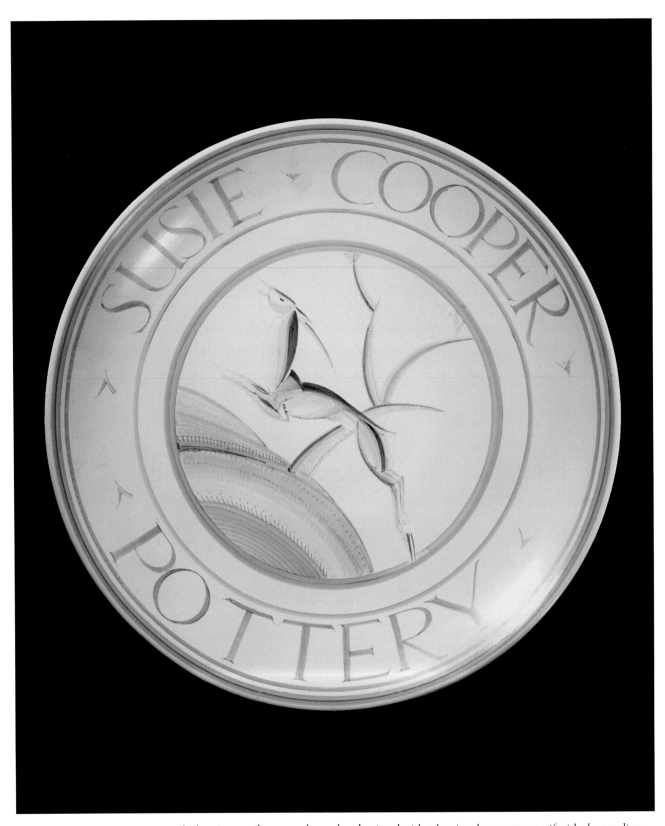

1. A unique earthenware plaque, hand painted with a leaping deer centre motif with the wording SUSIE COOPER POTTERY. This item was probably used for publicity at trade stands or in the showroom, about 1932-34.

CHAPTER 13

MARKETING SUSIE COOPER POTTERY

Andrew Casey

2. A Wedgwood publicity photograph of Susie Cooper in her studio, about 1978. In the background is her version of the RDI plaque from 1954.

Throughout her prolific career Susie Cooper approached marketing with the same blend of understatement and good design that characterised her ceramics. In 1930 she heralded her new business with an advertisement announcing her new products.[1] Marketing emphasised her role as an artist within the pottery industry, and her approach to good practical shapes decorated with tasteful patterns to appeal to the discerning customer.

Her stature as a known designer was another important selling point. During the twenties, whilst working as a designer for Gray's, she was given her own backstamp incorporating the words, 'DESIGNED BY SUSIE COOPER'. It was very unusual within the industry at that time for a pottery manufacturer to name a designer. Once her own company was established the Pottery used her name on various publicity materials, usually in the form of a facsimile signature reinforcing her role as a woman manufacturer. From 1932 until the Second World War she incorporated the leaping deer motif on her backstamp, of which she said: 'It is elegant, attractive, yet has great heart.'[2]

Susie Cooper was in an advantageous position as an independent manufacturer, as she was able to determine her own marketing strategy. Trade advertisements were the

NAMED PIECES

NURSERY WARE

MARGARET

DISCERNING JUVENILES

FOR THE

OF THE

FORRIDGE SET CONSISTS OF
MUG
PLATE
PORRINGER

MILK HORNS
BABY PLATES
TEACUP AND
SAUCER

RISING GENERATION

ZOOLOGICAL
PASTORAL
RHYME AND
OTHER SUBJECTS

PAGE TWELVE

Printed in England
W. H. Nagington & Son, Hanley
Stoke-on-Trent

3. A colour illustration from the 'Susie Cooper. Her Productions' catalogue illustrating nursery ware patterns, 1932.

first of many marketing ploys used by her business. For the first few years her use of advertisements in the trade press was limited, which may have been due to the limitations of production or cautious marketing. Early advertisements were stylishly modern and often carefully placed to advertise the company's stand at the forthcoming British Industries Fair in London. These simple quarter-page advertisements contrasted with those of her competitors such as Josiah Wedgwood and Sons Ltd. and A.J. Wilkinson Ltd., each of which took full-page space almost every month.

4. The cover of the 1932 catalogue.

5. The inside of the Christmas card sent out by the Susie Cooper company in 1937-38 to her business associates and stockists.

During the thirties Susie Cooper's reserve meant that she was rarely interviewed or even photographed by the press. Despite this a number of interviews were recorded with the national press that further promoted her stature as a designer within the British ceramics industry. At about the same time a catalogue entitled 'Susie Cooper. Her Productions' was issued for publicity. This important document not only outlined the designer's intentions but also featured several colour images, a costly undertaking in those days (plate 3). Towards the late thirties the company

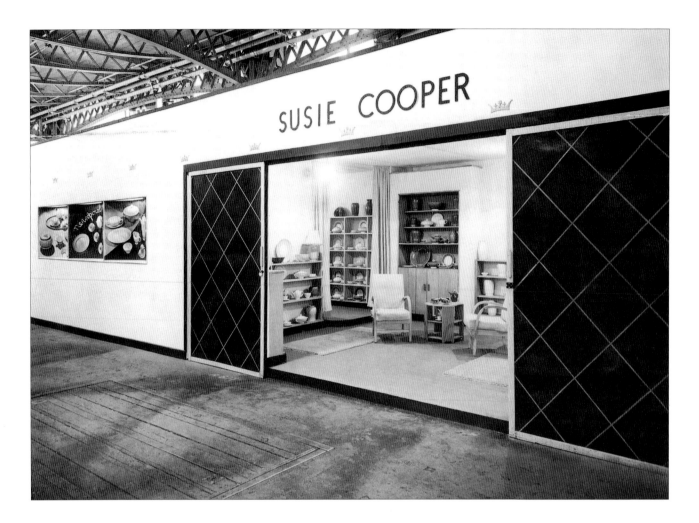

6. An exterior photograph of the Susie Cooper trade stand at the British Industries Fair in 1938. Note the enlarged photograph on the left of the new Spiral shape range.

issued Christmas cards designed by Susie Cooper for her prestigious clients and buyers (plate 5). One of these featured a drawing of the leaping deer motif, used in every aspect of her early marketing.

Within the firm the individual largely responsible for marketing was her brother-in law, Jack Beeson, who played an influential part in the success of the company. According to the family, he was a great character whose charm and charisma were enormous assets to the business. Harry Wood, the owner of Wood and Sons Ltd., recognised the potential in Jack Beeson and recommended that he would be the ideal person to represent Susie Cooper at her new showroom in London. Jack Beeson was instrumental in guiding marketing strategy, both as the London representative and as a close associate of the designer. To gain much-needed publicity he pursued a number of ideas above and beyond advertisements in the press. The firm produced special hand-painted early morning sets in presentation boxes that were sent to all the national newspapers and magazines.[3] The London buyers took to Jack Beeson, who used his charms on the female buyers to find out when their pottery department's budgets were due and when they were intending to buy new stock. It was Jack Beeson who declared at one of the British Industries Fairs: 'Susie Cooper – no home is complete without one.'[4]

The London showroom, situated in a fashionable area, played an important role in promoting Susie Cooper pottery and she designed the interior to display her work to best advantage, attracting many new customers. She also understood the

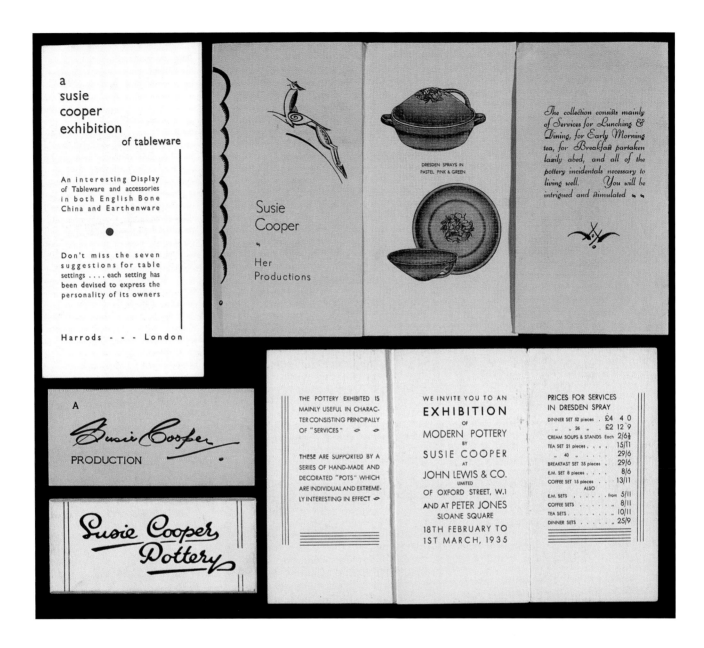

The collection consists mainly of Services for Lunching & Dining, for Early Morning tea, for Breakfast partaken lazily abed, and all of the pottery incidentals necessary to living well. You will be intrigued and stimulated

DRESDEN SPRAYS IN PASTEL PINK & GREEN

a
susie
cooper
exhibition
 of tableware

An interesting Display of Tableware and accessories in both English Bone China and Earthenware

Don't miss the seven suggestions for table settings each setting has been devised to express the personality of its owners

Harrods - - - London

Susie Cooper

Her Productions

A *Susie Cooper*
PRODUCTION

Susie Cooper Pottery

THE POTTERY EXHIBITED IS MAINLY USEFUL IN CHARACTER CONSISTING PRINCIPALLY OF "SERVICES"

THESE ARE SUPPORTED BY A SERIES OF HAND-MADE AND DECORATED "POTS" WHICH ARE INDIVIDUAL AND EXTREMELY INTERESTING IN EFFECT

WE INVITE YOU TO AN
EXHIBITION
OF
MODERN POTTERY
BY
SUSIE COOPER
AT
JOHN LEWIS & CO.
LIMITED
OF OXFORD STREET, W.1
AND AT PETER JONES
SLOANE SQUARE
18TH FEBRUARY TO
1ST MARCH, 1935

PRICES FOR SERVICES IN DRESDEN SPRAY

DINNER SET 52 pieces .	£4 4 0
„ „ 26 „	£2 12 9
CREAM SOUPS & STANDS Each	2/6½
TEA SET 21 pieces	15/11
„ 40 „	29/6
BREAKFAST SET 35 pieces . .	29/6
E.M. SET 8 pieces	8/6
COFFEE SET 15 pieces . . .	13/11
ALSO	
E.M. SETS from	5/11
COFFEE SETS „	8/11
TEA SETS „	10/11
DINNER SETS „	25/9

importance of a stylish trade stand that would not only display her latest work well but would also create interest amongst the London buyers (plate 6). Occasionally special promotional wares were produced, a notable example featuring the words 'Susie Cooper Pottery' (plate 1). At the British Industries Fair in 1932 the trade press commented that Susie Cooper had an artistic stand to show her original modern ware.

In order to show her work to a much wider buying public, selections of her current productions were displayed in many of the fashionable stores around the country, such as Doyle's in Leeds and those of the John Lewis Partnership. A stylish fold-out leaflet outlined the aims of the company and listed the prices (plate 7). Each individual store could have its logo stamped on the leaflet for special promotions, thus raising the firm's profile outside London. Special display cards were produced and probably used on in-store displays (plate 8). One of the important stores in Leeds, Awmacks, saw the sales potential of Susie Cooper

7. A selection of leaflets and cards used to promote the various exhibitions of the Susie Cooper company, about 1932-1935.

ELEGANCE & UTILITY.

"SUSIE COOPER" POTTERY.

pottery and commissioned Wood and Sons Ltd. to produce an exclusive range for them. Woods also perceived the advantages of including the designer's name on the ware and in the trade advertisements of the period. They saw the reputation of Susie Cooper as a sound marketing ploy (plate 9).

As well as displaying her pottery in retail department stores, agents were also appointed to promote the wares. Susie Cooper's sales representatives would take samples to the various stores and shops to gain orders. During the late fifties, hand-painted samples of Katina, Glen Mist and Talisman were taken to Scotland by Bill Burton, described as 'the stalwart agent'.[5] They proved successful and quite a breakthrough for the firm in this very traditional market. Overseas buyers were also essential to marketing and sales. The main contact with them was during the various trade fairs in London, but some would also travel to the Crown Works to meet Susie Cooper. These visits were valuable during the post-war period and one of the managers commented 'we were all made aware of their importance and the factory was given a spruce-up before these visits.'[6] He added, 'no-one did any overseas travelling at that time.'[7]

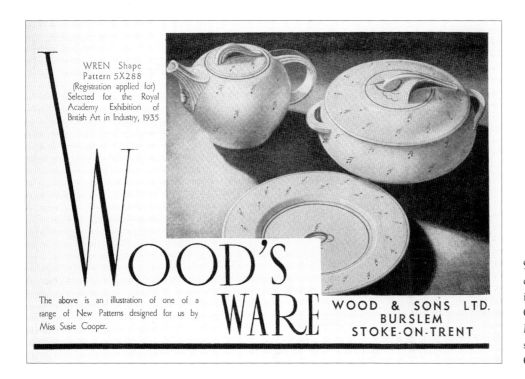

WREN Shape
Pattern 5X288
(Registration applied for)
Selected for the Royal
Academy Exhibition of
British Art in Industry, 1935

WOOD'S WARE

The above is an illustration of one of a range of New Patterns designed for us by Miss Susie Cooper.

WOOD & SONS LTD.
BURSLEM
STOKE-ON-TRENT

9. A Wood & Sons Ltd. company advertisement illustrated in *The Pottery Gazette and Glass Trade Review*, August 1935, showing the new Susie Cooper Academy pattern.

Susie Cooper's profile was raised further when examples of her work were shown in important exhibitions of industrial art. These included British Industrial Art in Relation to the Home at Dorland Hall, London in 1933 and British Art in Industry in 1935, which was staged at the Royal Academy. In 1937 a number of items, including a dinner service and game set, were shown at the International Exhibition in Paris.

Outside Britain her work was in great demand. As early as 1933 a newspaper noted that it was selling in 'Norway and South Africa.'[8] During the same year an arrangement was established with a North American agent, Gene Fondeville,

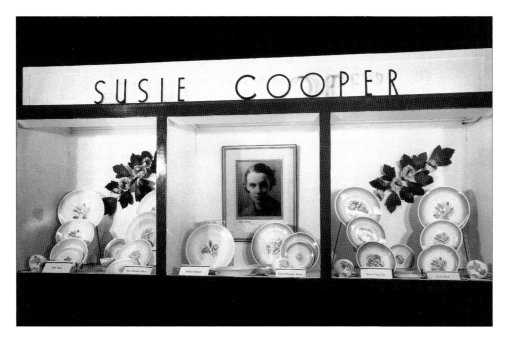

10. A photograph of a window display in Canada showing Susie Cooper pottery, with a portrait of the designer.

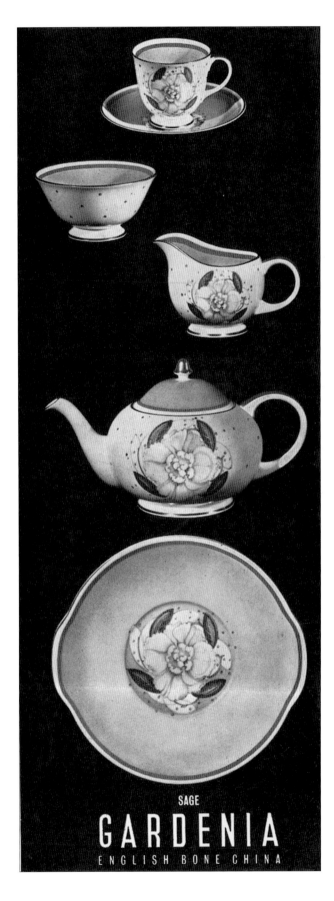

SAGE

GARDENIA
ENGLISH BONE CHINA

based on Fifth Avenue in New York City. Whilst he also represented other British companies such as Ambassador Ware, Paragon Fine China and Embassy Ware he developed a successful North American market for Susie Cooper. A number of advertisements were placed in the North American trade press and her work was often illustrated and discussed in these journals. Special attention was paid to the latest Susie Cooper productions in the *Crockery and Glass Journal*, that illustrated three banded plates.[9] A great emphasis was placed upon her unique style, innovative patterns and of course her 'Englishness'. Many advertisements declared Susie Cooper: 'The first woman potter to achieve international recognition.'[10] Another factor of her success in the North American market can be attributed to T.E. Eaton's, one of the most fashionable stores in Canada. Susie Cooper's original aim, to provide good design for people with taste but not necessarily a lot of money, was successfully exploited in the marketing of her wares to make a positive point: 'originality of shape and colours, clever practicality and a pleasing modestness as to pricing, make Susie Cooper ware a "find" for people who love artistic things, but have a budget to consider.'[11]

Gene Fondeville suggested new production lines, such as turkey sets and water pitchers, but most importantly he also convinced Susie Cooper to have a selection of photographs taken to use for promotion. These photographs, taken in the studio of the London photographer Cleo Cottrell, were used in many of the shop displays and did much to emphasise the designer's elegance and style (plate 10). She was soon supplying a worldwide market, with agents in Cape Town, South Africa from about 1938 and Sydney, Australia in 1939.[12]

During the post-war period, with the introduction of boxed wares, marketing was more co-ordinated. In about 1958 a stylish catalogue was issued featuring black and white images of her work complemented with sketches of each featured pattern. Simultaneously, colour leaflets were distributed, listing on the reverse items and shapes in the illustrated design. Typical patterns included Wild Strawberry (C.486), Black Fruit (C.493-498) and Glen Mist (C.1035). Gene Fondeville continued as her agent after the Second World War, promoting patterns such as Pomme d'Or. Throughout the fifties the exhibiting of Susie Cooper patterns continued in Britain and as

11. A page from the Susie Cooper Company catalogue, about 1958.

174

part of the many prominent overseas design exhibitions, organised by the Council of Industrial Design, to promote good British design abroad. In 1956 an extensive exhibition of the latest Susie Cooper products was shown at the Harrods department store in London (plate 12). This special range included tea, coffee and dinnerware, in both bone china and earthenware, as well as many of the new boxed giftwares (plate 13). The trade press commented that 'it was, perhaps, typical of the firm, that such major and far-reaching new projects were launched so unobtrusively. But there can be little doubt that though the inauguration may have been reticent, the effect will be widespread.'[13]

In 1964 Susie Cooper's Assyrian Motif pattern was used in the film *The Pumpkin Eater*. The film distributors produced a promotional booklet. The trade press noted that 'particular mention was made of Susie Cooper china and where it is obtainable.'[14] A year earlier she spoke on a *Woman's Hour* radio programme that was combined with a personal appearance at the important Selfridges store in London. A special window display had been arranged for this visit.[15]

In 1966 the Susie Cooper Company became part of Josiah Wedgwood and Sons Ltd. The Wedgwood Group had a different policy on marketing and greater resources and could afford to spend much more on advertising. The London showroom was closed but a new Wedgwood showroom at 34 Wigmore Street was

12. A photograph of the Susie Cooper exhibition at Harrods, London in 1956. Note the Spiral Fern pattern in the foreground.

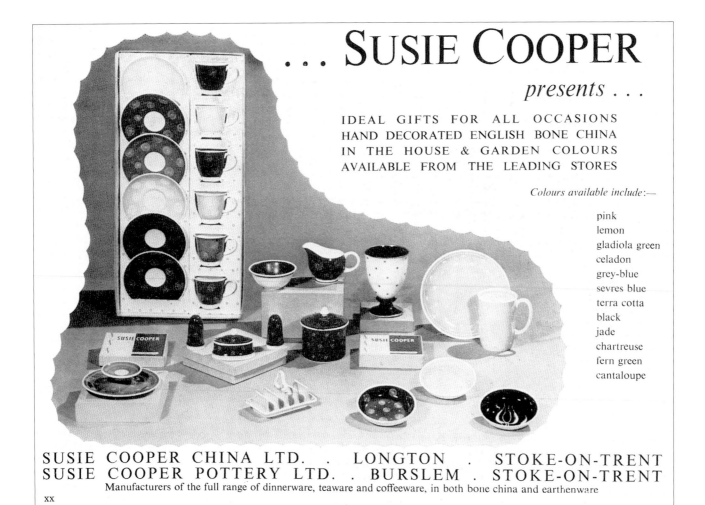

... SUSIE COOPER

presents ...

IDEAL GIFTS FOR ALL OCCASIONS
HAND DECORATED ENGLISH BONE CHINA
IN THE HOUSE & GARDEN COLOURS
AVAILABLE FROM THE LEADING STORES

Colours available include:—

pink
lemon
gladiola green
celadon
grey-blue
sevres blue
terra cotta
black
jade
chartreuse
fern green
cantaloupe

SUSIE COOPER CHINA LTD. . LONGTON . STOKE-ON-TRENT
SUSIE COOPER POTTERY LTD. . BURSLEM . STOKE-ON-TRENT
Manufacturers of the full range of dinnerware, teaware and coffeeware, in both bone china and earthenware

xx

13. A Susie Cooper Ltd. advertisement for the new range of boxed gift wares, about 1958.

allocated for Susie Cooper alongside W. Adams Ltd. In about 1969 a special promotional campaign featuring six patterns by Susie Cooper, including Everglade (C.2186) and Indian Summer (C.2185), was arranged for the important Canadian market. Perhaps with some persuasion from Susie Cooper, Wedgwood continued to use her name on each of her patterns – previously unheard of for an associated company. They too recognised the marketing potential of including the designer's name to emphasise the high quality and originality of her work (plate 14).

Throughout the seventies Susie Cooper, still working on new designs, became something of a celebrity with many national newspapers and magazines running features about her (between 1970 and 2000 over one hundred articles were written on the designer). These not only outlined her remarkable life but had the effect of promoting her latest patterns. The Channel Four series, 'Pottery Ladies', was probably the first time that the wider public saw Susie Cooper on television discussing her work. Subsequently, this programme and other forms of media coverage created a steady collectors' market that culminated with the 'Susie Cooper Productions' retrospective exhibition at the Victoria and Albert Museum, London in 1987. For the first time information and photographs detailing her entire career were catalogued and listed. Today, her cost-conscious wares are design classics.

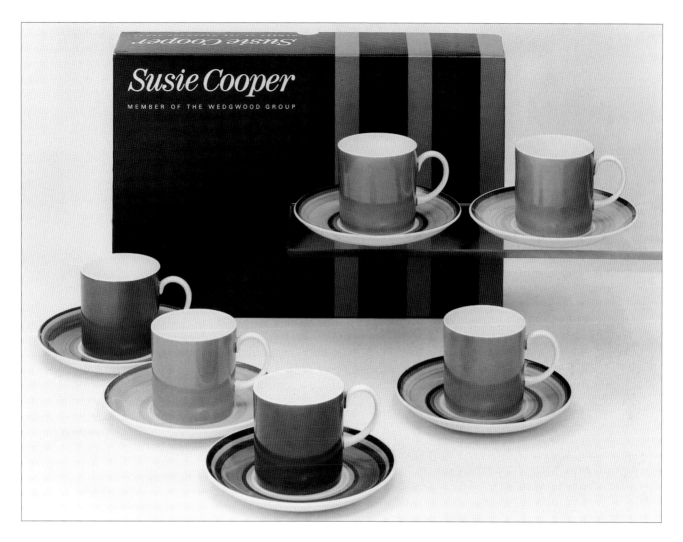

14. A Wedgwood company publicity photograph of the Gay Stripes pattern, decorated on the bone china Can shape, about 1968-69.

FOOTNOTES

1. Company advertisement, *The Pottery Gazette and Glass Trade Review*, April 1930, p.550. (See Chapter 3, plate 6)
2. Benn, E., Why Susie is top of the table, *The Daily Telegraph*, 27 May 1977, p.10.
3. Information from Eddie Sambrook, January 1999.
4. Information from Tim Barker, August 2001.
5. Information from Ron Hughes, 1991.
6. ibid.
7. ibid.
8. Critchlow, D., Susie Cooper – An artist who brings beauty to many homes, *The Manchester Evening News*, 1 March 1933.
9. Kay, Right out of the Kiln, *Crockery and Glass Journal*, June 1933, pp.16-17.
10. Information from a Susie Cooper advertisement for the Patricia Rose pattern.
11. Information from the T. Eaton Co. Ltd. advertisement for Susie Cooper pottery.
12. Susie Cooper advertisement in *The Pottery Gazette and Glass Trade Review*, 1 February 1938.
13. Portent to a new trend: Exhibition at Harrods, *Pottery and Glass*, November 1956, pp.378-9.
14. Film Star China, *The Pottery Gazette and Glass Trade Review incorporating Tableware*, November 1964, p.1210.
15. Susie Cooper at Selfridges, *Pottery Gazette and Glass Trade Review*, December 1963, p.1289.

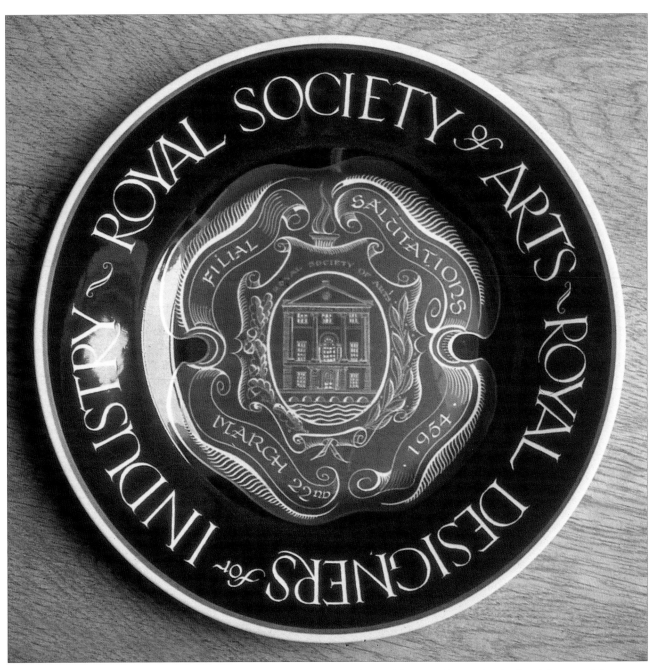

1. The Bicentenary bone china plaque designed by Susie Cooper for the Royal Society of Arts, 1954. Acrographed with sgraffito and gilt decoration. Diameter 12in (30.5cm). The back of the plaque is decorated with a freehand painted fern design in gold and olive green.

CHAPTER 14

SUSIE COOPER RDI AND THE ROYAL SOCIETY OF ARTS

Susan Bennett

A hundred per cent contribution to industrial art

Gordon Forsyth wrote to Susie Cooper in 1940 to express his delight that 'the Royal Society of Arts had the very good sense to confer upon you the very high distinction of the RDI. There is no member of that elite body who has made such a hundred per cent contribution to industrial art as you have.'[1]

The Society had recognised that industrial design made a significant contribution to British manufacture, as shown by the exhibits at the British Art in Industry Exhibition, 1935 – organised jointly by the Royal Society of Arts and the Royal Academy. This important British exhibition of design showed that a closer co-operation between artist and manufacturer led to the enhancement of Britain's design reputation both at home and abroad. As a result, in 1936 the Royal Society of Arts established a new award to be conferred on designers in industry – the distinction of Royal Designer for Industry (RDI). Limited to forty individuals, it acknowledges the high standard each designer has achieved in his or her individual

2. A photograph of the award given to Susie Cooper on the occasion of her election to the Faculty of Royal Designers in 1940.

3. The Royal Pavilion kitchen at the Festival of Britain, 1951. Note the cake plates and Gold Bud coffee wares designed by Susie Cooper.

discipline. Susie Cooper was one of the early recipients of this distinction. The only woman from the Potteries to be appointed, she was elected to the Faculty in 1940 (plate 2).[2]

The RDIs, as a group, support the work of the Royal Society of Arts' Student Design Awards [SDA] scheme instituted in 1923, judging the thousands of submissions from design students. The RDI Faculty continues to work with other bodies, including the Design Council, to ensure a high standard of design education.

Twelve years after it was founded, Gordon Russell, Master of the Faculty, gave a paper in 1948 to the Royal Society of Arts, on 'The Work of the RDIs'. He

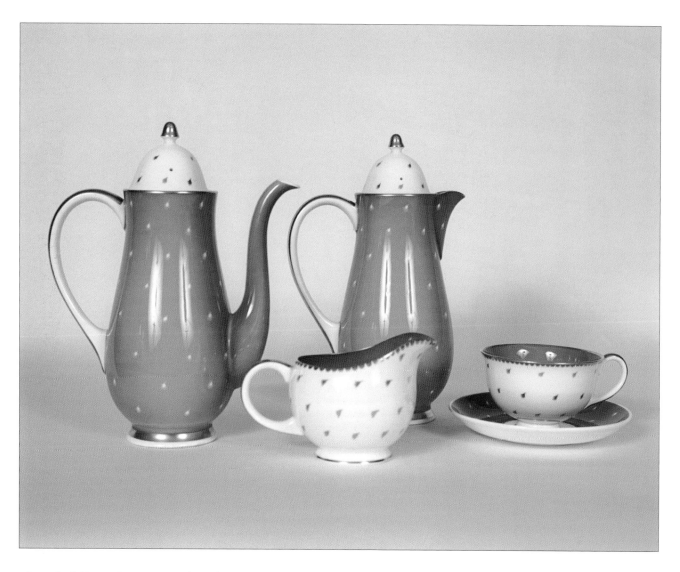

identified Susie Cooper as a key designer-manufacturer amongst the major design groups represented by his members. Fiercely proud of election, Susie Cooper readily responded to Gordon Russell's invitation to sit on the selection committee for the Design at Work Exhibition at Burlington House in 1948, at which examples of her own work were on display.

The RDIs were called on to furnish designs for the Festival of Britain, 1951. As well as Gold Bud (plate 4), Susie Cooper produced what must surely count as one of her most technically accomplished designs, 'Lion and Unicorn', for the Royal Pavilion in the form of cake plates (plate 3). This pattern was first commissioned for a set of sixty cups, saucers and side plates for a Royal reception at the RSA on 7th November 1950 (plate 5). Princess Elizabeth was presented with a number of these as a gift. Susie Cooper later recalled that the evening 'was enjoyable, but one thing that stands out in my memory is the cups. We'd just started doing them, and we hadn't had time to match the shrinkages of different items. So when we made these cups and saucers we didn't get the shrinkage quite right. The feet of the cups were a little bit big for the wells of the saucers. Of course, the Queen was very observant and noticed this. I had to make my explanations.'[3]

4. Examples of the Gold Bud service (C.163), decorated on the bone china Quail shape, 1951. Aerographed in green with painted, sgraffito and gilt decoration. Height of coffee pot 9½in (24cm).

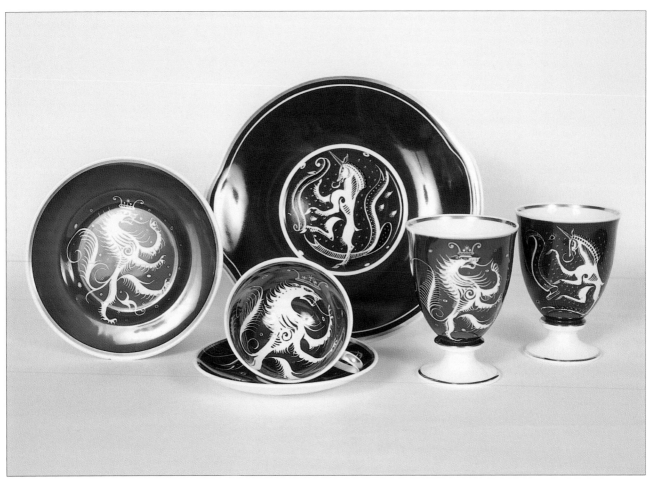

5. A selection of bone china shapes decorated with the Lion and Unicorn pattern, 1950. Aerographed in either mahogany or blue with sgraffito, painted and gilt decoration. Diameter of plate, 9⅞in (25cm) and height of goblet, 4¾in (12cm).

In 1951 Susie Cooper designed the 'Astral' service in one of her favourite colours, Sèvres blue, exclusively for the RSA. This was used by its Council members regularly for many years and only a few pieces have survived (plate 6).

To mark its forthcoming bicentenary in 1954, and to acknowledge their thanks to the Royal Society of Arts for the establishment of the Faculty, the members commissioned Susie Cooper to produce a plaque on their behalf (plate 1). At its meeting on 8th April 1954 the RDIs, including Wells Coates and Gordon Russell, expressed their 'admiration for her excellent design work.'[4] The plaque was aerographed in mahogany and decorated with gilt around the rim, with the inscription in gold. In the centre of the design is the Society's Adam house, incised by Susie Cooper, together with banners proclaiming 'Filial salutations, March 22nd 1954'.

The Faculty of RDIs continues to be active in encouraging better design and design education. At one of their annual dinners the members decided to build a small and eclectic archive of the work of the RDIs, for future generations of design students and researchers to consult. Susie Cooper was instrumental in encouraging Wedgwood to supply information and material for her own archive box.

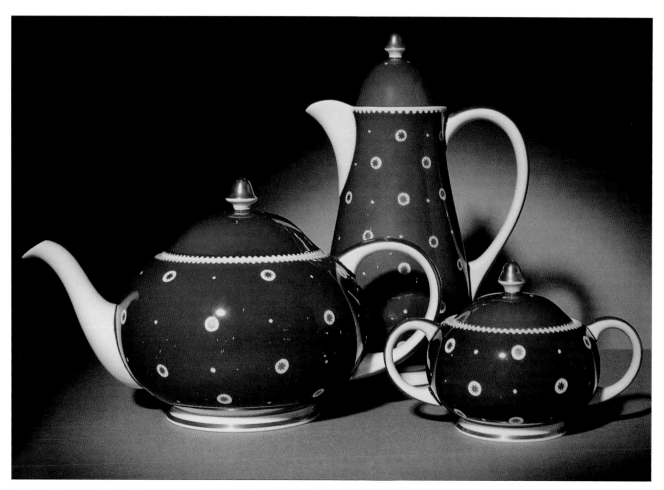

6. A a selection of bone china Quail shape wares decorated with the Astral pattern (C.11), aerographed in blue with sgraffito and gilt star decoration. 1951. Height of coffee pot 9¼in (23.5cm).

FOOTNOTES

1. Letter from Gordon Forsyth to Susie Cooper. Information from the Wedgwood Museum, Josiah Wedgwood and Sons Ltd.
2. Other ceramic designers to be appointed to the Faculty during this period: Keith Murray (glass, pottery and silverware), Harold Stabler (potter, enameller and silversmith), both from 1936, and Alfred B. Read (industrial and light-fitting designer although better known by many for his ceramics for the Poole Pottery during the fifties), 1940.
3. Susie Cooper O.B.E., *Designer*, March 1979, pp.13-14.
4. Information from the Royal Society of Arts Archives, London.

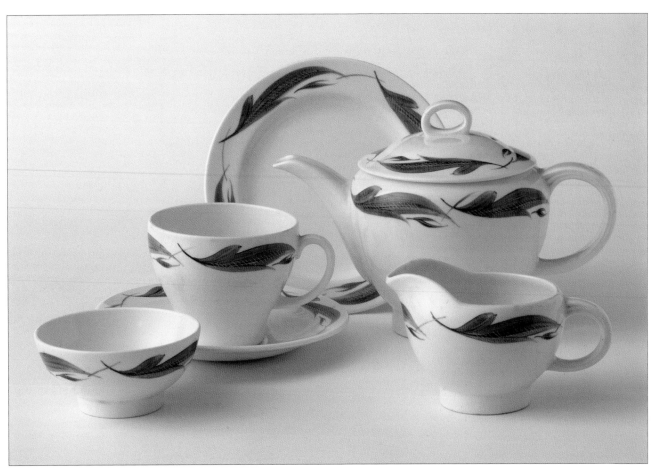

1. An earthenware Rex shape part tea service decorated with a hand-painted stylised leaf border, probably late 1940s.

SUSIE COOPER PRODUCTIONS

REPRESENTATIVES •
LONDON: MR. A. E. BEESON, AUDREY HOUSE, ELY PLACE, HOLBORN, E.C.1
NORTH: MR. E. J. HARPER, 27, COMPTON ROAD, BUXTON
SOUTH: MR. E. W. BURTON, 29, PRETORIA ROAD, CAMBRIDGE

STAND C16
AT OLYMPIA

CROWN WORKS
BURSLEM

CHAPTER 15

SUSIE COOPER: THE CRITICAL RESPONSE

Alun Graves

In April 1930, the recently formed Susie Cooper Pottery placed its first advertisement in the press, proclaiming: 'Elegance combined with utility. Artistry associated with Commerce and practicability.'[1] This early statement of intent, which succinctly expressed the ethos of the Pottery, was entirely in tune with progressive design thinking of the period. From the outset, therefore, Susie Cooper can be seen to have placed herself and her work at the heart of the debate about good design that raged throughout the 1930s. It is the intention here to consider the critical response to her design and production of the 1930s in the context of these on-going debates, and with reference to the various professional groupings who expressed opinion. For the purposes of the discussion, three constituent groups have been identified, representing the industry itself, the design establishment and the voice of International Modernism. What stands as remarkable is that Susie Cooper came to find favour in each of these camps. This was, indeed, something of a rare achievement.

The ceramics industry during the inter-war period was notoriously conservative in its outlook, and appears to have been relatively unwilling to experiment with new designs.[2] Establishing whether the blame for this situation lay with the manufacturers, the retailers or the buying public was a hotly contested issue. Regardless of where this inertia lay, issues of commercial viability, perhaps not

2. A Susie Cooper advertisement of 1933 illustrating examples of the Wedding Ring pattern available on the Kestrel shape and on a Curlew shape tureen.

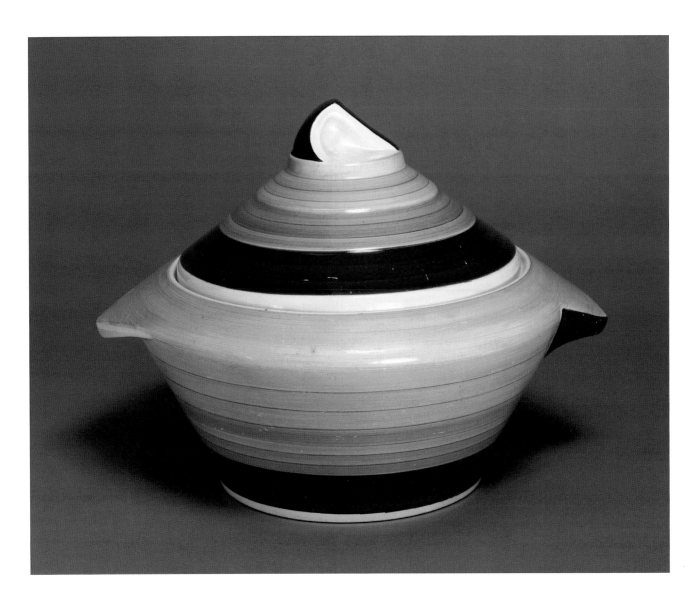

3. A Curlew shape tureen and cover decorated with one of the more popular Wedding Ring patterns (E/479), 1933.

unreasonably, underpinned the industry's stance on design. The reluctance to embrace anything remotely new was particularly acute within the porcelain industry, whose consumers were seen as having traditional tastes. Modern design was a much greater feature of earthenware production, yet even within this industry there seems to have been little appetite for new types of designs, at least until they had been demonstrated as commercially successful. Inevitably therefore, the wares of the new Susie Cooper Pottery were seen as somewhat radical, though their commercial potential appears to have been quickly realised. In 1931 *The Pottery Gazette and Glass Trade Review* wrote: 'It was a wonderful range of decorated pottery with which they [the Susie Cooper Pottery] approached the trade from the very start, and many far-seeing buyers were not slow to recognise that the new line was one of great potentiality, especially in the better-class retail establishments. Experience has proved that the public was ready to accept decorations of the kind which the Susie Cooper Pottery became established to produce – decorations which are characterised by a freshness of outlook and which reveal in a very special manner the workings of an artistic mind, unfettered by restrictions imposed from without.'³

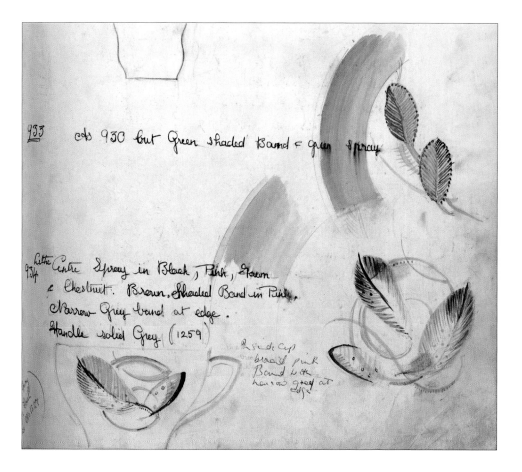

Evidence of a certain degree of suspicion in the industry's initial response to the Pottery, as well as its gradual acceptance of its products, is nevertheless to be found in a report from the same journal three years later: 'It will be recalled that a few years ago some of Miss Cooper's efforts were looked upon in certain quarters as being decidedly venturesome, if not, indeed, so daring as to rule themselves out as impracticable. That idea has, however, been exploded, for it cannot be denied that Miss Cooper, advanced though her ideas may be, has "got away with it." She has found, if not actually created, a market for her productions.'[4]

If Susie Cooper's commercial instincts and consequent success convinced those within the industry of her merit, her concern over matters of good design found favour among the increasingly prominent design establishment.[5] The need for the promotion of good industrial design had long been a matter for impassioned debate, but following the establishment by the Board of Trade of the Gorell committee in 1931, and the publication of its report the following year, this became a matter of the highest priority.[6] The Board of Trade committee was representative of establishment opinion. Industry itself was under-represented, although Susie Cooper's former employer, Edward Gray, was a member. The committee also lacked a spokesperson for International Modernism, which had finally, if belatedly, begun to take root in the United Kingdom.[7] Rejecting the idealism of the Arts and Crafts Movement, the 'Gorell' Report concluded that the solution to the problems of design could not be solved through handicraft. Its actual recommendations, which included better education and a more prominent role for artists in industry, were nevertheless somewhat vague.[8] Despite this lack of clarity, however, concerted efforts were made to act upon the report, and this led directly to the exhibition of

4. A pattern book entry illustrating two lithographic patterns: 'Two Leaf Spray' (E/933) and 'Leaves' (E/934). These hand-painted patterns record the designs before they were printed on lithographic sheets.

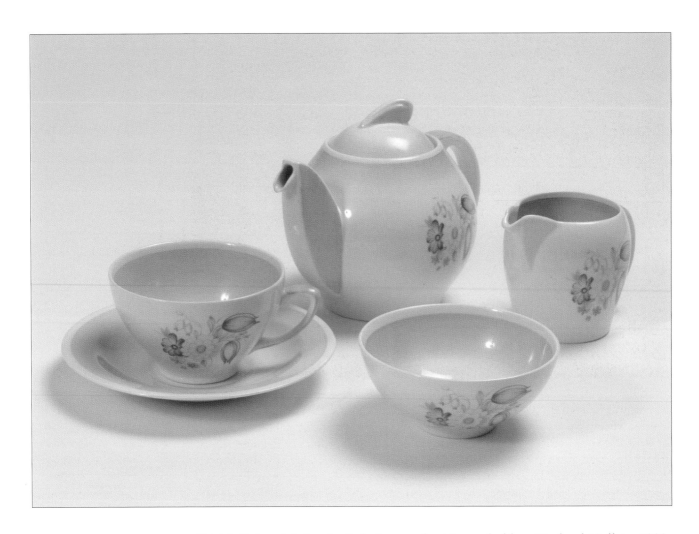

5. Part of an earthenware tea set decorated with the printed floral Swansea Spray (E/1205) with shaded band in pink, about 1936.

British Industrial Art in Relation to the Home, held at Dorland Hall in 1933. Tableware by Susie Cooper was chosen for display in the exhibition, and the selection of ceramics was subsequently defended by Harry Trethowan of Heal & Sons in the *Architectural Review*, one of Susie Cooper's celebrated Kestrel tureens being used to illustrate the article.[9] Considered a great success, the Dorland Hall exhibition was the first in a series sharing similar aims, the most eagerly awaited of which was the Exhibition of Industrial Art held at the Royal Academy in 1935.[10] The advisory committee for the ceramics section of the exhibition included, among others, Edward Gray, Harry Trethowan, Josiah Wedgwood V, and the Superintendent of the Stoke-on-Trent City Art Schools, Gordon Forsyth, all of whom are certain to have been sympathetic to Susie Cooper's designs.[11] Not surprisingly, her work was again selected for display, and featured prominently in the illustrated souvenir guide. Gordon Forsyth, who had been something of a mentor to Susie Cooper in her early years, later expressed his admiration for her designs in his treatise *Twentieth Century Ceramics*. Here, Forsyth illustrated an uncompromisingly modernist discussion about shape design with a Kestrel tea pot, prefacing it with the remark 'the following illustrations may be considered as good examples of functional design'.[12]

A central aim of the Royal Academy exhibition had been to 'show the public what an important part design plays and can still further play in the objects they habitually use and purchase',[13] and the show attempted to further promote the

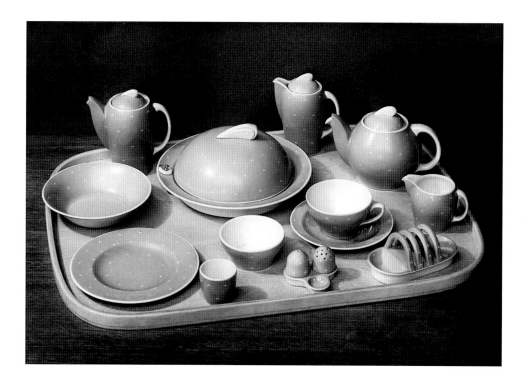

6. A breakfast in bed set, Kestrel shape, on a wooden tray. The set is decorated with the 'Crescents' pattern, about 1938.

role of the designers by displaying their names alongside the items exhibited – names which, by and large, would have been unfamiliar to the public.[14] The role and professional status of the designer were in fact fundamental issues of the 1930s. It was during this decade that the design profession established its identity, this being largely due to the formation of the Society of Industrial Artists in 1930. In the ceramics industry, however, the role of designer remained poorly regarded. In 1936, little more than ten per cent of companies employed a full-time in-house designer, and those that were employed were generally poorly paid.[15] Susie Cooper's design role was therefore exceptional. The Society of Industrial Artists nevertheless established a highly active branch in North Staffordshire, staging a succession of lively debates in which Susie Cooper frequently took part.[16]

Despite the Royal Academy exhibition's central aim of promoting good design, the show was roundly condemned by the modernist critic Herbert Read. Writing in the *Architectural Review*, Read complained that the exhibition had failed to give sufficient consideration to factors of form and functional efficiency, and had neglected objects within the reach of the great mass of people served by modern industry.[17] Of the ceramics display in particular, Read commented that 'a drastic reduction in the number of exhibits would have been all to the good, for then the acceptable ones would have had a better chance to make their effect.'[18] Unfortunately Read was not explicit about which these 'acceptable' exhibits were. However, the pro-modernist *Architectural Review*, having attracted criticism for its negative stance, followed up their coverage of the exhibition with a 'catalogue' of what they considered to be the best examples of design from British manufacturers. Needless to say, pottery from Susie Cooper featured in a small and highly select group of tablewares.[19]

Susie Cooper was also singled out for praise by art historian and modernist-sympathiser Nikolaus Pevsner. About 1936, Pevsner carried out a comprehensive study of design, production and marketing in the ceramics industry, initially

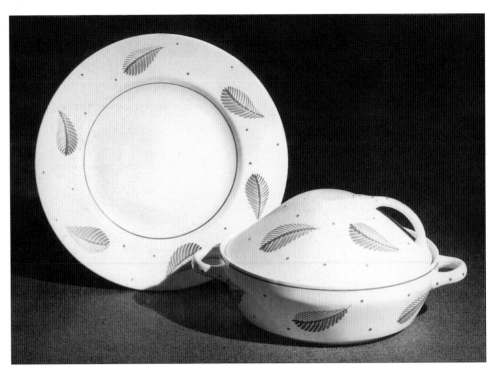

7. A contemporary photo-graph of an earthenware Kestrel tureen and cover and plate, decorated with a hand-painted pattern, about 1946.

published in the *Architectural Review*, and later as part of his broader *Enquiry into Industrial Art in England* of 1937.[20] One of the subjects for discussion was the use of lithographs. Of these Pevsner stated: 'The designing is, as a rule, done by the printing firm. Only one out of five patterns, I heard, comes from the pottery studio. There is no technical reason for this, and it seems to me that the aesthetic results might be improved by increasing the potter's share in the invention of the lithographed pattern. I know of only very few cases where adventurous potteries have begun to design modern lithographs to satisfy their standards. Miss Susie Cooper, so far as I know, was the first to do this. Apart from hers and a couple of others, I have not seen any acceptable lithograph.'[21]

Although not mentioning Susie Cooper by name, Pevsner also heaped praise on the 'pioneers of banded pottery', describing its growth in popularity as 'a very gratifying fact indeed'.[22] Considering her pivotal role at Gray's Pottery in establishing banding as a form of decoration complete in itself, such comments can only be construed as a mark of considerable approval.

Susie Cooper can, therefore, be seen to have attracted a favourable response from an extraordinarily wide range of spokespersons representing a variety of different professional interests and viewpoints. This is, of course, not to mention the enthusiasm of the buying public itself. That Susie Cooper gained such widespread recognition stands as a testament to her design abilities as well as her adeptness in the sphere of marketing, and it was this combination of talents which enabled her to produce beautiful yet highly practical objects, tailored to suit the needs of a modern public with modern lifestyles. While the proponents of modernism naively believed that commercial success was an inevitable consequence of good design, Susie Cooper at least proved that the two were not mutually exclusive.

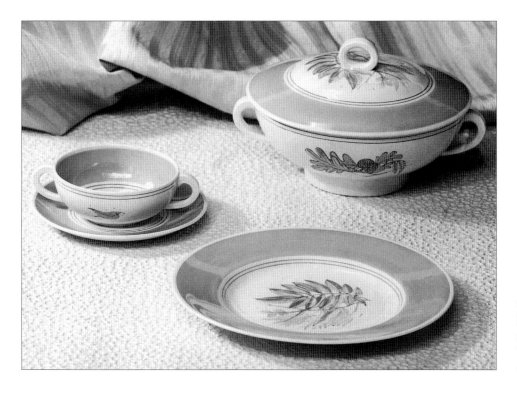

8. A group of earthenware Falcon shape dinner wares, decorated with the Woodlands pattern (E/1841), about 1940.

FOOTNOTES

1. *The Pottery Gazette and Glass Trade Review*, April 1930, p.550. (See Chapter 3, plate 6)
2. See for example Pevsner, N., 'Pottery: Design Manufacture Marketing', *Trend in Design*, Spring 1936, pp.9-18.
3. 'The Susie Cooper Pottery', *The Pottery Gazette and Glass Trade Review*, June 1931, p.817.
4. 'The Susie Cooper Pottery', *The Pottery Gazette and Glass Trade Review*, April 1934, pp.467-8.
5. Documents in the Public Record Office show that Susie Cooper was asked to participate in the national debate on design and industry. The Council of Art and Industry (founded 1934) set up a Pottery Committee in March 1934 to report on the provision of training for designers, their position in the ceramic industry and the problem of design in relation to pottery. Susie Cooper gave evidence and served on a local committee consisting of Gordon Forsyth, Robert Copeland, Harry Wood and H. Irving. Her views and the recommendations of the committee can be found in a number of papers (e.g. BT 579/A/150/35 and BT 57/3). She submitted her own proposal 'A suggestion for the application of Art to Industry' which was an attempt to get more talented and trained designers into the ceramic industry (BT 57/3).
6. On the 'Gorell' committee's role in the promotion of design, see for example Naylor, G., 'Design and Industry', in Ford, B. (ed.), *The Cambridge Cultural History of Britain Vol 8: Early Twentieth Century Britain*, Cambridge, 1992, pp.288-9.
7. A key event in the transmission of modernism to Britain had been the publication in English of Le Corbusier's *Towards a New Architecture* in 1927.
8. An analysis of the report was published as Appendix to Herbert Read's *Art and Industry*, London, 1934, pp.134-6.
9. *Architectural Review*, vol.74, 1933, p.36.
10. An announcement regarding the forthcoming Royal Academy exhibition, which included details of the Advisory Committee for the Ceramics Section, was placed in *The Pottery Gazette and Glass Trade Review*, May 1934, p.606.
11. According to an interview conducted by Jennifer Hawkins-Opie on 16 August 1977, Susie Cooper believed Josiah Wedgwood to have been responsible for recommending her for the award of Royal Designer for Industry, which she received in 1940. Victoria and Albert Museum, Ceramics and Glass Department Library.
12. Forsyth, G., *Twentieth Century Ceramics*, Studio Ltd., 1936, p.12.
13. The Royal Academy, Exhibition of British Industrial Art in Industry: Illustrated Souvenir, London, 1935, p.1.
14. Forsyth, G., 'British Art in British Pottery', in de la Valette, J. (ed.), *The Conquest of Ugliness*, London, 1935, p.142.
15. Pevsner, op. cit. at note 2 above, p.14.
16. One notable occasion being a lecture given by the modernist designer Serge Chermayeff, following which Susie Cooper, counter to many in the audience, declared herself to be 'completely in sympathy with everything the lecturer had said'. *The Pottery Gazette and Glass Trade Review*, December 1932, p.1507.
17. Read, H., 'Novelism at the Royal Academy', *Architectural Review*, Vol. 77, 1935, pp.45-50.
18. ibid., p.46-7.
19. *Architectural Review*, Vol.78, 1935, pp.291-2.
20. Pevsner, op. cit. at note 2 above. Also, *An Enquiry into Industrial Art in England*, Cambridge, 1937.
21. Pevsner, op. cit. at note 2 above, p.16.
22. Pevsner, op. cit. at note 2 above, p.13

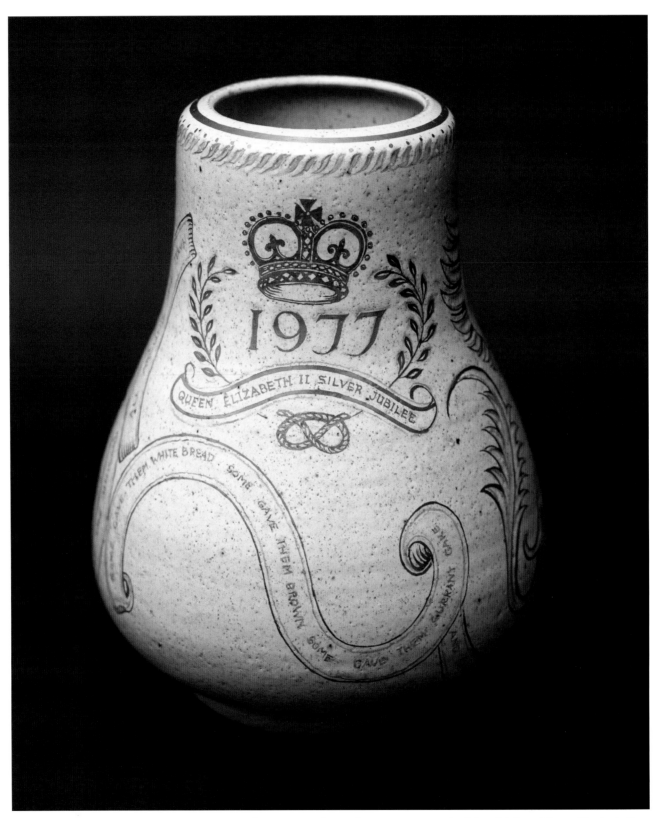

1. A unique earthenware vase designed to commemorate the Silver Jubilee of Queen Elizabeth II, 1977. The pattern, incised with gilded decoration on an oatmeal glaze, also features a Lion and Unicorn design. Height 9in (23cm).

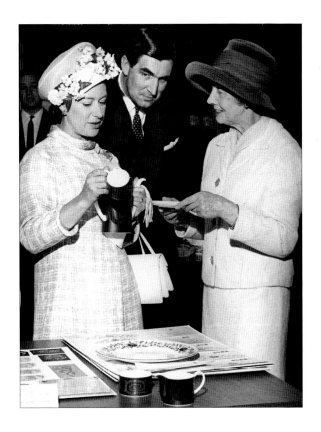

CHAPTER 16

ROYAL PATRONAGE

Andrew Casey

Throughout her creative period of work, from the early thirties onwards, Susie Cooper had been honoured by Royal patronage. Her high quality and stylish ceramic products appealed to the British Royal Family and over many years they made purchases for their own use and as gifts. As the trade press noted, 'These Royal purchases were a striking tribute to Miss Cooper's efforts as a pottery designer of the modern school, and must have encouraged her tremendously to further endeavours.'[1]

Once Susie Cooper was firmly established at the Crown Works she took her first stand at the British Industries Fair (BIF) in 1932, staged at Olympia in London. As usual the Royal entourage visited the Fair and the trade press, that had supported the fledgling Susie Cooper company, recorded that, 'there was constantly a crowd of admirers around the stand, and the Queen herself was arrested by what she saw here, and, entering the stand, conversed with Miss Cooper and made purchases, included amongst which was a breakfast-in-bed set in an all-hand painted briar rose design. Also purchased by the Queen was a jug, somewhat in the Persian style the texture being matt and the design in black.'[2]

2. Susie Cooper meeting the late Princess Margaret during her tour of the Kingston-upon-Thames store Bentalls, in connection with the 'Best of Britain' exhibition. She is showing the royal visitor a coffee set decorated with the Nebula pattern. On the table is a bone china dinner plate decorated with the Mariposa pattern (C.2103). Colin Wright, a Wedgwood Director, was also introduced to the Princess. About 1968-70.

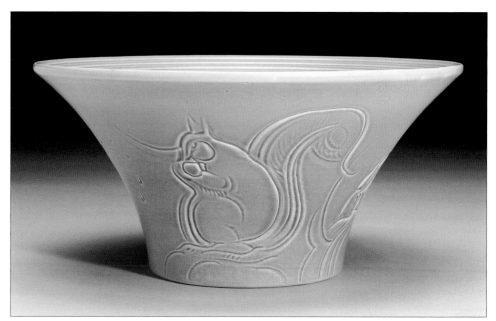

3. An earthenware bowl, diameter 9⅝in (24.5cm), incised with the Squirrels decoration, on a matt green glaze (E/345), 1932.

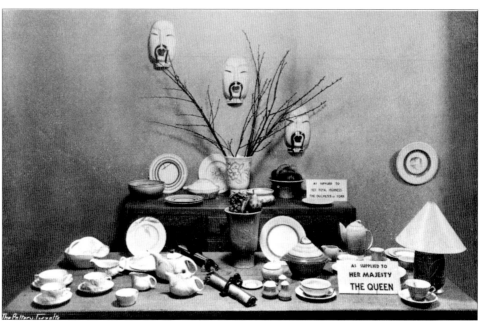

4. Part of the Susie Cooper trade stand at the British Industries Fair in 1933. Note the various shapes such as Curlew tea wares (bottom left) decorated with a bird motif (E/544), and the elephant napkin holders.

At the same fair the Duchess of York purchased a set of jade green dessert plates and some nursery ware sets, including an incised Squirrels bowl (plate 3). A year later she purchased further incised wares. Other members of the Royal Family, including the Princess Royal, purchased a novel triangular lamp base decorated with a clown (plate 5). The trade press commented that it was decorated 'in a truly modernistic style'.[3]

Susie Cooper's associate and business partner, Jack Beeson, who had just taken control of the London showroom, boldly added a sign to the display of the latest products, announcing AS SUPPLIED TO HER MAJESTY THE QUEEN, following further Royal purchases at the British Industries Fair in 1933. This astute marketing was intended to create further business for the firm and more importantly raised Susie Cooper's profile as an innovative independent designer (plate 4).

As she developed new decorative treatments, these were showcased at the important trade fairs. At the BIF in 1935 Susie Cooper displayed the latest transfer-printed patterns such as Dresden Spray and a range of crayon-decorated wares. The Royal Family made several purchases, including a crayon line service and some storage jars. The local newspaper for the Potteries, *The Evening Sentinel*, reported that the Royal visitors stayed for 'for an hour and a quarter placing orders for china and earthenware.'[4] Besides describing the various pottery manufacturers and the many purchases made by the Royal entourage, it recorded that the Duke of York enquired, 'how long it was since Miss Cooper had been in business on her own account, and whether the shape (Kestrel) of an interesting new cover dish was her own invention, to which she replied in the affirmative.'[5]

The range of transfer-printed patterns shown at this trade fair proved very

5. An earthenware lamp base, height 5in (12.8cm), depicting the 'Clown' pattern (E/354), hand painted in colours, 1933.

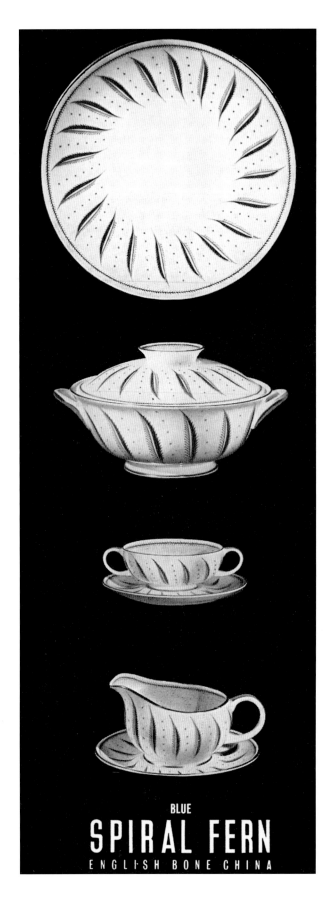

BLUE
SPIRAL FERN
ENGLISH BONE CHINA

popular with the general public and also with a controversial figure of the time. In 1936 Edward VIII, who later abdicated from the throne, purchased the pink version of the Dresden Spray pattern for Mrs Simpson.

The continued support of the Royal Family throughout the rest of the thirties must have been rather gratifying for Susie Cooper. At the BIF in 1937 the Duchess of York purchased a number of items from the new Acorn range. A year later, at the 1938 Fair, the Queen (formerly the Duchess of York) attended the Susie Cooper stand and spoke to her. The trade press reported that she said: 'What pretty things have you this time?'[6] Queen Mary bought a breakfast-in-bed set and two sets of hors d'oeuvres, one with scalloped edges and the other bearing fish motifs and vegetables.

In 1939 the Royal entourage again took time to examine the latest products from the Susie Cooper Pottery. Whilst the Duke of Kent purchased no less than eight early morning sets, the Queen bought a morning set decorated with printed blue stars. The Queen remarked to Susie Cooper, 'You seem to have grown since you first came here.'[7] 'The King enquired "Could we have a hot-water jug to match?" An assurance that this could and would be done was promptly forthcoming. A soup set, in sage green with a tool-scratched patterning, was also purchased by Her Majesty the Queen.'[8]

Following the Second World War, the latest bone china productions by Susie Cooper again found favour with the Royal Family. A particular favourite of the Queen Mother was the Spiral Fern design on the Quail shape (plate 6). In 1958 the Glen Mist pattern was launched and according to Susie Cooper was used at the Queen's Sandringham home in Norfolk (plate 7).[9] In the late sixties Susie Cooper met Princess Margaret during her tour of a store in Kingston-upon-Thames, London in connection with a special 'Best of Britain' exhibition (plate 2). On this occasion Susie Cooper had the opportunity of showing her the latest patterns.

Some years later, for the Queen's Silver Jubilee celebrations, the most commercially and artistically successful products by Wedgwood were silver lustre pieces designed by Susie Cooper. These small giftwares, in a limited edition of 500, sold out almost immediately and prompted similar patterns such as floral lustres. Two years later Susie Cooper was awarded the Order of the British Empire in 1979. It was presented to her by the

6. A page from the Susie Cooper catalogue, from about 1958, illustrating the Spiral Fern pattern.

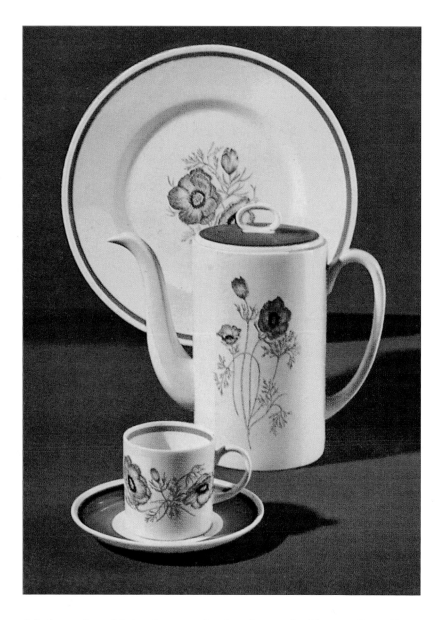

Queen Mother, who told the designer that her first set had been a Susie Cooper one.

During Susie Cooper's ninetieth year she produced a leaping deer figure in an edition of ninety pieces (one for each year of her life). At a special retrospective exhibition of her work in London an important visitor, the Queen Mother, attended and was presented with one of these figures. There is no doubt that Susie Cooper was proud to have enjoyed Royal patronage for almost sixty years.

7. A contemporary advertising leaflet for the Glen Mist pattern (C.1035) produced by Josiah Wedgwood and Sons Ltd, about 1966-68.

FOOTNOTES

1. Information from a trade journal, about 1938.
2. Buyers' Notes, *The Pottery Gazette and Glass Trade Review*, April 1932, p.489.
3. ibid.
4. The Queen Again Visits Olympia Fair, *Evening Sentinel*, 21 February 1935.
5. ibid.
6. Susie Cooper Pottery, *The Pottery Gazette and Glass Trade Review*, April 1938.
7. Buyers' Notes, *The Pottery Gazette and Glass Trade Review*, 1 April 1939, p.152.
8. ibid.
9. Information from an interview with Susie Cooper on the BBC World Service, 1978.

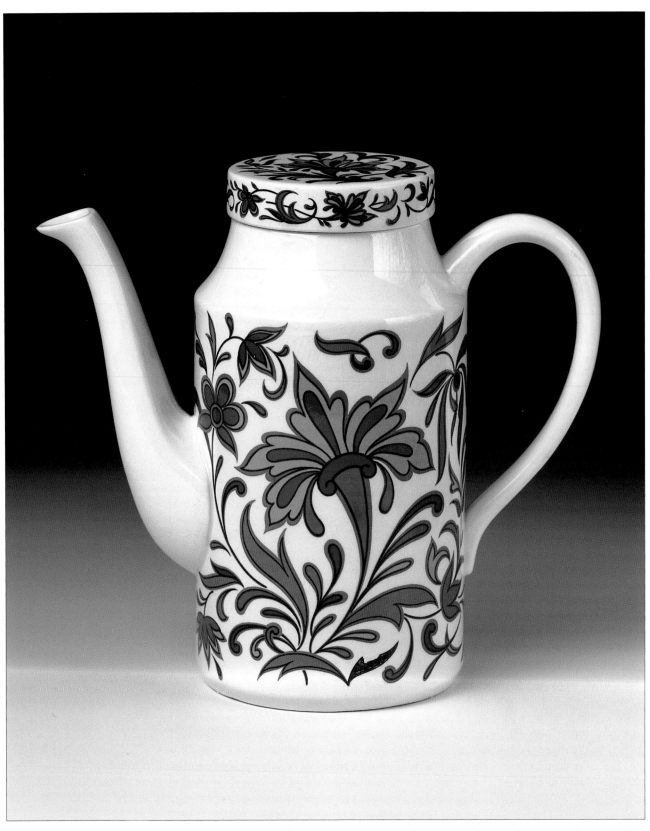

1. An earthenware Fine shape coffee pot and cover, height 8¼in (21cm), decorated with the transfer-printed Spanish Garden pattern designed by Jessie Tait for W.R. Midwinter Ltd., 1966.

CHAPTER 17

SUSIE COOPER AND JESSIE TAIT, DESIGNING IN THE POST-WAR PERIOD

Kathy Niblett

Susie Cooper was already a well-established pottery owner and designer when the Second World War broke out in 1939. At that time, Jessie Tait was still a young girl but by the mid-1950s she had become an experienced and accomplished designer. In spite of the generation gap, it is possible to draw many comparisons between these two outstanding twentieth century ceramic designers.

Both were trained at the influential Burslem School of Art, where Gordon Forsyth, Superintendent of Art Education for the city of Stoke-on-Trent, had enormous influence on the pottery industry through the excellent training provided for designers, painters and technicians. Both were recommended by tutors at the art school to their first employer – Susie Cooper to Edward Gray and Jessie Tait to H.J. Wood Ltd. in Burslem. Both chose to leave their first employer – although Susie Cooper had achieved her ambition to be a designer, she left Gray's Pottery because of the frustration of designing for other potters' shapes. Jessie Tait's ambition was never fulfilled at H.J. Wood Ltd. and when the opportunity arose to

3. A publicity photograph of Susie Cooper, 1950s.

join W.R. Midwinter Ltd. as a designer, she grasped it eagerly. They both influenced the choice of designs for production – Susie Cooper at Gray's and of course when she was designer for her own company and Jessie Tait as part of the Midwinter team. Each designer had her name included in her company backstamp, acknowledging their exceptionally valuable contributions.

Design in the pottery industry stood still for more than ten years because of the war and its aftermath. Potters were champing at the bit to progress but regulations held them back until late 1952. It is not surprising that when new design was made possible there was an explosion of primary colours and fluid shapes which were named contemporary as soon as they appeared.

Jessie Tait, who was born in 1928, was a generation younger than Susie Cooper but her skill and sensibility as a pottery designer was as sharp and in touch with the day's needs, as was Susie Cooper's. When Jessie Tait joined W.R. Midwinter Ltd., Burslem in 1946 as a designer, the firm had only recently re-opened. It had been a 'closed-down' firm for the duration of the war.[1] The company had not been allowed to produce pottery or to trade. The works were requisitioned by the Ministries of Supply and of Air Production. Plans for modernisation of the works were implemented, taking several years to complete.[2] At the end of the war, all pottery manufacturers were restricted by the tight controls still in place as the country struggled to resolve the resettlement of Service personnel, and potters in particular were penalised by shortages of coal and lithographs. The home market was allowed mainly plain white or ivory ware, although a little luxury was afforded through export rejects, and in the early 1950s frustrated exports,[3] but people were hungry for colour. Even Members' questions in The House of Commons brought no comfort,[4] until August 1952 when an unexpected announcement from the President of the Board of Trade stated that 'all controls on the manufacture, distribution, and price of domestic and ornamental pottery have now been removed.'[5]

Susie Cooper Pottery Limited was a 'concentrated firm' during hostilities.[6] The company continued to trade as a separate entity but production was concentrated on Wood and Sons Ltd., Trent, New Wharf and Stanley Potteries, Burslem, a certificated nucleus company.[7] This continuity meant that Susie Cooper was ready to take a leading role when a form of normality returned. She had new hand-decorated designs ready for both the 1946 Britain Can Make It exhibition and the 1948 Royal Society of Arts/Council of Industrial Design exhibition Design at Work, the first exhibition of work by Royal Designers for Industry.[8] The Festival of Britain in 1951 was another tremendous showcase for Susie Cooper. Her designs could be seen in the 'Royal Pavilion', the 'Power and Production' pavilion, where employees demonstrated their skills, and in the 'Homes and Gardens' pavilion.[9] It was here that Susie Cooper was able to show her new ceramic body, bone china, which she began to make in 1950 with the purchase of the Jason Works, Longton.

And so, in the new decade of the 1950s, both Jessie Tait and Susie Cooper were on the brink of very exciting times.[10] Susie Cooper had her bone china company to nurture and develop. She had to learn new skills relating to the production of ceramics, something she had not undertaken previously, since all her earthenware had been made on her behalf by Wood and Sons Ltd. The opportunity of working with a translucent body gave her scope for patterns of a different style from those needed on earthenware. Susie Cooper exploited her new material, giving us a legacy of exquisite design on the amended Fluted shape, which she inherited at the Jason Works, and her original Quail and Can shapes.[11] Earthenware production continued at Susie Cooper's Crown Works until 1964, but her main interest lay in

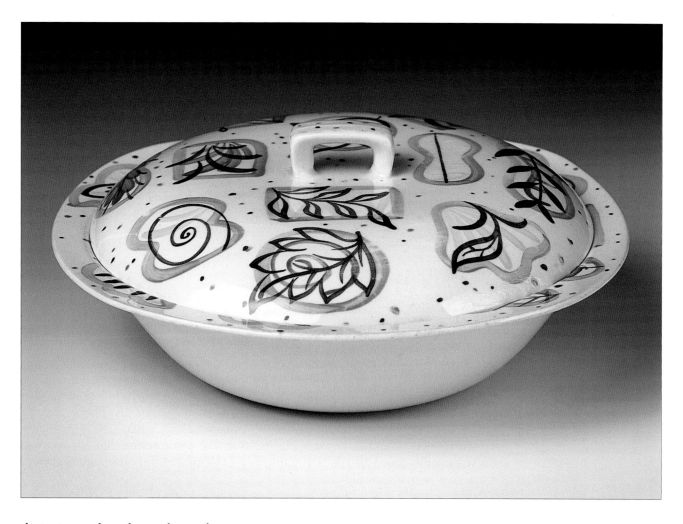

designing and producing bone china.

Jessie Tait's excitement resulted from the limitless energy which Roy Midwinter brought to his family firm when he returned from Bomber Command in 1946.[12] His first forays into Canada and North America with pottery designs had met with rebuttal. The patterns and shapes which he offered to buyers did not suit the modern taste. After experiencing the West Coast lifestyle, he had a much clearer idea of what he should be making to satisfy customers. He was in America when the wartime restrictions were lifted. On his return, fired with enthusiasm, he urged Jessie Tait to design surface patterns for his new Stylecraft shape. Her innate ability as a pottery designer had been under-used during the austerity years but the trade press noted her potential.[13] She was soon able to devise patterns which used the skills of the workforce to the full.[14]

Some of her patterns had printed outlines, filled in by hand with colour; others were painted by hand and the high quality of the very complex designs was ensured by using a 'pounce' (plate 4). The launch of Stylecraft at the British Industries Fair in February, 1953 saw the dawn of a new and exciting contemporary age in pottery design.[15] Midwinter's advertisement of February 1953 summed up this excitement: 'stylecraft has been created to fit in with the changing trend of design and to harmonise with contemporary furnishings. Exclusive patterns by our designer Jessie Tait are reproduced on the finest Staffordshire semi-porcelain.'[16]

The Pottery Gazette and Glass Trade Review confirmed the excellence of

4. An earthenware Stylecraft tureen and cover decorated with the hand painted Primavera pattern. Designed by Jessie Tait for W.R. Midwinter Ltd., 1954.

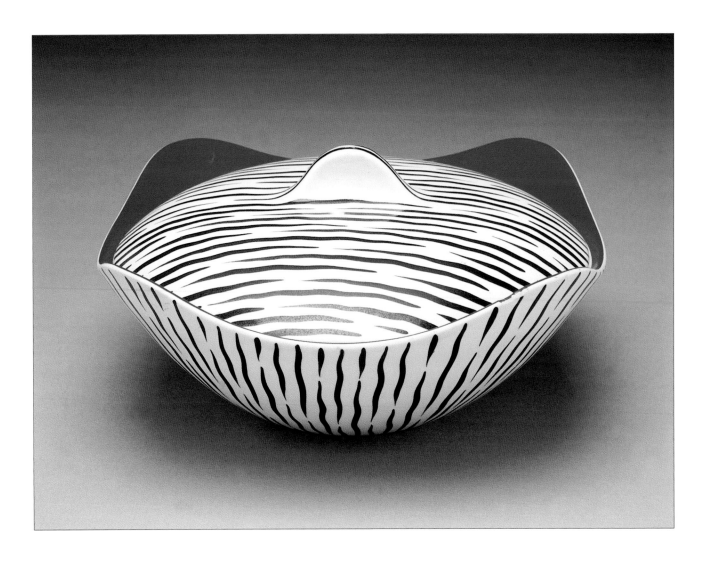

5. An earthenware Fashion shape tureen and cover, width 9⅞in (25cm), decorated with the hand painted Zambesi pattern. Designed by Jessie Tait for W.R. Midwinter Ltd., 1956.

Midwinter design in an article in June 1955: 'Among the several pottery manufacturers who devote some part of their production of domestic table ware to contemporary design, …the name of Midwinter is outstanding not only as a pioneer, but also as probably the most prolific producer.'[17]

Jessie Tait's design motifs and colours for Stylecraft took account of current trends and her sources were numerous. The design and architecture of the Festival of Britain inspired many people, as did patterns on textiles and wallpapers. Topical symbols, such as stars, spots, woven thread, stylised flowers and leaves in red, yellow, blue, turquoise, black and white, grey and maroon were used in profusion by Jessie Tait, as they were at companies such as Royal Doulton, Wade and J. and G. Meakin and, of course, by Susie Cooper on both earthenware and the new bone china production with patterns such as Astral (C.12) and Raised Spot (C.501).

The launch of the Fashion shape in 1954 and 1955 gave Jessie Tait a new outline upon which to work (plate 5).[18] The taller hollowware and the rimless Quartic plate[19] allowed a different layout of design motifs. Midwinter's Fashion shape and Susie Cooper's Quail shape have much in common, with bulbous bellies tapering towards the shoulder, very much a trend throughout the pottery industry. Like so many other earthenware potters, throughout the 1950s Midwinter was striving to whiten its earthenware body so that it could compete head-on with bone china. The success

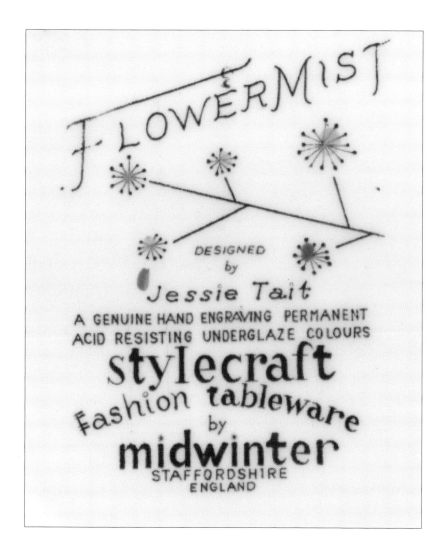

achieved was emphasised by the new name given to the body, 'China White'.

Roy Midwinter acknowledged Jessie Tait's huge and important contribution to the success of Midwinter and its recovery from 1953 by including her name on the backstamps of her designs (plate 6). This echoes the use of the special backstamp for Susie Cooper at Gray's Pottery.[20] To be acknowledged in this way was and remains very uncommon in the pottery industry. Individuals are rarely named on pots.

Although parallels can be drawn between these two significant, leading-edge women designers, one difference is outstanding. Jessie Tait designed for tableware shapes which had been devised by Roy Midwinter and his team (the only exception being a range of vases and candlesticks in 1954-55), whereas Susie Cooper designed her own shapes. Nevertheless, Jessie Tait occupied an unusually influential position as part of a management team, directing the design output of the company. It is fortunate that Susie Cooper's pattern books are available to researchers but design books relating to Midwinter have not come to light.[21]

By the end of the 1950s consumers were weary of the organic shapes which they had welcomed in 1953 and a more severe, geometric style began to emerge. Susie Cooper's Can shape, based on a straight-sided cylinder, round or oval, set a trend which lasted from its launch in 1958 until the end of the 1960s, but like all classics Can has been in production for decades. Midwinter launched its Fine tableware in

6. A typical backstamp (enlarged) incorporating the designer's name, 1955.

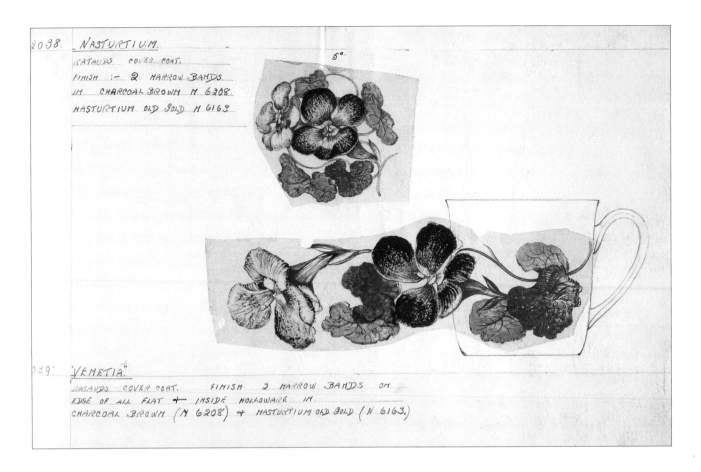

2038. NASTURTIUM.
RATAUDS COVER COAT.
FINISH :- 2 NARROW BANDS.
IN CHARCOAL BROWN N 6208.
NASTURTIUM OLD GOLD N 6163.

5"

2039. "VENETIA."
RATAUDS COVER COAT. FINISH 2 NARROW BANDS ON
EDGE OF ALL FLAT + INSIDE HOLLOWARE IN.
CHARCOAL BROWN (N 6208) + NASTURTIUM OLD GOLD (N 6163.)

7. A pattern book entry for the Nasturtium pattern (C.2038) designed by Susie Cooper for Susie Cooper Ltd., about 1965-66.

1962. A circular cylinder with curved shoulder, which tapered to the neck, Fine had a tall expanse of body on which to place patterns reflecting the geometry of the shape. Jessie Tait designed patterns including Mexicana, Sienna, Whitehill, Graphic, Oakley, Shetland, Berkeley, Spanish Garden, Paisley, English Garden, Country Garden and Summer Day for the Fine shape (plate 1). She reinterpreted the work of guest designers, often from the world of textile design, just as she had done during the 1950s when Hugh Casson and Terence Conran offered a small number of designs to Roy Midwinter.[22] As a result, the squares remained square and the pattern 'worked' as successfully on the tiny items like eggcups and cruet sets as on the larger pieces like vegetable dishes and oval serving dishes.[23] This was an invaluable contribution to the success of Fine, which remained in production for more than a decade.

1967 saw a limited launch of a new shape, MQ2,[24] by Midwinter, with its major launch in February 1968. It was based on the shape of a retort flask – a sphere with a cylinder rising from it.[25] Several potters produced hollowware shapes in this vein during the mid-1960s.[26] Of the four patterns on MQ2, three were Jessie Tait's: April Showers, September Song and Columbine (plate 8).

Unfortunately, earlier business decisions impacted on the working lives of both Susie Cooper and Jessie Tait. In 1966, a major change occurred in Susie Cooper's business life. She had joined R.H. and S.L. Plant in 1957, since the company had spare bottle-oven capacity and she wished to expand her business (see Chapter 7). Josiah Wedgwood and Sons Ltd. began an expansion programme in 1966 when it acquired William Adams and Sons Ltd. of Tunstall,[27] R.H. and S.L. Plant, Tuscan Works, Longton and therefore, by default, Susie Cooper Ltd., along with New

8. An MQ2 shape earthenware coffee pot, height 8¼in (21cm), decorated with the transfer-printed Columbine pattern designed by Jessie Tait for W.R. Midwinter Ltd., 1967.

Chelsea China Co. Ltd, Longton.[28] After an exciting and productive start, this amalgamation led to heartache and disappointment for Susie Cooper in the long term.

Jessie Tait's working life was changed for ever as the result of a business decision made by Roy Midwinter as early as August 1964. Roy offered to buy A.J. Wilkinson Ltd., Royal Staffordshire Pottery, Burslem and its subsidiary company, Newport Works in Middleport, Stoke-on-Trent and by 1965 had expanded his company.[29] Many improvements were made at Newport Works. This drain on resources was compounded by a sequence of launches which failed to attract the consumer. None of the new shapes, Trend, 1965;[30] Portobello, thought to be around 1966, and MQ2, 1967, matched the success of Stylecraft, Fashion or Fine. In September 1968, J. and G. Meakin bought W.R. Midwinter Ltd.[31] Jessie Tait's studio, located in Burslem for twenty-two years, was moved to the Eagle Pottery, Hanley, where she designed for both companies.[32] Further disruption followed the purchase of Meakin/Midwinter by the Wedgwood Group in January 1970.[33] Jessie Tait rose to the new challenge of designing for the Wedgwood Group earthenware division, including Johnson Brothers Ltd., which had been taken over in January 1968.[34]

Jessie Tait had fewer and fewer opportunities to design for Midwinter after 1968 and her last pattern was Nasturtium, on the Stonehenge shape, 1974 (plate 9). Her main output was for Johnson Brothers until she finally retired from Wedgwood in 1994, six years beyond the usual retirement age for women, having worked for three days a week since 1988. She is still designing in her retirement. Susie Cooper worked in The Potteries until the summer of 1986, by which time she was eighty-four years old, and she continued to design ceramics and textiles until her death in 1995. The longevity of creative ideas is remarkable – perhaps that saying about Potteries people who love the industry is true: 'they have slip rather than blood flowing in their veins'!

The working lives of Jessie Tait and Susie Cooper show many similarities. Both designed at the leading edge of style throughout very long careers. They brought well-designed pottery to an eager public, at affordable prices, as the result of their skills, understanding and ability.

FOOTNOTES

1. *Pottery Gazette and Glass Trade Review*, October 1941, p.791; November 1941, p.855 and supplement i-xii and *Pottery Gazette and Glass Trade Review Year Book 1946*, p.83.
2. A Notable Burslem Potter, *Pottery Gazette and Glass Trade Review*, March 1952, pp.421-3.
3. *Pottery and Glass*, June 1952, p.85.
4. *Pottery Gazette and Glass Trade Review*, March 1949, p.264.
5. *Pottery Gazette and Glass Trade Review*, September 1952, p.1401.
6. *Pottery Gazette and Glass Trade Review*, October 1941, p.791; November 1941, p.855 and supplement i-xii.
7. Niblett, K., 'Ten Plain Years 1942-1952'; *Northern Ceramic Society Journal*, Vol. 12 1995, p.202. The Susie Cooper Pottery ceased manufacturing from 1913 until the end of the war.
8. op.cit. pp.182-5 – sources listed in Footnotes.
9. op.cit. pp.212-3 – sources listed in Footnotes.
10. Conversation with Jessie Tait, July 2001.
11. Conversation with Susie Cooper, 1981.
12. Conversation with Jessie Tait, July 2001.
13. Welcome to British Coupe Ware, *Pottery Gazette and Glass Trade Review*, February 1953, p.253. 'A quiet unassuming artist, Miss Tait has not hitherto achieved prominence as a pottery designer. Her work for Midwinter's however shows that she is one of the industry's most promising young artists of whom more will be heard in the future.'
14. Conversation with Jessie Tait, July 2001.
15. Welcome to British Coupe Ware, *Pottery Gazette and Glass Trade Review*, February 1953, p.251.
16. *Pottery Gazette and Glass Trade Review*, February 1953, p.237.
17. Keeping Ahead with Contemporary Designs: New Midwinter range for home and export, *Pottery Gazette and Glass Trade Review*, June 1955, pp.912-5.

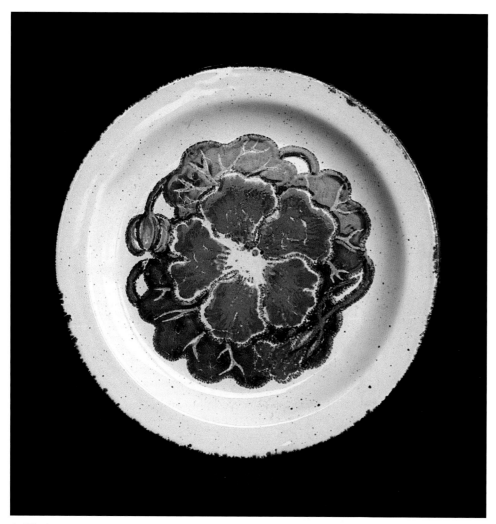

9. The Nasturtium pattern decorated on an earthenware side plate, diameter 7in (18cm), as part of the Stonehenge range. Designed by Jessie Tait for W.R. Midwinter Ltd., 1974.

18. *Pottery Gazette and Glass Trade Review*, June 1954, p.874; February 1955, p.189.
19. *Pottery Gazette and Glass Trade Review*, January 1954, p.104.
20. For further information see Chapter 2.
21. Jenkins, S., *Midwinter Pottery a revolution in British tableware*, Richard Dennis Publications 1997, p.73.
22. Focus, by Barbara Brown, 1964; Diagonal, by Nigel Wilde, 1964; Madeira, by Nicholas Jenkins, 1965.
23. Conversation with Jessie Tait, July 2001.
24. *Pottery Gazette and Glass Trade Review*, September 1967, p.875.
25. ibid., pp.875-8.
26. Royal Doulton and Co. Ltd. tempo shape by Jo Ledger, Art Director, 1966, *Pottery Gazette and Glass Trade Review*, February 1966, pp.186-7; Josiah Wedgwood and Sons Ltd. Orbit shape by Robert Minkin, Art Director, 1967, *Pottery Gazette and Glass Trade Review*, June 1968, p.575.
27. Bryan, A., ADAMS – A New Subsidiary, *Wedgwood Review* Vol.3 No.10, March 1966, p.14; *Pottery Gazette and Glass Trade Review*, January 1966, p.65.
28. *Pottery Gazette and Glass Trade Review*, April 1966, p.426, with effect from 31 March 1966.
29. Niblett, K., *Dynamic Design – The British Pottery Industry 1940-1990*, Stoke-on-Trent City Museum and Art Gallery 1990, pp.83-4. Information confirmed by Company Secretary of The Wedgwood Group.
30. *Pottery Gazette and Glass Trade Review*, March 1965, p.336.
31. See note 29, p.83.
32. Conversation with Jessie Tait, July 2001.
33. See note 29.
34. See note 29, p.82.

1. The screen curtains designed by Susie Cooper for the Regal Cinema which opened in London in 1928. The photograph was taken in the 1960s. Joy Couper, a Susie Cooper free-hand paintress who went to the cinema, recalled that seeing the curtains was so exciting that she soon forgot about the film.

CHAPTER 18

A WIDER FIELD

Ann Eatwell

Susie Cooper will be rightly remembered as a leading designer and manufacturer of English industrial ceramics. However, she was not only a businesswoman, manager and ceramic designer but also an artist in the fullest sense of the term. This essay aims to show how her broad interests emerged and were pursued when time allowed and how they complemented and enhanced the main thrust of her artistic endeavour, the ceramics.

Susie Cooper 'could always be kept good' with a drawing book as a child.[1] She attended evening classes at the Burslem School of Art and won a scholarship to continue her studies. 'I was interested in the idea of wood carving and making china figures.'[2] She remembered taking classes in freehand drawing, modelling, stained glass and plant form. At art school her ideas about a career began to centre on fashion design. 'I intended to do painting and wood carving, then fancied fashion design.'[3] This early exposure to a range of media gave Susie Cooper the confidence and desire to design outside ceramics.

She hoped to go to the Royal College of Art but later commented: 'I couldn't get

2. Examples of Susie Cooper's textile designs from the late 1940s.

3. This painted panel by Susie Cooper was displayed on her first trade stand at the British Industries Fair in 1932. She later hung it in her own home.

a scholarship to the Royal College of Art in London without first having had a job in industry.'[4] Ceramics was the local industry, so Gordon Forsyth, Superintendent of Art Education, suggested she work at the Gray's Pottery to qualify for the scholarship. 'He painted a very rosy picture of the work I could do at Mr Gray's factory. I might be able to design in lustre. I think I'd painted two pieces of pot at the school up till then but once I really got started I got bitten by the bug.'[5] The firm certainly nurtured her creative talent. She designed and decorated their trade stands with paintings and customised cushions in geometric patterns. A contemporary visitor to the British Industries Fair of 1927 noted: 'When I commented on the artistic quality of his (Mr Gray's) exhibit, he promptly referred me to his chief designer who was present (most unusual in my experience!). This lady is a recent product of the Burslem School of Art, and still attends there in the evenings.'[6]

As she gained in experience and understanding of the techniques and practicalities of designing and decorating the patterns on bought-in ceramics at Gray's Pottery, it became clear to Susie Cooper that more could be done: 'I knew that if I stayed there, I'd be just a decorator rather than a designer. And I wanted a wider field.'[7] In an attempt to find this 'wider field', she accepted an offer to design for the textile firm Skelhorn and Edwards. Her cushions had been admired by Mr Edwards and for a year she commuted between Staffordshire and London, spending a month at a time with each firm.[8] The curtains for the Regal Cinema chain's Marble Arch building that opened in the winter of 1928 must have been her largest design in textiles (plate 1).

In the early twentieth century, it was becoming possible for designers to turn their skills into a business. In America, Raymond Loewy opened a design firm in 1929, designing cars, refrigerators and ceramics. In the same year, Susie Cooper decided to stay in the Potteries, but on her own terms. She achieved this aim by managing her own business and the main thrust of her creativity was the ceramics themselves.

Gifts for the House-Proud

LEFT—

LF 13 SPECIAL PURCHASE of hard-wearing linen cloths. Fast colours with Green, Blue, Rose or Gold borders. LESS THAN PRE-WAR PRICES. 50" × 50", 1/11½; 50" × 68", 3/11. Napkins to match, 12" × 12", dozen 1/-

LF 11 Linen to match your China. SPECIALLY MADE FOR US. Breakfast Set in embroidered Irish linen. Tea cosy, tray cloth, egg cosy and napkin to match Susie Cooper "Dresden Spray." Tea and egg cosies have detachable covers. Fast colours in Natural, Green or Rose ground with contrasting border. Set **7/11**

LF 12 Natural Irish Linen drawn-thread luncheon sets, hand-worked in China. 13 pieces. Square, **6/11**. Oblong, including 6 napkins, **19/11**. Many other designs in stock.

IR 10 Service Holdall in pliable peccary grained chrome tan leather, lined heavy patent leather cloth. Fitted with solid stainless steel knife, fork and spoon. 3" × 8" when closed. **5/11**

CGL 10 (*below*) SUSIE COOPER-ware coffee set, porcelain finished, with a wide shaded grey and green band on ivory ground. **15/1**. Matching Dinner Set, 26 pieces, **56/8½**. Tea Set, 21 pieces, **19/0½**. Breakfast Set, 29 pieces, **30/6½**. Early Morning Set, **9/3½**. 100-Piece set, **£7/19/6**. Replacements obtainable from stock.

CGL 11 (*above*) Stainless and heat-resisting Tray, cellulose finished in a range of 5 colours. Chromium edge and handles. 18" × 13". **11/6**

EL 10 Pottery Lamp in Off White, Pale Pink, Green, Duck Egg Blue or Black, **6/11**. 10" Natural buckram shade, trimmed velvet ribbon to match lamp. Height 13½". **6/1**

IR 11 Strong Oak and Roan Leather Bellows, antique finish. Solid brass ferrule and studs. 17" × 6". **15/11**

RSL 13 Matching Brown Antique Leather Writing Set stamped in gilt. Blotting Pad: 17½" × 12", **3/11**. Stand-up perpetual calendar, 6⅜" × 5", **4/11**. Telephone index, with message pad, pencil and calendar. Shut, 7½" × 5¼", **9/11**. Brass-topped glass inkstand with leather base, 4⅞" × 4⅝", **11/9**. Letter rack, base 9⅞" × 4½", height 7¼". **15/11**.

R 12 Matt natural-finished oak cheese board, glass butter dish space for biscuits. Stainless steel cheese knife and butter knife, **12/-**. In walnut, **12/6**. **R 13** Toast Rack to match, **2/6**. **R 14** Jam or Pickle Stand, 2 glass jars Walnut only, **7/6**

S112 (*Right*) Canteen for 6 persons, fitted 49 pieces Old English Design Elkington Monarchy Plate and Ivorine-handled stainless steel cutlery. Light, medium or dark oak case. A really handsome present. **5½ gns.**

4. A page from the Peter Jones catalogue of 1939 illustrating the Dresden Spray patterned tea cosy and other pieces of linen (top left) and a Susie Cooper Kestrel shape coffee set (bottom left).

5. Susie Cooper Miniatures. Susie Cooper planned to launch a clothing range for children in cotton jersey. An existing document drawn up to create a company to support the venture is dated February 1940 and lists Susie Cooper and her husband, Cecil Barker, as subscribers.

However, to enhance their appeal she continued to design the firm's stands for the British Industries Fair, the advertising and packaging of her products and her London showroom, for which she painted decorative panels (plate 3) and developed a system of oak cubes for the display.

Throughout her career she designed products to enhance the appeal of the tablewares and to create a modern interior. From the 1930s, she experimented with linens to match her ceramic patterns. In 1939, John Lewis sold a breakfast set in linen embroidered with Dresden Spray (plate 4). Later, she formed an arrangement with Cavendish Fabrics and produced cotton chintz in Dresden Spray and Patricia Rose, as well as abstract leaf patterns on a theme of the Tree of Life designs (plate

6. An example of the packaging for co-ordinated linen, launched during the mid-1960s with Wemyss textiles.

7. A selection of the Susie Cooper cushion kits, produced by Twilleys of Stamford Ltd. about 1993-94. Six embroidery kits were authorised by Susie Cooper to commemorate her ninetieth year. The publicity claimed: 'The design itself is carefully printed on satin cotton and is intended either for framing or as a cushion.'

2). In the 1960s, an association with Wemyss textiles resulted in table linens that were sold in gift-wrapped folders (plate 6). The fabrics were dyed to her specified colours. In the early 1990s, as a result of an exhibition of her seed paintings, she was commissioned by Twilleys, a textile firm, to design tapestry cushion cover kits (plate 7). As the firm later went into receivership the kits were not on the market for very long. Although these textile lines may not have been commercially successful, the designs themselves demonstrate the classic Susie Cooper concern with elegant, practical and modern styling. Co-ordinating the place setting led to another experiment, this time with the cutlery firm Harrison Brothers and Howson of Sheffield. The cutlery developed to her design had curved and incised bone

8. A contemporary illustration showing examples of her experimental cutlery with wavy bone china handles. Made with the help of Harrison Brothers and Howson of Sheffield, 1960s.

9. Trials of cutlery with decorations to match bone china patterns, 1960s.

214

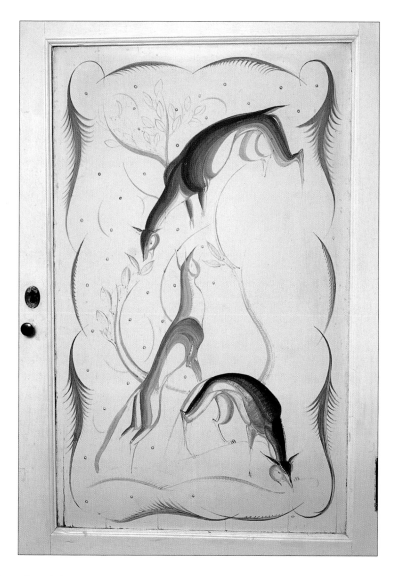

china handles (plate 8). She later commented that they did not sell well as the handles were considered to be too fragile. Used in many of the firm's publicity photographs, they added to the appeal of her tablewares. A trial set of metal cutlery shows that she had larger ambitions in the field that were not realised (plate 9). Designing for the home, particularly her own home, gave Susie Cooper a satisfying creative outlet. Some of her designs had a commercial application, like the curtain fabric and table linens, whilst others, such as the painted furniture and rugs, were especially created for her own home (plate 10).

10. A painted panel with deer decorates a corner cupboard. Probably painted by Susie Cooper in the 1930s, the cupboard was used to store her son's toys. Size of painting 17⅜in (44cm) x 27½in (70cm).

<h2 style="text-align:center">FOOTNOTES</h2>

1. Eatwell, A., *Susie Cooper Productions*, Victoria and Albert Museum, 1987.
2. Susie Cooper O.B.E., *Designer*, March, 1979, pp.13-14.
3. Woodhouse, A., Back to the Drawing Board, *The Mail on Sunday* (*You* magazine), 18 October 1992, p.72-76.
4. ibid.
5. Susie Cooper O.B.E. *Designer*, March, 1979, pp.13-14.
6. Minute investigating a complaint by Daisy Makeig-Jones concerning the quality of students produced by the local art schools, written by Mr Stone, an Inspector of Education for the Board of Education, 1927, Public Record Office, ED 83/009.
7. Susie Cooper O.B.E., *Designer*, March, 1979, pp.13-14.
8. Ann Eatwell interview with Susie Cooper, 1988.

RESOURCE FILE

Compiled by Andrew Casey

This Resource File has been designed to provide the reader with further opportunities for study and research. Included in this section are informative guides on published sources, both specific and general, as well as information on backstamps, glossary of terms and decorative treatments and other material on Susie Cooper pottery. The selection of museums and galleries that have examples of work does not represent the entire public ownership of her work.

BOOKS

Woodhouse, A., *Elegance and Utility*, Josiah Wedgwood and Sons Ltd., 1978.
This small, well-designed exhibition catalogue was for the first retrospective of Susie Cooper pottery, staged at the Sandersons Gallery, London. The colour illustrations are complemented by reproductions of drawings by the designer.
Eatwell, A., *Susie Cooper Productions*, V & A Publications, 1987.
An extensive guide to Susie Cooper's ceramics produced throughout her career with twenty-three colour and eighty-eight black and white images. This book contains information on decorative techniques, compositions of sets (illustrated), a list of employees and associates, the agents, retailers of Susie Cooper ceramics, suppliers of enamel colours and lithographic transfer prints and an interview with the designer.
Casey, A., *Susie Cooper Ceramics – A Collectors Guide*, Jazz Publications, 1992.
This book focuses both on the history of the Susie Cooper Pottery and information for collectors on the various periods of her working life. It contains a comprehensive list of backstamps, composition of sets and a chronology. The pattern guide lists information such as patterns, with brief descriptions, dates and the variations. The book has thirty-nine colour and fourteen black and white images.
Woodhouse, A., *Susie Cooper*, Trilby Books, 1992.
This biographical account of Susie Cooper's life illustrates several examples of her early work from the Burslem School of Art, to her latter years. There are seventeen colour photographs and many black white photographs from the Gray's period. There is a list of backstamps, a pattern guide and collectors' notes.
Collecting Susie Cooper, Francis Joseph Publications, 1994.
This informative book on Susie Cooper features many pages of colour photographs, some black and white images and a price guide.
Susie Cooper, Gakken, 1995.
This Japanese book consists of excellent high quality images of Susie Cooper pottery from her entire career. There are notes on backstamps, history and also details on specialist dealers in Japan.
Youds, B., *An Elegant Affair*, Thames and Hudson, 1996.
This large format book outlines Susie Cooper's life and work with ninety-eight colour photographs and thirty-five black and white images. In particular this book illustrates some of Susie Cooper's work, including modelled figures, from the Burslem School of Art. A pattern guide list with a backstamps guide is supported by information on shapes and a glossary of decorative techniques.

SELECTED ARTICLES IN DATE ORDER

Throughout her life many articles have been written about Susie Cooper. The list below represents articles and features that are relevant to students, collectors and historians.

*Indicates that Susie Cooper was interviewed for the article.

The Pottery Gazette and Glass Trade Review, 1 June 1931, pp.817-819.

Simple and Direct Design, The Art of Susie Cooper Pottery, *The Manchester Guardian*, 29 August 1932, p.182.

Susie Cooper Pottery, *The Pottery Gazette and Glass Trade Review*, 1 October 1932, pp.1249-1251.

Art Pottery that Appeals, *The Industrial World*, October 1932.*

Critchlow, D., Susie Cooper – An artist who brings beauty to many homes, *The Manchester Evening News*, 1 March 1933.

Warren, P., Susie Cooper, Artist in Pottery, *News Chronicle*, 6 October 1952.*

Portent of a new trend, *Pottery and Glass*, November 1956, pp.378-9.

Susie Cooper and William Adams, *Pottery Gazette and Glass Trade Review incorporating Tableware*, November 1966, p.1131.

Ades, J., Design for Many Markets, *Illustrated London News*, 1 February 1969, pp.18-19.*

Wedgwood, Susie Cooper Design, *Birmingham Sketch*, September 1971.

Crossingham-Gower, G., Susie Cooper – Pride of the Potteries, *Art and Antiques*, 12 April 1975, pp.16-19.

Jenkins, V., Designing Lady, *Evening Sentinel*, 5 June 1976.

Gosling, K., She creates beautiful china ware, *Evening Sentinel*, 21 April 1977, p.3.*

Susie Cooper, No.1 woman in the world of pottery, *Evening Sentinel*, 11 September 1977.*

Benn, E., Why Susie is top of the table, *The Daily Telegraph*, 27 May 1978, p.10.*

Winstone, V., World of Tableware, *Tableware International*, May 1978, pp.12-13.

Robertshaw, U., Designing Lady, *Illustrated London News*, 1 July 1978, pp.85-86.

Susie Cooper, O.B.E, *Designer*, March 1979, p.13-14.*

Snodin, S., Susie Cooper Diverse Designer, *Antique Collector*, August 1982, pp.53-55.

Celebrate in Style, *Evening Sentinel*, 30 October 1982.*

Winstone, V., Daisy Day, *Homes and Gardens*, March 1983.

Levin, A., At Home with the Queen of Ceramics, *The Mail on Sunday*, 26 June 1983, pp.38-39.*

Benn, E., All Set for a Fresh Look at Tableware, *The Daily Telegraph*, 23 August 1983, p.9.*

Susie Cooper, British Through and True, *Homes and Gardens*, February 1984.*

Rose, A., Woman whose success came on a plate, *The Times*, 11 July 1984, p.9.*

Fletcher, N., Sixty Glorious Years, The Work of Susie Cooper, O.B.E, *Antique Collecting*, October 1984, pp.26-30.

Niesewand, N., Leading Lady, *House and Garden*, September 1985, pp.146-147.*

Eatwell, A., Susie Cooper, Her Pre-War Productions 1922-1939, *V & A Album*, 1986, pp.225-233.

Hill, R., Economic Elegance – The work of Susie Cooper, O.B.E., *Country Life*, 10 April 1986, pp.922-923.*

Susie Cooper: Still Designing Sixty Years on, *Tableware International*, May 1987, pp.36-37.

Trucco, T., A London exhibit of Stylish Pottery, *The New York Times*, 25 June 1987.

Susie Cooper at the V and A, *The Gazette*, 27 June 1987, p.500.

Bell, J., The Susie Cooperists, *Vogue*, June 1987, pp.120-122.

Peake, G., In the Advanced Spirit, *Antique Collector*, July 1987, pp.54-56.

Segall, B., In search of Whispering Grass, *Taste*, July 1987, pp.103-107.

Woodhouse, A., Our Susie, *Homes and Gardens*, July 1987, pp.120-123.*

Dale, S., Designed for Elegance and Utility, *Antique Collector*, October 1990, pp.76-79.

Ellis, A., Collecting, *Observer*, March 1991, p.56.

Dale, S., Ceramics Revolution, *Antique Dealer and Collectors Guide*, November 1991, p. 28-30.

Woodhouse, A., The China Syndrome, *Crafts*, June/July 1992, p.22-25.

Innes, M., Susie Cooper, *Country Living*, October 1992, pp.102-106.*

Woodhouse, A., Back to the Drawing Board, *The Mail on Sunday* (*You* magazine), 18 October 1992, pp.72-76.*

Marsh, M., If you knew Susie, *The Independent on Sunday*, 8 November 1992, pp.66-67.*

Taylor, M., Susie Cooper, *Period Living*, March 1993, pp.42-44.

Scott, M., Susie Cooper, *The John Lewis Gazette*, 6 March 1993, pp.120-123. *

Forbes, L., Susie Cooper, *Sunday Observer* magazine, 28 March 1993.*

Susie Cooper Honoured by University, *Evening Sentinel*, 27 August 1993.

Marsh, M., Susie Cooper, *Woman and Home*, June 1994, pp.116-119.

Price, E., Career in Clay, *Architectural Digest*, June 1995, pp.56-57.*

Marsh, M., Kitchen Sink Classics, (Obituary), *The Guardian*, 31 July 1995,

Susie Cooper (Obituary), *The Times*, 1 August 1995.

Susie Cooper (Obituary), *The Daily Telegraph*, 1 August 1995.

Niblett, K., Susie Cooper (Obituary), *The Independent*, 1 August 1995, p.10.

Susie Cooper (Obituary), *The Economist*, 12 August 1995, p.99.

Susie Cooper (Obituary), *Newsline* (Wedgwood Newsletter) September 1995, p.5.

Youds, B., Susie Cooper (Obituary), *Tableware International*, September 1995, p.11.

Eatwell, A., Susie Cooper, O.B.E., R.D.I., (Obituary), *Crafts*, November 1995, p.64.

Casey, A., Dynamic Designer, A Tribute to Susie Cooper 1902-1995, *Antique Collecting*, November 1995, pp.12-17.

Silver, R., Susie Cooper: Ceramic Designer 1902-1995, *Studio Pottery Magazine*, November/December 1995, p.24-31.*

Youds, B., Susie Cooper OBE, RDI, *RSA Journal*, March 1997, pp.44-48.

Casey, A., Susie Cooper, *Collect It*, March 1998, pp.22-24.

Miller, J., Very Susie Cooper, *Homes and Antiques*, August 2001, pp.80-84.

GENERAL BIBLIOGRAPHY

Anscombe, I., *A Woman's Touch: Women in Design from 1860 to the Present Day*, Virago, 1984.

Atterbury, P., Denker, E., and Batkin, M., *Twentieth Century Ceramics, A Collectors Guide to British and North American Factory Produced Ceramics*, Mitchell Beazley, 1999.

Attfield, J., and Kirkham, P. (Editors), *A View from the Interior: Feminism, Women and Design*, Women's Press, 1989.

Batkin, M., *Wedgwood Ceramics 1846-1959: A New Appraisal*, Richard Dennis, 1982.

Buckley, C., *Potters and Paintresses: Women Designers in the Pottery Industry 1870-1955*. The Women's Press, 1990.

Casey, A., *Twentieth Century Ceramic Designers in Britain*, Antique Collectors' Club, 2001.

Forsyth, G., *Twentieth Century Ceramics*, The Studio Ltd., 1936.

Hannah, F., *Twentieth Century Design: Ceramics*, Bell and Hyman, 1986.

Jackson, L., *The New Look, Design in the Fifties*, Thames and Hudson, 1991.

Jenkins, S., *Midwinter Pottery: A Revolution in British Tableware*, Richard Dennis, 1997.

MacCarthy, F., *British Design Since 1880: A Visual History*, Lund Humphries, 1982.

McLaren, G., *Ceramics of the 1950s*, Shire Publications, 1997.

McCarthy, F., and Nuttgens, P., *Eye for Industry: Royal Designers for Industry 1936-1986*, Lund Humphries in association with the Royal Society of Arts, 1986.

Niblett, K., *Dynamic Designers, The British Pottery Industry 1940-1980*, Potteries Museum, 1990.

Niblett, P., *Hand painted Gray's Pottery*, City Museum and Art Gallery, Stoke-on-Trent, 1982.

Sarsby, J., *Missuses and Mouldrunners. An Oral History of Women Pottery Workers at Work and at Home*, Open University Press, 1988.

Spours, J., *Art Deco Tableware*, Ward Lock.

Stevenson, G., *Art Deco Ceramics*, Shire Publications, 1998.

Stevenson, G., *The 1930's Home*, Shire Publications, 2000.

JOURNALS AND NEWSPAPERS

Design for Today
Decorative Art, Studio Year (1920-1960)
The Pottery Gazette and Glass Trade Review (Tableware International)
Pottery and Glass Record
Crockery and Glass (US)
The Pottery and Brass Salesman
Design Magazine
Evening Sentinel, Staffordshire Sentinel Newspapers Ltd., Stoke-on-Trent
Journal of the Royal Society of Arts

ARCHIVES

The Susie Cooper pattern and description books for the Chelsea Works and Crown Works and pattern books of W. Adams Ltd. and other archival material are held at the Wedgwood Museum.

PLACES TO VISIT

Please note that the various examples of Susie Cooper's pottery and associated items may not be on public display. Individuals wishing to view certain materials should contact the institution directly to make an appointment.

City of Aberdeen, Art Gallery and Museum's Collections
This museum has a small collection of Susie Cooper pottery that includes a muffin dish and hors d'oeuvres set from the 1940s and a Pink Fern breakfast set from 1987.
Art Gallery, Schoolhill, Aberdeen AB10 1FQ.
Telephone: 01224 523700

Geffrye Museum
The Geffrye Museum, well known for featuring twentieth century design, has a 1930s period room setting with Susie Cooper pottery on display.
Kingsland Road, London E2 8EA.
Telephone: 020 7739 9893

Manchester Art Gallery
The Manchester Art Gallery has a strong collection of twentieth century design. They have a wide selection of Susie Cooper pottery, particularly from the Gray's period, including a ginger jar and a vase decorated with cherubs. Many examples were given by the designer during the thirties.
Manchester Art Gallery, Moseley Street, Manchester M2 3JL.
Telephone: 0161 234 1456
Website: www.cityartgalleries.org.uk

National Museum and Gallery
This museum holds a varied and diverse range of pottery by Susie Cooper including a wide selection of studio wares, a 'Brunette' (Greta Garbo) face mask and several hand-painted floral tea sets.
77 Cathays Park, Cardiff, CF1 3NP.
Telephone: 029 2057 3104
Website: www.nmgw.ac.uk

National Portrait Gallery
This museum purchased a self portrait face-mask introduced by Susie Cooper in 1933.
St Martin's Place, London WC2H 0HE.
Telephone: 020 7306 0055
Website: www.npg.org.uk

The Potteries Museum & Art Gallery
The Potteries Museum has a good collection of Susie Cooper pottery from all the periods of her career, many of these donated by the designer during her latter years.
Bethesda Street, Hanley, Stoke-on-Trent, Staffordshire, ST1 3DE.
Telephone: 01782 232323
Web site: www.stoke.gov.uk/museums/pmag

Plate 1. A part earthenware Kestrel shape coffee set decorated with the popular Crayon Line pattern, about 1934.

Victoria and Albert Museum
The V & A holds a wide range of Susie Cooper material. Notable items include the Leaping Deer vase from the Gray's period, the Fish vase from about 1932, the Clown lamp base and the Leaping Deer table centre. Several examples were donated by Susie Cooper over the years. The collection also includes a number of lithographic sheets, paper goods and an example of her textile designs.
Cromwell Road, South Kensington, London, SW7 2RL.
Telephone: 020 7942 2000
Web site:www.vam.ac.uk

Plate 2. A rare earthenware vase decorated with a hand-painted pattern of fish, about 1932-33.

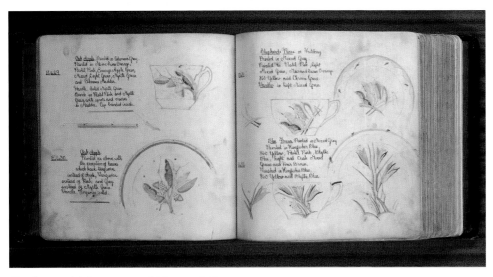

Wedgwood Museum and Visitors' Centre
The Wedgwood Museum has a large collection of Susie Cooper material. Besides a number of production pieces they have a collection of trials and lesser-known patterns that were not put into production. They also have printed material, ephemera and important company documents such as the pattern, description and price books.
Josiah Wedgwood and Sons Ltd., Barlaston, Stoke-on-Trent, Staffordshire, ST12 9ES.
Telephone: 01782 204141
Web site: www.wedgwood.com

Plate 3. Pages from the Susie Cooper pattern book showing the Oak Apple (E/429/430), Shepherd's Purse or Fritillary (E/431) and Blue Freesia (E/432) patterns, about 1932.

BACKSTAMPS

Throughout Susie Cooper's long working career many different marks were stamped, printed, incised and hand painted on to her pottery. The following list is meant to be a general guide to the main marks used during her career. The Susie Cooper books, listed above, each have a more comprehensive list of the marks and variations.

GALLEON MARK

This mark was used on all types of pottery from about 1912 to about 1928. Variations include 'GRAY'S POTTERY' replacing 'A.E. GRAY & Co. LTD'.

GALLEON MARK

This mark, featuring a galleon with yellow sails, was introduced in about 1921 until about 1931. The variations include the words HAND PAINTED above the mark and 'GRAY'S POTTERY' replacing 'A.E. GRAY & Co. LTD.'

LINER MARK

This mark, used on all types of ware, was introduced in about 1923 and used until about 1931.
Several variations have been recorded including 'SUSIE COOPER NURSERY WARE' and 'SUSIE COOPER WARE' instead of 'DESIGNED BY SUSIE COOPER'. There are examples with the pattern name included. This mark was later used, after she left the company, with the words 'DESIGNED BY SUSIE COOPER' taken off.

GLORIA LUSTRE MARK

This mark was used on lustre decorated ware. It was printed in black and gold (also in all gold or all black). This mark was introduced in 1923 to about 1928. The foot rings on pottery with this mark are usually painted, often black but green, blue and gold have been recorded.

TRIANGULAR MARK

This lesser-known mark was in use for a limited period during 1929 and 1931. The rubber-stamped mark in black often featured either the words Tunstall or Burslem, which gives some indication of the date of production.

LEAPING DEER MARK

This printed mark was first issued in 1932 and used on all wares throughout the thirties and for a short period after the Second World War. Many variations have been identified of this mark with the addition of the pattern name.

SIGNATURE MARK

Throughout her career the Susie Cooper signature was applied in various forms on both bone china and earthenware such as painted or incised into the clay for the series of art wares. The painted signature was usually applied by the decorator unless it was a special item that probably would have been signed by the designer.

BONE CHINA MARK

Introduced about 1950-March 1966. Printed in brown with several variations including printed in black, blue, green or old gold. With pattern name or number, or both from the mid-fifties.

WEDGWOOD MARK

This mark was introduced in about 1969 and in use until about 1988. Following the merger the general bone china mark issued prior to the takeover was continued with the words 'MEMBER OF THE WEDGWOOD GROUP' added. Printed in black and old gold with a number of additions such as pattern names and numbers.

ADAMS MARK

During her short period of time at William Adams Ltd., three different marks were used. This mark was introduced when the new Micratex body was launched in 1984.

GLOSSARY OF TECHNIQUES

This part of the resource file has been designed to provide information on some of the basic forms of decorative treatments that were used by Susie Cooper. Anyone wishing to acquire further details should see: Eatwell. A., *Susie Cooper Productions*, V & A Publications, 1987, pp.96-97 and Youds, B., *An Elegant Affair*, Thames and Hudson, 1996 p.80.

Aerographing

This was a method of colouring large areas of pottery using a spray jug. This technique, introduced by Susie Cooper during the mid-thirties, this technique was often combined with sgraffito decoration with patterns such as Crescents being typical (plate 6, page 189).

Banding

Throughout her career Susie Cooper used banded decoration. There are several types, using either underglaze or overglaze colours, that include solid banding, wash banding and shaded banding. For solid banding tar was mixed with the enamel colour to achieve a greater depth of colour. Typical pattern ranges that employed this form of decoration included Chinese Fern and Tree of Life from the late forties (plate 16, page 82).

The more subtle shaded banding technique, used to complement the popular transfer-printed floral sprays, was achieved by decreasing the weight of colour during the application to create a shaded edge. Notable examples using transfer-printed patterns include Dresden Spray and Swansea Spray (plate 12, page 53).

The popular wash banding technique, later known in publicity as Wedding Ring, was achieved by combining size and turps into the colour. The result gives a smooth and light depth to the colour, showing no brushmarks. This technique allowed for many colour variations and often the addition of painted motifs (plate 9, page 77).

Carved decoration

This technique, also known as incised decoration, was used on the Susie Cooper art ware range. The pattern was incised into the leatherhead clay body using a pounce as a guide. This range was later slip cast with the outline sharpened by a decorator (plate 1, page 46).

Covercoat (slide)

This superior method of applying transfer prints to pottery was introduced during the early sixties for bone china production. The transfer is printed on to a collodion film attached to a backing paper that was soaked on a damp cloth; the print was then taken off and applied to the ware. Notable patterns that used this technique included Persia (C.2019) and Venetia (C.2039) (plate 5, page 115).

Crayon decoration

This distinctive method of decoration, introduced in about 1934, utilised crayon sticks. The decorator applied the sticks on to the unglazed ware that was later fired to give a subtle effect. This innovative method was often combined with printed lines, such as Crayon Loops (E/1147) from 1936, and for a series of matt glazed dessert sets and vases. The most well known use of crayon decoration was for a series of banded patterns incorporating painted bands (plate 1, page 146). During

the fifties Susie Cooper introduced a series of transfer-printed patterns based on crayon designs with a notable example being Green Feather (E/2349).

In glaze decoration
Under glaze colours were applied on to the glaze and then fired. The colours melted into the glaze giving an appearance of depth to the pattern (plate 1, page 98).

Lithographic Prints
Susie Cooper used this method of decoration extensively until the late 1950s/early 1960s, when improved forms of printing were introduced. Transfer-printed patterns had the advantage that patterns comprising several colours could be printed. Notable examples include Dresden Spray and Patricia Rose (plate 10, page 78).

Lustre decoration
Susie Cooper used lustre decoration throughout her career, from the Gray's period with her Gloria Lustre patterns to the range of Silver Jubilee giftwares for Wedgwood in the seventies. This technique required metallic oxides in suspension to be applied over the glaze, which is then fired in a reducing, or oxygen-starved atmosphere leaving a thin film of metal to give an iridescent appearance.

Pounce
The outline of a pattern was drawn on to paper that was then pricked and laid over the ware. Charcoal dust was rubbed through to create an outline on the ware as a guide for the decorator. The charcoal disappeared during the firing.

Sgraffito
The pattern was scratched out through coloured glaze by a free hand paintress. Typical patterns range from simple scrolls to more complex patterns of animals and stylised classical borders (plate 15, page 81).

Tube-lining
Susie Cooper used the tube-lining decorative technique for a brief period during 1933-34. It is thought that some of the Bursley workers who had worked on patterns by Charlotte Rhead undertook the work. Slip was applied under the glaze using either a rubber bag or a glass syringe, a development of an old technique known as slip trailing. Notable examples include the Dropped Lines pattern (E/679) (plate 8, page 137).

Underglaze decoration
The painted pattern was applied to the biscuit ware (unfired) and used special colours. Both crayon and tube-lined decoration were also applied under glaze. Introduced by Susie Cooper after the Second World War, when greater durability was demanded by customers.

THE EDITORS

ANDREW CASEY is the author of *Susie Cooper Ceramics – A Collectors Guide*, Jazz Publications (1992) and *Twentieth Century Ceramic Designers in Britain*, Antique Collectors' Club (2001). He formed the Susie Cooper Collectors' Club in 1990. He has curated several exhibitions including 'Susie Cooper Productions' (from private collections in East Anglia) for Ipswich Museums and Galleries in 1989 and 'Dynamic Designers' for Croydon Museum in 1999. He lectures widely on the decorative arts.

ANN EATWELL is an Assistant Curator in the Sculpture, Metalwork, Ceramics and Glass Department of the Victoria and Albert Museum. She curated the major retrospective exhibition, 'Susie Cooper Productions' in 1987 and wrote the accompanying book. She contributed to the research and presentation of the Channel 4 programme 'Pottery Ladies'. She has researched and written widely on the history of ceramics and silver, including modern industrial ceramic production. Her published articles include 'The Harrods Experiment 1934' and 'Midwinter Pottery' for *Antique Collecting*. She edited an exhibition catalogue on the work of Daisy Makeig-Jones.

THE CONTRIBUTORS

SUSAN BENNETT, former Curator of the Royal Society of Arts in London, has raised awareness of the rich and varied history of the Society through talks and publications. She has assisted researchers from all over the world to access materials within the RSA collections. Susan Bennett has lectured to a number of organisations including the Williams Morris Society and The Metropolitan Police History Society.

DR CHERYL BUCKLEY, BA Hons. (East Anglia, 1977), M.Litt. (Newcastle, 1980), Ph.D. (East Anglia, 1991) is Reader in Design History at the University of Northumbria. For the last twenty years she has researched and published widely on aspects of design and gender. Her Ph.D. thesis, entitled 'Women Designers in the North Staffordshire Pottery Industry 1914-1940', and her book *Potters and Paintresses, Women Designers in the Pottery Industry 1870-1955* (The Women's Press, 1990) made a major contribution to the study of questions of gender, women and design history. She has written extensively on ceramics, gender and fashion and her new book (with Hilary Fawcett) is entitled *Fashioning the Feminine. Representation and Women's Fashion from the Fin de Siècle to the Present* (I.B. Tauris, 2002).

NICK DOLAN studied The History of Design and the Visual Arts at North Staffordshire Polytechnic, writing his thesis on Susie Cooper pottery. He helped with research for the Channel Four documentary 'Pottery Ladies', and the Victoria and Albert Museum's retrospective exhibition on Susie Cooper in 1987. Following fifteen years curatorial work with Tyne and Wear Museums he now manages Souther Lighthouse and the ancestral home of George Washington for the National Trust. He has appeared on a number of television programmes and lectures widely.

SHARON GATER is a Graduate of Oxford (Brookes) and Keele Universities and she recently completed her twenty-second year at Josiah Wedgwood and Sons Ltd. She specialises in twentieth century and Victorian Wedgwood history. She co-authored a book, *Factory in a Garden*, published in 1989. She first met Susie Cooper during the early eighties. Together with her colleagues at the Wedgwood Museum she staged the 'Portrait of Susie Cooper' exhibition in 1992, at the Wedgwood Visitors Centre in Barlaston, Stoke-on-Trent. She has contributed to many journals, lecturing in this country and in North America.

ALUN GRAVES is an Assistant Curator in the Sculpture, Metalwork, Ceramics and Glass Department of the Victoria and Albert Museum. He has contributed a number of articles and essays on twentieth century British art and ceramics to books, catalogues and journals, including *The Burlington Magazine* and *The New Dictionary of National Biography*. He has recently completed a volume in the V & A Decorative Arts series: *Tiles and Tilework of Europe*.

KATHY NIBLETT was born in The Potteries. She is a graduate in the History of Art from the Open University and ceramic history has been a long-held interest and hobby. From 1978 to 1999 she was the curator in charge of twentieth century ceramics at The Potteries Museum & Art Gallery, Stoke-on-Trent. Kathy Niblett has researched and presented many exhibitions, several of which toured to other museums, and has written the accompanying books and catalogues. She lectures to a wide variety of audiences and has had papers published in scholarly journals and antiques magazines.

JOHN RYAN, a former Managing Director for the Wedgwood Earthenware Division, worked closely with Susie Cooper in the 1980s.
Greg Stevenson is the author of *Art Deco Ceramics* (1998) and *The 1930s Home* (2000), both published by Shire Books. He is a material culture historian who lectures at the University of Wales, Lampeter. Visit him at www.the1930shome.co.uk

JULIE TAYLOR is a Curator and Project Manager at the Victoria and Albert Museum. She is currently Assistant Project Manager (Operations) for the British Galleries Project, which opened in November 2001. She previously worked in the Registrar's Department at the V & A, organising loans and touring exhibitions, and in the V & A's Ceramics and Glass Department.

BRYN YOUDS is the author of *Susie Cooper, An Elegant Affair*, published by Thames and Hudson (1996). He lectures in art and design history. He presented a Channel Four television programme on the life and work of Susie Cooper.

EMPLOYEES AT THE SUSIE COOPER POTTERY

	1932	1934/36	1946/70
Printers	1		
Enamellers	4		
Lithographers	5	8	12
Aerographers	2	5	6
Freehand paintresses	5	8	10
Other decorators	15	30	55
Glost warehouse	5	6	8
Enamel warehouse	10	15	20
Polishers	1	2	3
Kilnmen	3	3	3
Packers	1	2	3
Office staff	3	5	7
Warehouse staff	3	3	5
approximate totals	58	87	132

Longton – Jason Works. I believe about 80 staff were employed as follows:

Manager	1
Makers, casters, spongers, etc.	20
Warehouse staff	10
Others	5
Total	41

There was some decorating at the Longton Works but gradually this all took place at Burslem, with Longton being confined to the production of bone china.

SUSIE COOPER POTTERY (PRE-WAR) ORGANISATION

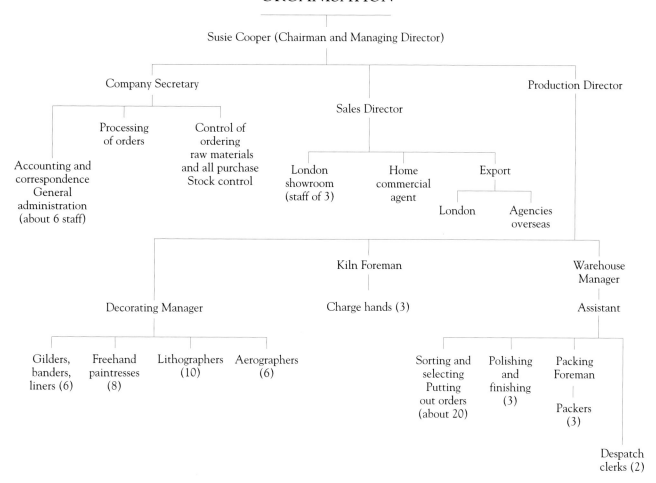

Susie Cooper (Chairman and Managing Director)

Company Secretary

Sales Director

Production Director

Processing of orders

Control of ordering raw materials and all purchase Stock control

Accounting and correspondence General administration (about 6 staff)

London showroom (staff of 3)

Home commercial agent

Export

London

Agencies overseas

Kiln Foreman

Warehouse Manager

Decorating Manager

Charge hands (3)

Assistant

Gilders, banders, liners (6)

Freehand paintresses (8)

Lithographers (10)

Aerographers (6)

Sorting and selecting Putting out orders (about 20)

Polishing and finishing (3)

Packing Foreman

Packers (3)

Despatch clerks (2)

PICTURE CREDITS

INDEX

Printed in England.

PATTERN No. 8900